THE SECRETS OF
CLOSE-UP PHOTOGRAPHY

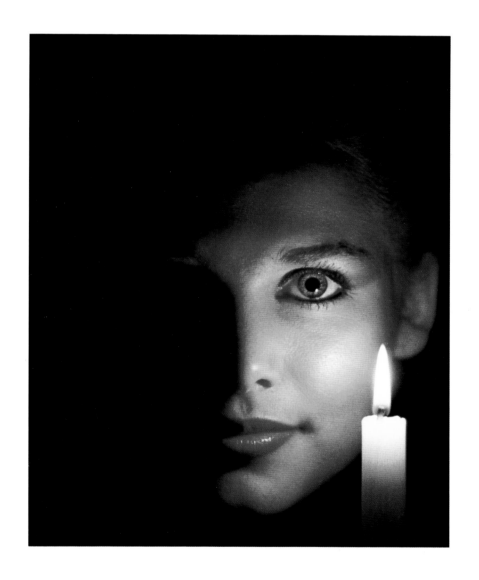

Lou Jacobs, Jr.

WRITER'S DIGEST BOOKS

CINCINNATI, OHIO

ABOUT THE AUTHOR

Lou Jacobs, Jr. began his career in photojournalism in 1950. He has taught at the Brooks Institute of Photography, UCLA and Cal State Northridge, and is a member and former president of the American Society of Media Photographers. This is his twenty-third photography book.

The Secrets of Close-Up Photography. Copyright © 1997 by Lou Jacobs, Jr. Printed and bound in Hong Kong. All rights reserved. No part of this book may be reproduced in any form or by any electronic or mechanical means including information storage and retrieval systems without permission in writing from the publisher, except by a reviewer, who may quote brief passages in a review. Published by Writer's Digest Books, an imprint of F&W Publications, Inc., 1507 Dana Avenue, Cincinnati, Ohio 45207. (800) 289-0963. First edition.

Other fine Writer's Digest Books are available from your local bookstore or direct from the publisher.

01 00 99 98 97 5 4 3 2 1

Library of Congress Cataloging-in-Publication Data

Jacobs, Lou.
 The secrets of close-up photography / by Lou Jacobs, Jr.
 p. cm.
 Includes index.
 ISBN 0-89879-727-6 (pbk. : alk. paper)
 1. Photography, Close-up. I. Title.
TR683.J33 1997
778.3'24—dc 96-41089
 CIP

Edited by Mary Cropper
Production edited by Marilyn Daiker
Designed by Brian Roeth
Cover illustrations by Lou Jacobs, Jr., Manny Rubio and courtesy of the 3M Corporation

Our thanks to the following photographers and companies for permission to reproduce the photographs in this book: 3M Corporation, John B. Carnett and *Popular Science*, Eastman Kodak, Lydia Clarke Heston, Barry Jacobs, Kathleen Jacobs, Kathleen Jaeger, Levenger: Tools for Serious Readers, Donald E. Martin, Darlyne A. Murawski, Olympus America Inc., Vincent Reed, Manny Rubio and Ken Whitmore.

This book is dedicated to my wife, Kathy, who has been so understanding when I needed extra time focusing a few inches from flora, fauna and all the miscellany in the close-up world.

ACKNOWLEDGMENTS

My thanks to all the photographers and to Eastman Kodak, 3M Corporation and Olympus for so generously contributing many fine photographs to my book. I also appreciate the help and encouragement of my editor, Mary Cropper, and her boss and mine at Writer's Digest Books, Bill Brohaugh.

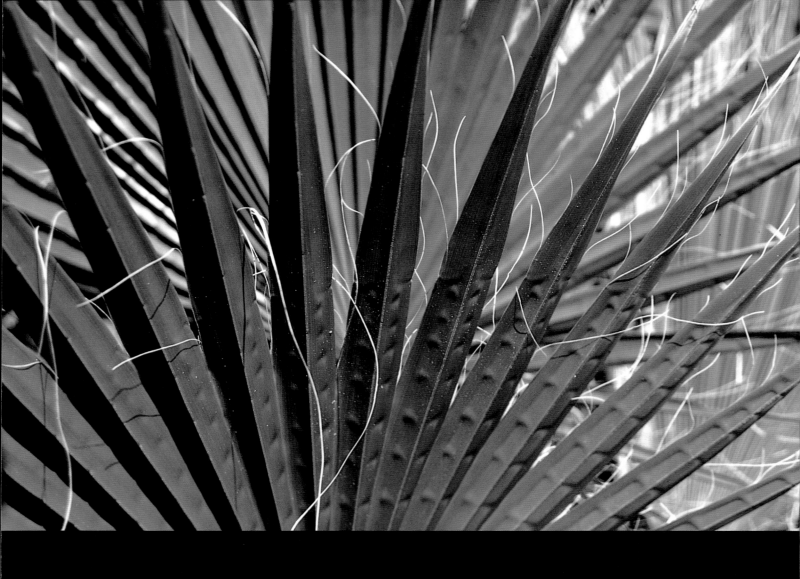

Introduction

Since I bought my first single-lens reflex (SLR) camera three decades ago, close-up photography has fascinated me. Shooting varied subjects such as flowers, faces, seashells, still lifes or assorted small objects lifts my spirits, like capturing a beautiful sunset does. Close-ups give us a magnified look at both the natural world and man-made worlds. Searching for likely subjects for close-up photography increases your awareness of and enthusiasm for everything around you—indoors and in the streets and fields.

One challenge is to isolate sections of things through the camera finder in a suitable composition and appropriate lighting to create images, practical and aesthetic. Imagine, for example, how exciting the patterns in the bark of a tree, the colors of fallen leaves or the fantastic details of some toys might look on film. Getting closer to a subject often gives it greater impact. The most ordinary object may become mysterious when its identity is no longer easily recognized.

Close-up photography offers a quiet kind of excitement. The small scale of the image and the need to focus on details challenge your skills in composition and lighting, promoting improvement of your work. Close-up patterns and textures stimulate your sense of design. It can be an exciting change of pace to find subjects that make "what-is-it?" puzzles out of coils of twine or a slice of orange when you are close enough.

Narrow your vision to find intriguing areas with small patches of color or design to focus on more closely. Go to county fairs, zoos, marinas, museum exhibits, farms, flower shows or stores where you have permission to shoot. You can find good subjects for close-up photography almost anywhere. Nature offers many wonders—a rosebud, a bee on a flower, a hummingbird or a reptile, just to name a few. You can create still-life setups—arranging seashells, colored glass, stamps, coins or whatever interests you—and shoot them in daylight or artificial lighting.

The techniques of most close-up photography are not complicated, but care and precision are required for pictorial satisfaction. All the most accessible aspects of close-up photography are covered in clear explanations in this book. I don't believe in being esoteric to make an impression. I'll explain photographic principles, and I'll show and tell how a large variety of close-up pictures can be taken with affordable equipment. I'll also mention specialized gear for specific photo problems, but I prefer to take pictures as simply as possible, using reasonably priced equipment. Since beginning my career as a professional photographer in the 1950s, I've taken numerous close-up pictures for publication and for fun. I've also enjoyed writing many how-to photography books. This book covers approaches to photography that I find rewarding, and I hope to make close-ups enjoyable for you, too.

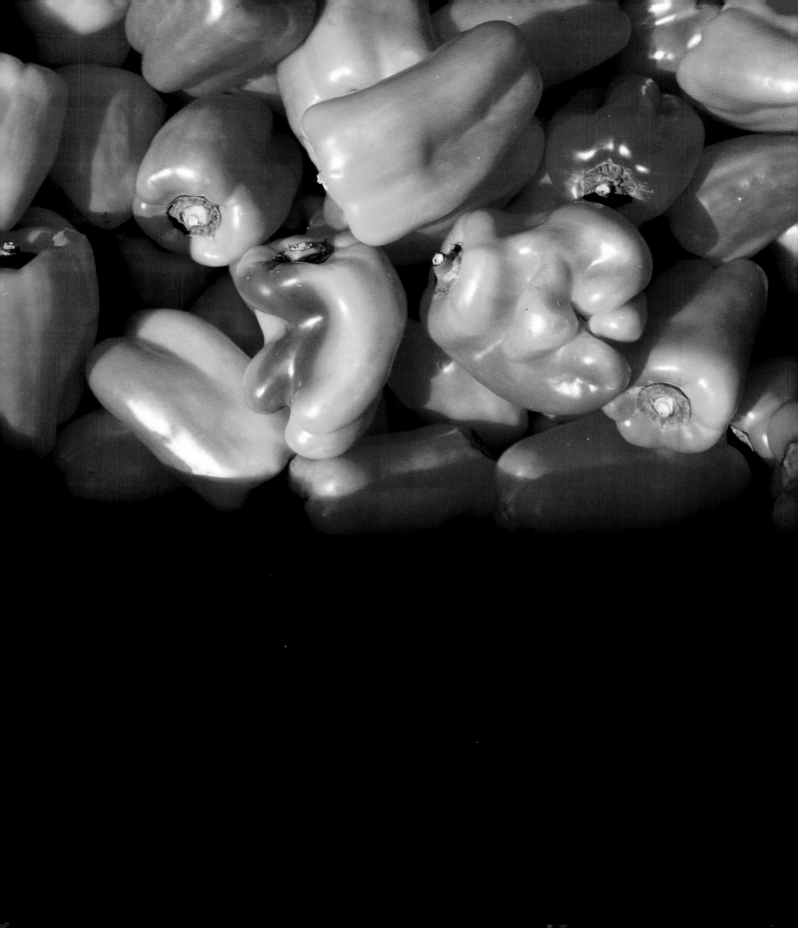

Table of Contents

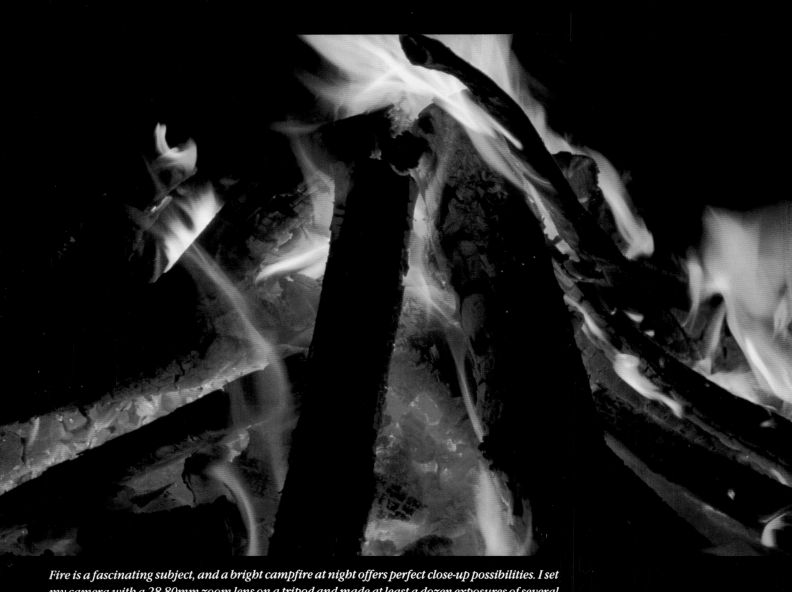

Fire is a fascinating subject, and a bright campfire at night offers perfect close-up possibilities. I set my camera with a 28-80mm zoom lens on a tripod and made at least a dozen exposures of several compositions at camera meter readings of 1/15, 1/8 and 1/4 to blur the fire and make it more decorative. I think this was shot at 1/15 using Ektachrome Elite 100.

Close-Up Principles and Techniques

HOW CLOSE IS A CLOSE-UP?

The definition of the term "close-up" in photography varies. If you're shooting people, a tight shot of a face or head and shoulders is a close-up. If you're shooting natural subjects or still lifes, a close-up could be an image of a butterfly that fills the entire frame of a 35mm slide or a bowl of fruit on a table that appears one-fifteenth of life-size on film. Close-ups often show intimate detail compared to landscape shots, and in many cases the main subject is closely singled out. You expect close-ups to enlarge what you photograph to a greater extent than in other pictures, due to the lens you choose and how far you are from the subject.

However, the distance from image to subject is not a good gauge of whether a picture is a close-up since lens focal length is also involved. For instance, you may be able to photograph the same size area of rock detail with a 50mm lens and a 100mm lens because many of today's lenses and accessories have excellent close-up capability. Focusing from about eighteen inches for a 50mm lens and about thirty inches for a 100mm lens, the rock close-up you get on film would be approximately the same.

To describe close-ups, photographers often refer to image enlargement, which is measured as a ratio between the actual size of the subject and the size it appears *on film*. Image enlargement is given as a ratio or written as a fraction followed by an *X* (also called close-up ratio numbers). An image on film that is one-quarter the size of the original could be written as 1:4 or 1/4X. A subject on film that is the same size as the real thing is designated 1:1 or 1X. Use the method you prefer to express close-up ratio terms.

In this book I use fractional *and* ratio numbers because both are widely understood. However, I've used close-up enlargement numbers sparingly in picture captions because subject size on film and printed size in this book or by a processing lab is not the same. When I mention shooting something half-size or 1:2, for instance, I'm trying to help you understand the photographic situation as the camera saw it. I'm not describing the relationship of subject size to image size you see on the page.

Here are loose guidelines to help you visualize different degrees of closeness in terms of image size on film:

Close images may be defined as those that are one-tenth (1:10) to one-fourth (1:4 or 1/4X) life-size on film. The term usually covers lens-to-subject distances from about eighteen inches to three feet, the approximate close-focusing limits of lenses in the 50-100mm range. I photographed the bowl of fruit shown opposite at top left against a black background with a zoom lens at 90mm from a distance of about thirty inches. (Lens manufacturers don't use uniform definitions of close-up, so make yourself familiar with the minimum focusing distance of each of your lenses.)

Closer images are roughly half life-size (1:2 or 1/2X up to 1:4). This results from focusing eight to eighteen inches from subjects like small objects or patterns. The photo shown opposite at top right of the same bowl of fruit you see to its left, with the fruit slightly rearranged, was taken from about fourteen inches with a 50mm macro lens.

Closest images are those between 1:2 and 1:1, or life-size on film, as a result of focusing only a few inches from the subject. The photo shown opposite at lower left was taken with a 50mm macro from about ten inches and the one shown at lower right was shot from about eight inches. Photographing images with this close-up ratio is often called macro photography. (Photomicrography, making images with a camera mounted on a microscope, can produce large magnifications of even tiny subjects, such as viruses.) Macro lenses, designed specifically for close-up images, produce life-size pictures, as do some lenses with added extension tubes or supplementary lenses called *diopter lenses* that allow regular lenses to focus closer. (For more on both types of equipment, see pages 43-45.)

The term *macro mode* was originally used for zoom lenses with a button for closer than-usual focusing. Zooms that focus to their closest distance without special adjustment are still described as having a macro mode, i.e., close-focusing capability. A close-focusing lens may be described as having *macro capability*, which means it can shoot close-ups, but how closely a lens will focus does not tell you its maximum close-up ratio. When you know the minimum focusing distance of a lens, you can evaluate its actual macro capability. The word *macro* is loosely applied, so you must dissect its meaning when you're not sure what a manufacturer or salesperson means. They're usually saying the lens can be used for *close-ups*, a word as imprecise as *big*.

EQUIPMENT BASICS

Some cameras and lenses are better suited for close-up work than others. The closer you are to a subject, the more your camera needs a viewfinder that will give an accurate image. You will often shoot subjects, or details from them, that require careful composition; a single-lens reflex camera (SLR) that lets you view and focus through the lens as you shoot is ideal for this type of work. Both 35mm and medium-format SLR cameras are good choices. Some photographers swear by their medium-format cameras, even in the field. Many others find 35mm

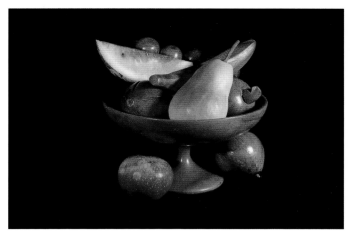

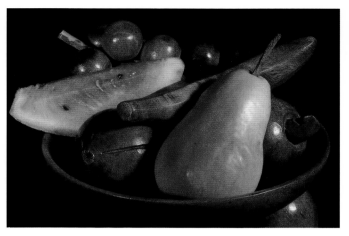

This series of shots illustrates how degrees of closeness affect the size of film image. This close image, about one-twentieth life-size, was taken at the 90mm setting of a 28-105mm zoom lens about thirty inches from the subject. Light came from a 500W photoflood bulb at right, and at the left I positioned a white card reflector to partly fill the shadows. All four images were taken at f22 at 1 second on Ektachrome Elite 100 film. I used an 80A filter to correct daylight film for artificial light.

I took a closer shot of the fruit, about one-tenth life-size, from fourteen inches with a 50mm macro lens and the same lighting setup. Notice how much less of the composition you can see than in the image at left. Compare how much more fruit texture you can see than before. Some zoom lenses will focus this closely, but I preferred the 50mm macro, which offers greater depth of field than a zoom at the longer focal length needed to get the same size image.

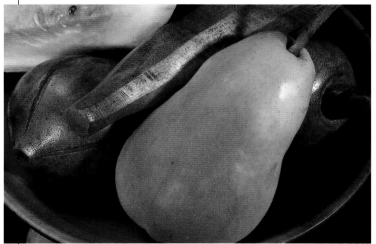

This closest example was taken with the 50mm macro from about ten inches. It's about 1:6 or one-sixth life-size. You continue to see more and more detail of less and less of the subject than in the previous shot shown above at right. As film images approach life-size, you can present intimate details not easily seen any other way.

Though the fruit appears close to life-size on this page, the image is about 1:4 on the film or one-fourth life-size (photographed from about eight inches). You don't have to shoot a subject 1:1 or even 1:2 on film in order to present it close to life-size in an enlarged print, or larger than life-size in a projected slide.

cameras more practical because they are lighter, more compact and easier to maneuver for close-ups. Medium-format models adapt well to studio and outdoor shooting on a tripod. Some commercial studio and fine art photographers also use view cameras, with which they must compose and focus an upside-down image on a ground glass. When they insert the film, the finder is blanked out as the picture is taken. View cameras can make lovely close-ups, but they are slow to use, heavy to carry and are best adapted to nonmoving subjects.

Because of their view-finder design neither point-and-shoot (P&S) or range-finder (RF) 35mm cameras are as suitable for close-ups as SLR cameras. With these models you don't view through the lens but through a separate finder window located off the central axis of the lens. Although the finder is close to the lens, the image you see when you are three feet or less from your subject is not the same one that will be on the film, creating a parallax problem. Even with parallax correcting marks in the finder, P&S and RF *window* finders require guesswork for close-up pictures. A few new RF models include automatic parallax correction, but an SLR is still more precise.

Lenses

Once you've chosen the camera type and model to use for close-up work, you need to think about which lenses will give you the results you want. Remember this key point: The longer the focal length, the larger the image you'll get on film *from a given distance*. For example, you're standing eighteen to twenty-four inches away from a group of four roses. You can see all four of them filling the finder of your 50mm fixed focal-length (or prime) lens. If you change to a 105mm or 135mm lens at its closest focus, you may see only two roses filling the finder from the same camera

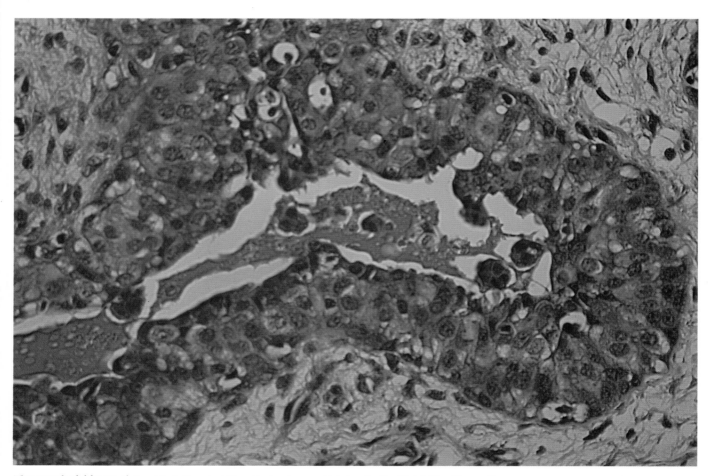

This may look like an abstract painting, but it's a photomicrograph taken by Dr. Hal deMay (loaned to me by his colleague, Dr. Craig L. Fischer). These doctors are pathologists who study and photograph tissue samples, such as this one from a diseased breast magnified to 250X (250 times life-size on the slide) through a microscope. (The purplish tone is a stain used on the biopsy specimen.) Their slides are often presented at medical conferences, but for immediate diagnosis, Dr. Fischer uses a digital camera setup through which photomicrographs appear on a TV monitor a few minutes after exposure.

position. The longer the focal length, the farther you can stay from a subject to get the same image enlargement. This is helpful when you shoot butterflies or other skittish subjects. When I photographed a hummingbird in her nest with newborns, I had to be satisfied with a medium-large image using a 50mm macro lens (the one I had with me), because I felt I'd anger or scare the new mother if I got closer. With a 100mm macro I could have shot from the same spot and gotten the image of the bird twice as large.

The three main categories of SLR lenses used for close-up work are prime, zoom and macro lenses. Prime lenses have a single nonadjustable focal length, and may focus as close as twelve to fifteen inches for wide-angle types, to eighteen to twenty-four inches for lenses in the 50mm to 80mm range, and to roughly twenty-four to thirty-six inches for longer focal lengths. The average zoom with close-focusing, or what some lens makers call macro, capability may focus twelve to twenty inches from a subject, depending on the zoom range and the lens design. Zooms give you the versatility of a series of focal-length options within a single lens. You can shoot relatively easy close-ups with focal-length ranges such as 28-80mm, 28-105mm, 28-200mm, 35-70mm and 35-80mm. A zoom lens will focus to the same minimum distance at each focal-length setting.

Macro lenses—available in focal lengths such as 50mm,

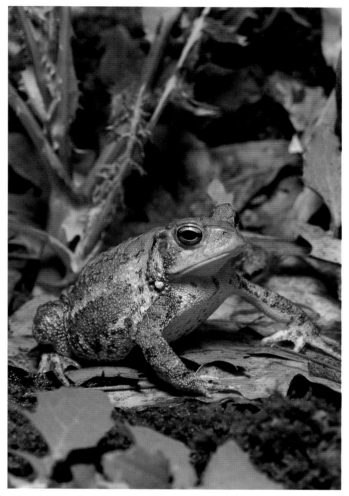

A single lens reflex (SLR) camera was Manny Rubio's first choice to photograph an American toad. He lit the scene using one large flash array behind a diffuser mounted in a box above and right. He stayed behind the camera in the dark to put the toad at ease. Rubio, an expert on reptiles, builds marvelous sets, such as this one in a darkroom tray filled with real outdoor materials. He rested the tray on a kitchen turntable to rotate the frog and its environment for his camera with its 100mm macro lens. (You can see more of Rubio's beautiful work on pages 49, 88 and 95.)

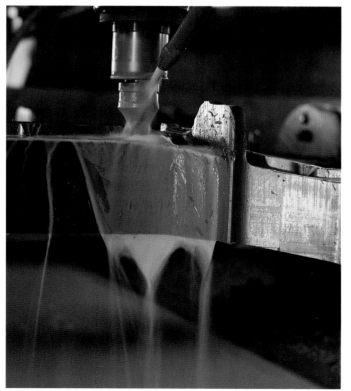

This shot of machining a large aircraft part was taken at a manufacturing plant in existing light augmented by floodlights using a 2¼ × 2¼ camera on a tripod. I was shooting pictures for an annual report, and the client requested larger-than-35mm color transparencies. Without moving the camera, I was able to remove the color film back and attach a back with black-and-white film in it, an advantage with medium-format cameras. I used an 80mm lens, normal for a medium format camera, and shot at about 1/8.

90mm, 105mm or 180mm—are made to capture the closest shots of even small subjects, such as someone's eyes or the interior of a flower. A 50mm macro that focuses from very close to infinity can be as compact as an f1.5 50mm lens, and may be used instead of the latter. A 90mm macro is less compact but allows you to shoot farther away, from small creatures that scare easily, for example. Some macro lenses require an added lens component (effective only on the lens it's made for) that makes a 1:2 lens into a 1:1 performer.

DEPTH OF FIELD

Depth of field in a photo is the area between the nearest and farthest objects appearing in acceptably sharp focus. Depth of field is shallow when *only* the main subject is sharp; it is deep when the main subject *and* its foreground and background are equally sharp. Close-up pictures are prone to shallow depth of field. The closer you focus at a given aperture, the less depth of field is created and the harder it is to obtain front-to-back sharpness. Using a 50mm lens focused at twenty-four inches, depth of field may be eight to ten inches at f11. With a 100mm lens focused at twenty-four inches, depth of field may be only six to eight inches at the same f-stop.

However, maximum depth of field isn't always pictorially desirable. Sometimes you may want to maintain relatively shallow depth of field to separate the main subject from a distracting background. At other times you want deeper depth of field so foreground and background subjects are both sharp. Three interlocked factors influence depth of field: f-stop, lens focal length and focusing distance. Changing any one of these three can increase or decrease depth of field.

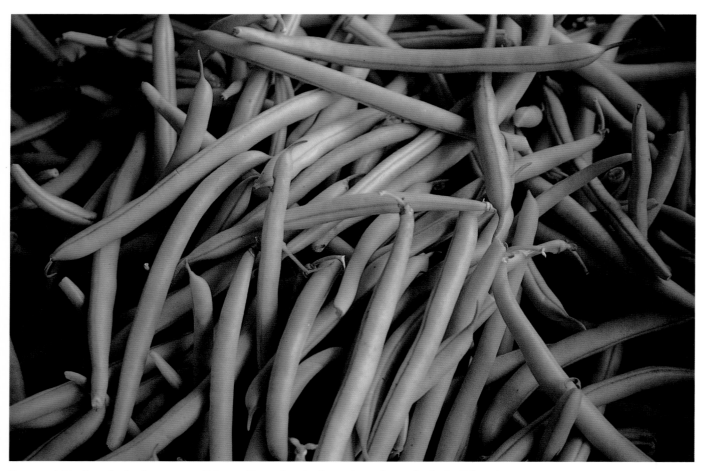

I snapped this shot of string beans at an Ephrata, Pennsylvania, farmer's market in shady daylight using a 28-80mm zoom lens on an SLR camera. The exposure was f8 at 1/125 and I could hand-hold the camera with ISO 200 Ektachrome Elite film. A medium-speed film lets you use small apertures with shorter exposures; you could say it acts as a "tripod surrogate" because it reduces the effect of any camera movement and increases depth of field. The trickiest part of the shot was finding an attractive composition in the random array of beans.

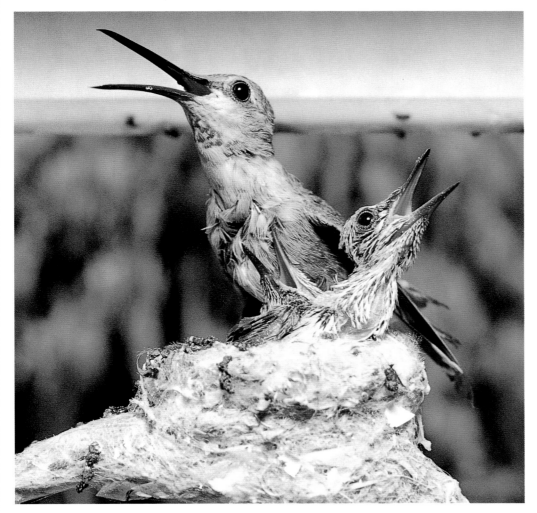

The bird's nest was in an awkward place to work. I clamped my Canon Elan SLR to a ladder and held a Vivitar 283 flash off-camera to light the shaded nest. I didn't get closer to avoid scaring the new mother. I used a close-focusing 28-80mm zoom at 80mm; my 70-210mm would have been unsteady clamped to the ladder. The out-of-focus greenery made a good background, but I couldn't avoid the white metal strip on top, which may make the picture harder to sell. Exposure was 1/125 (the highest flash shutter speed for my camera) between f8 and f11.

All sorts of subjects can be adapted for rewarding close-up pictures, such as foreign money and a vintage letter opener. I shot with a 50mm macro lens from eight to ten inches away, using Ektachrome Elite 100 film and, of course, a tripod. Reflected floodlights provided illumination, and I used an 80A filter for color correction. The exposure was around f16 at one-half second. A macro lens is a joy, but adding diopter lenses to a zoom or prime lens is also handy for close-ups up to one-half life-size.

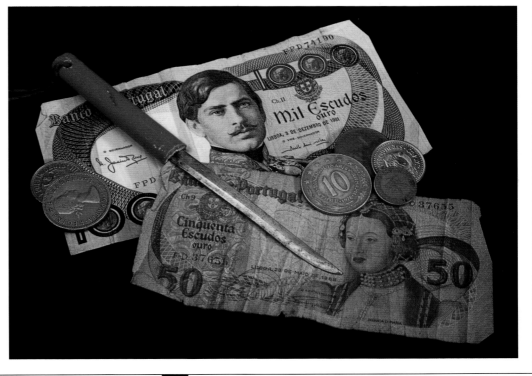

F-Stop

You are probably most familiar with the way changing the f-stop affects depth of field. The smaller the f-stop, or aperture, with a lens of any focal length, the greater the depth of field created; i.e., the greater the area of sharpness from front to back. If you shoot a picture at f16, the depth of field will be greater than at f8 or f11 when the same lens stays focused in the same spot from the same distance. Therefore, choose a small f-stop, such as f16 or f22 to assure a greater area of sharpness front to back in a close-up than you'll get from a larger aperture. You can stop down farther and increase depth of field by switching to a faster film, by shooting in stronger light and by using a tripod (allowing slower shutter speeds and smaller apertures). On the other hand, to limit depth of field and blur the background so the main subject stands out better, choose an aperture of f8 or larger.

Try a short series of pictures that not only demonstrates the effects of different apertures but also shows how to control background. Choose a single flower to photograph against a confusing background several feet away. (You can also do this with a small still-life setup, such as the one shown on page 20, photographed in sunlight or indoors by floodlights.) Start with f5.6, and then, without moving the camera or changing lens focal length, shoot a series of

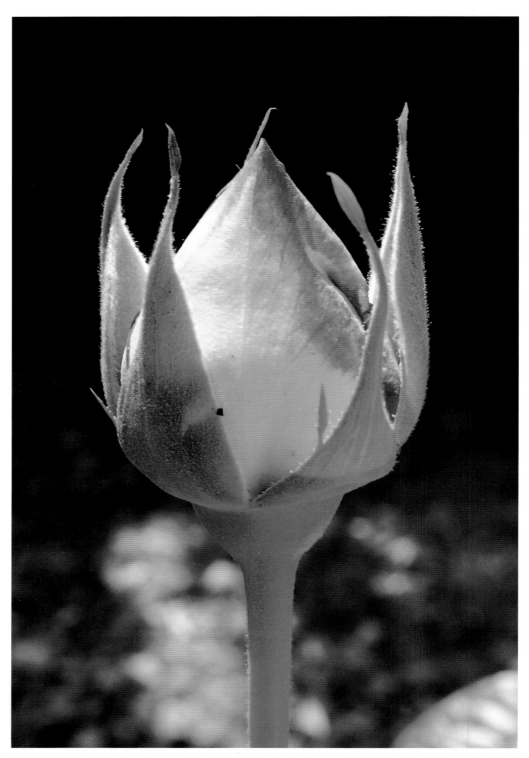

Depth of field is shallow here because I shot at f11 to blur the background behind the sharply focused rosebud. It was taken in morning sunlight with ISO 100 slide film at 1/60 between f11 and f16, using a 50mm macro lens on a tripod-mounted SLR. I checked depth of field approximately in the camera finder by pressing a button that stops down the lens. I could see the f-stop was small enough to show the entire flower sharply, and since this was taken at about 1:4 from six to eight inches away, I knew the background would be soft focus even though the depth of field preview is not always accurate.

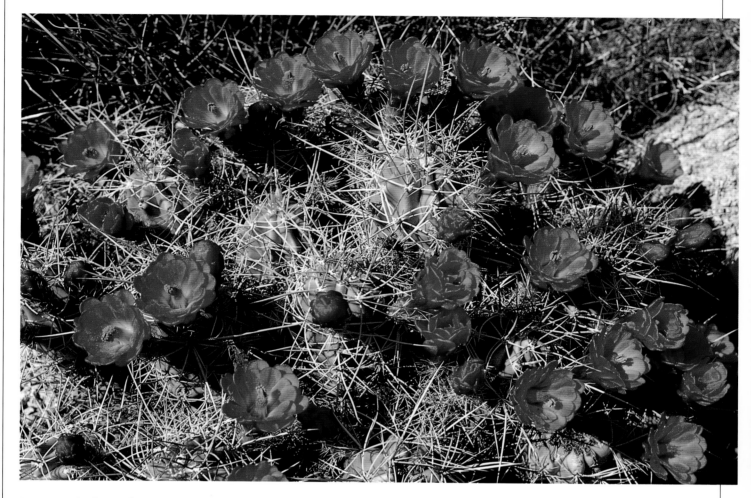

images at f8, f11, f16 and f22. When you get your film developed, note how the depth of field changed as you stopped down. Keep a record of the f-stop for each shot so you'll remember how you achieved either a soft-focus or sharp background. Try this exercise with more than one lens to be familiar with how each handles depth of field.

Some 35mm SLR lenses include a depth-of-field scale for a rough idea of the sharpness zone. Many SLRs offer depth-of-field preview, which lets you stop down the lens and look through the finder at each f-stop you may use. In bright light this feature can be helpful, but in weaker light, especially at larger f-stops like f8, it's only marginally useful. An SLR finder image is small, and it may be hard to distinguish sharp from fading focus. Depth-of-field tables, published by some lens manufacturers or found in technical books, show precise depth-of-field measurements, but they are difficult to find.

Do your own depth-of-field research by shooting a series of pictures at different apertures from the same spot and comparing depth of field in prints or slides. Project the slides at a size of 16″ × 20″ or look at 4″ × 6″ prints, and you'll have pictorial evidence to remember how f-stops and

This Mojave mound cactus was a lucky discovery during a hike at Joshua Tree National Park in California. Shooting from a tripod with a 28-105mm zoom lens, I stopped down to f22 for greater depth of field. Notice the top background is still slightly out of focus, which helps separate it from the flowers. The film was Kodachrome 64, and the shutter speed was 1/30. Some zoom lenses stop down only to f22 while some go to f32, an advantage because the smaller the f-stop, the greater the depth-of-field potential.

shutter speeds influence depth of field. For example, look at the shot of a cribbage board, shown on page 21, that I took at f32 and 1/4 with a close-focusing 28-80mm zoom lens to get the pegs sharp from front to back. I also shot at f16 and f22, but the rear peg became sharp only at f32.

In many photo situations, compromise guides your choice of f-stop in relation to shutter speed. Outdoors with ISO 100 speed film, using a small aperture for good depth of field means using slower shutter speeds, such as 1/30, 1/15 or slower. You can easily shoot f16 at 1/60 in the sun, but in the shade a foot or so from your subject, you might have to shoot at f5.6 or f8 at 1/60. Of course, you might have to wait for clouds to uncover the sun if you don't have a handy tripod or don't want to bother using it.

Using a tripod makes decisions about shutter speed and f-stops easier when depth-of-field control and a steady camera are involved. A number of photographs in this book were taken using a tripod to attain maximum image sharpness because I could shoot at longer exposures, usually with smaller f-stops, and perhaps with slower film. Unless you always use ISO 200 film, trust a tripod for sharpness and good depth of field even though you have steady nerves. Then you can choose shutter speeds too slow for hand-holding the

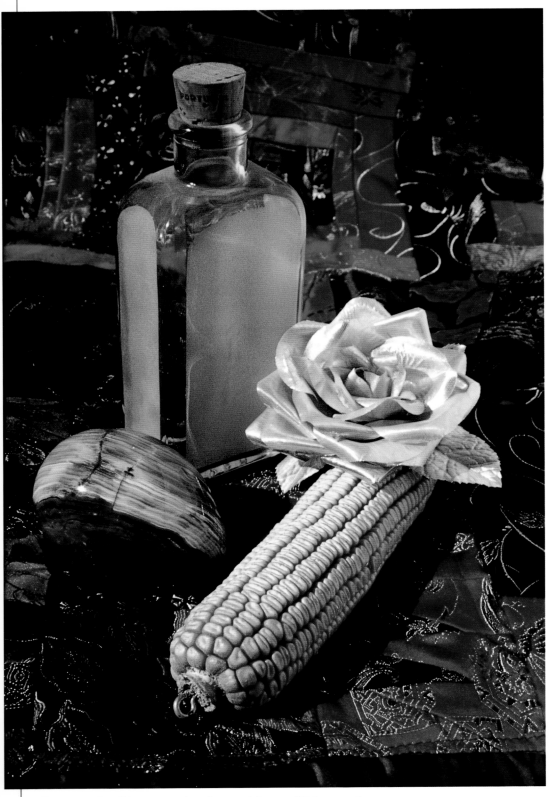

Shooting with a 55mm macro lens, I stopped down to f32 for overall sharpness. The foreground is sharp, but the background isn't completely so, which in this case is suitable because the muted pattern works well in the composition. I used an ISO 100 Ektachrome slide film in my SLR, and I set up outdoors in sunlight.

camera, with correspondingly smaller f-stops to suit the subject. Though a tripod can be a photographer's best friend, I often shoot hand-held pictures, especially when I can use 1/250 and faster shutter speeds (usually with ISO 200 film).

Lens Focal Length

Changing to a lens with a different focal length can affect depth of field at a particular f-stop. The shorter the focal length of a lens, the greater the depth of field it produces compared with a lens of longer focal length at the same f-stop and focusing distance. You can demonstrate this easily with a zoom lens. Choose a subject to photograph from eighteen to twenty-four inches away, and shoot a picture at f8 or f11 using the lens at its 35mm focal length, for example. Shoot from the same distance at the same f-stop, but use an 80mm lens. You get a larger subject and less depth of field.

On the other hand, if you keep aperture size and image size the same, all focal-length lenses give the same depth of field. Move the camera back to a spot where you get the same size composition with the lens set at 80mm that you had at 35mm, and shoot with the same aperture. Depth of field will be the same for each focal length because you adjusted the size of the image by changing the distance to subject.

The longer the focal length, the narrower the angle of view and the less sharpness you have behind the subject. Changing to a smaller aperture (stopping down) will offset the longer focal length by giving you increased depth of field. If the light only allows you to shoot at f8, you'll get better depth of field with a 35-70mm lens than you will with an

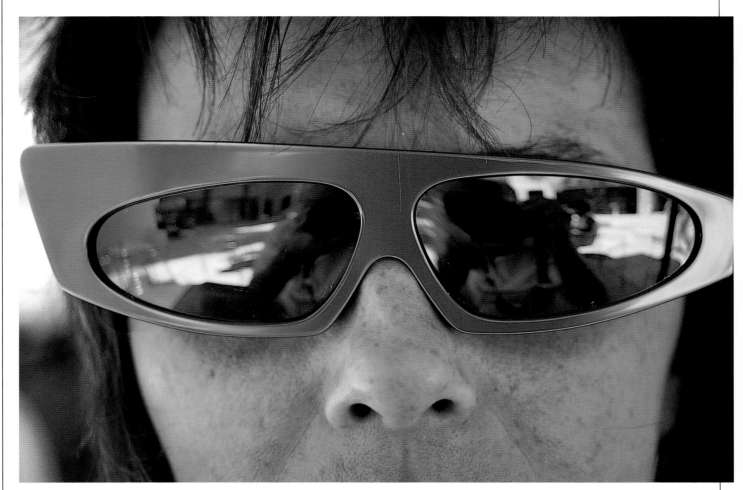

This photo was taken with a close-focusing zoom lens set at its 35mm focal length. The focus was somewhat shallow. Note that my image in the sunglasses—probably twelve inches away—is blurred. The mirror image is seen at twice the distance from the lens (or your eyes) to the glasses, which accounts for its being out of focus when I focused on the model's face. The exposure was 1/60 at between f8 and f11 on Kodachrome 64. Had a tripod been handy, I could have stopped down to at least f22 and shot at 1/15, which would have sharpened the image in her sunglasses.

This depth-of-field series shows how focus becomes sharper into the background as you stop down. In this first shot, taken at f5.6 and 1/60, the rooster is out of focus, but it is almost sharp at f11 as shown at right. At f16, below left, the rooster is finally sharp, but the onyx egg still isn't. At f22, below right, the egg is acceptably sharp. The series was taken using General Electric 3200 Kelvin (K) reflector flood bulbs in sockets with handles attached. Although a 50mm macro lens was used, a zoom such as a 35-70mm or a 28-80mm would also have been able to focus as closely.

Taken at f11and 1/30.

Taken at f16 and 1/15.

Taken at f22 and 1/8.

80-200mm lens from the same distance. When there's enough light to stop down to f16 or f22, you'll get appropriate depth of field for the same size image with either a long or a short focal-length lens.

Compare the sharpness you get with a 50mm and a 100mm focal-length lens. Choose a small subject for the foreground, such as a toy six or eight inches long, and place another toy or object four or five inches behind it. Focus from no more than twelve inches away with the camera on a tripod and shoot at f8, then f16 and finally f22, at both a 50mm and a 100mm focal length. Compare the background sharpness in your prints or slides from each focal length at each aperture.

Focusing Distance

The closer to a subject you focus, the less depth of field a lens of any focal length produces at a given focal length and f-stop. The reverse is also true; as focusing distance increases, depth of field becomes greater. It's easy to demonstrate this on film. Pick a subject with elements that go back into the distance, such as a picket fence. Move close enough with a zoom lens set at 50mm to shoot perhaps five boards in the finder, at f5.6 and f8. Change to a 100mm focal length and shoot again at the same two f-stops from the same angle, and you'll get fewer boards in the composition. Compare prints or

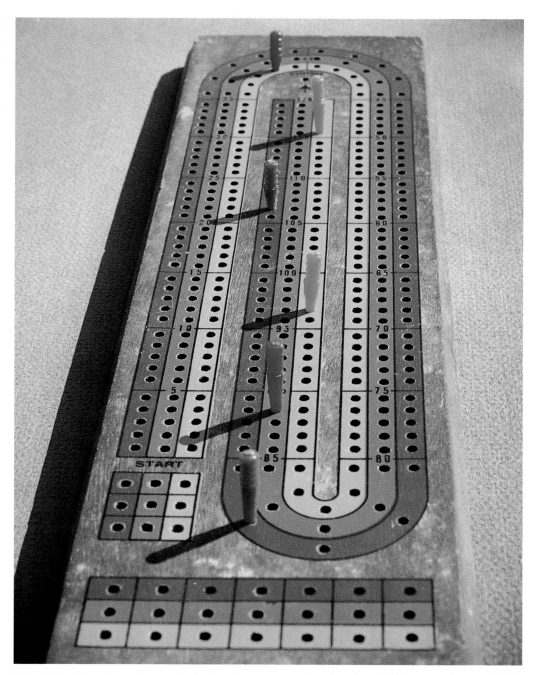

The cribbage board was photographed in bright sun using a close-focusing 28-80mm zoom lens and Kodachrome 64 in my SLR. I arranged six pegs from front to back and shot at f32 at one-fourth second. I also shot at f16 and f22 (neither shown here) to compare depth-of-field results, but the rear peg became sharp only at f32. I recommend a cribbage board for depth-of-field tests because board design and peg shape make it easy to determine where the shot is and isn't sharp.

slides, and you'll see that there are more sharp boards in the 50mm shot than in the 100mm shot.

It's also true that a lens of any focal length creates more depth of field *behind* the point of focus than it does in front of that point. You can compensate for this optical phenomenon by adjusting the focus slightly *forward* of a desired focus spot to increase sharp foreground focus, while using an f-stop small enough to maintain sharpness in the background. This is called "splitting the focus."

Let's assume your lens is about eighteen inches from the main subject in a still life, a perfume bottle, for example. Start by focusing on it and stop down to check depth of field by whatever means you find convenient. Then focus a few inches in front of the main subject, and check depth of field again. If there is something in the foreground before the main subject, decide if it should be sharp. Let's say the perfume bottle is on a tray, the curving edge of which shows in the foreground. If you want the tray sharp, focus on it, stop down and check depth of field.

SHARPNESS AND DEPTH OF FIELD

Because details in close-up pictures are more noticeable than in typical landscape shots, you'll get better images when you're aware how depth of field and image sharpness combine. As an

Here is a portrait made with a zoom set at 105mm, which nicely isolated my brother's face and eliminated any confusion in the background. The f-stop, f16, was small enough for complete depth of field. I was using ISO 200 Kodachrome, so I had a shutter speed, 1/125, fast enough to hand-hold the camera. Had a reflector been handy, I could have added some light on the shadow side of his face; I didn't want to use flash fill because it would have flared in his glasses.

example, you want to shoot a flower, but you don't want other flowers and grasses in the photo background, too. Focus on the foreground and choose an f-stop that softens the background to restrict depth of field and sharpness to your subject. When the background is important and you want it sharp, too, focus slightly forward of the main subject. Check the depth of field and choose a small f-stop for overall sharpness. When you are really close to the subject—a few inches away with a macro lens— even at small f-stops, sharpness increases more slowly as you stop down than if you're a few feet away.

Camera steadiness obviously contributes to sharpness and successful control of depth of field. Potential clients understand out-of-focus backgrounds when they improve aesthetic quality, but they will not tolerate camera movement or poor focus. My experience in selling pictures over many years is that content and photographic quality go hand in hand, and when a subject is still and the light is bright enough, only sharp pictures are acceptable. (For moving subjects there's always flash; see pages 105-107.) With experience, you'll be able to view a slide with an 8X loupe and decide if it's sharp enough to be saleable. You could also project a slide to 16" × 20" or have an 8" × 10" print made from a negative to check sharpness.

Subject blur—created when a subject moves and shutter speed isn't fast enough to freeze motion—may be tolerated if the effect is attractive, but unsharp pictures caused by camera movement or soft focus are unacceptable. Study lots of images to learn to distinguish subject movement from camera movement. If buyers reject pictures you feel have attractive subjects and are well composed, decide whether insufficient sharpness or depth of field might have undermined them pictorially. In time it becomes instinctive to recognize conditions that make hand-holding a camera marginal, and probably not profitable. At such times try to brace your camera on a table or a rock if a tripod isn't handy.

I often shoot close-ups with a hand-held camera, and I can get saleably sharp pictures when I stop down enough to permit suitable depth of field at a shutter speed of 1/125, 1/250 or faster. I have practiced for many years holding my breath at the instant I shoot, bracing the camera by tucking my elbows against my sides. My hands are relatively steady, but I don't fool myself that hand-held pictures will always equal those taken from a tripod. I depend on hand-holding my camera steadily enough only when using a higher shutter speed, which is possible when using a faster film such as ISO 200 or 400. I also enjoy using a tripod, knowing that sharpness—and depth of field— are guaranteed (if subjects

A sculpture garden at UCLA provided the setting for this charming portrait. Note that the foreground sculpture framing the young lady is not in focus. I focused on the girl, and depth of field didn't extend far in front or back of her. Kodachrome 64 is not very fast for outdoor shade, so I had to shoot at f8 and 1/90. My Canon Elan and other modern SLRs provide convenient half-stop shutter speeds. Using a 35-70mm lens, I split the focus, meaning I focused on her face and then on the far edge of the sculpture to add a little sharp focus in the foreground.

are still enough), but when I'm on a trip, walking a lot, I rely on ISO 200 and 400 slide films for faster shutter speeds and smaller f-stops. An ISO 100 speed may be fast enough for sharp hand-held pictures in bright sun, but it's hard to stop down far enough to avoid shallow depth of field.

When you shoot close-ups using a tripod, you improve image sharpness and depth of field. At almost any shutter speed, using a tripod means you can use smaller f-stops when a subject is not moving, or moving only occasionally, than when hand-holding the camera. Test the difference between hand-held and tripod steadiness

for yourself. Take some close-up shots of a subject in bright shade with the camera hand-held at 1/125 or 1/250, using an f-stop around f8 if you're shooting ISO 100 film. Then shoot the same subject again with a tripod, using the same film at smaller f-stops and slower shutter speeds. Compare the images using a loupe, and differences will be apparent. Unless the subject is moving, the tripod assures better depth of field and sharpness. The result of your comparisons may encourage you to bring your tripod when shooting outdoors in good light. (How to choose and use a tripod will be covered in detail on pages 49-51.)

Finding signs and other nostalgic subjects, such as this group at an arts festival, is one of the pleasures of close-up photography. There was no depth-of-field problem here because the subject is flat. I shot between f5.6 and f8 knowing the whole picture would be sharp because depth of field would only have to be a few inches. With ISO 200 film, I could hand-hold my SLR steadily in the bright shade at 1/125. I was not carrying a tripod, but felt I didn't need one since I rarely get camera movement at 1/125. If I had intended to have the shot blown up to poster size, I'd have used a tripod to guarantee the best sharpness.

CLOSE-UP EXPOSURE

When a lens is focused at its closest range, or closer with diopter lenses, slightly more exposure is necessary to compensate for lens extension. With a camera and separate meter, you must manually figure exposure increases; check the data that comes with lenses. However, if your SLR has a match-needle system (which selects an f-stop to match your chosen shutter speed) or a fully automatic exposure, close-up calculations for subject distance are made without your effort in their little electronic brains. How your camera's meter determines exposure depends in part on the type of metering pattern it uses.

Modern SLRs use at least one of three metering patterns. The *center-weighted* mode concentrates on an area across the horizontal center of the viewfinder, at varying widths depending on the camera. The *evaluative* mode reads the whole area of the finder in a grid with multiple accent points depending on camera brand and model. I like this mode because it reads a wider blend of tones from light to dark and averages them. There is also the *spotmeter*, which lets you read highlights and shadows separately when there are few middle tones, then choose an average exposure as a gray card does.

To better understand exposure and how your in-camera or hand-held meter averages

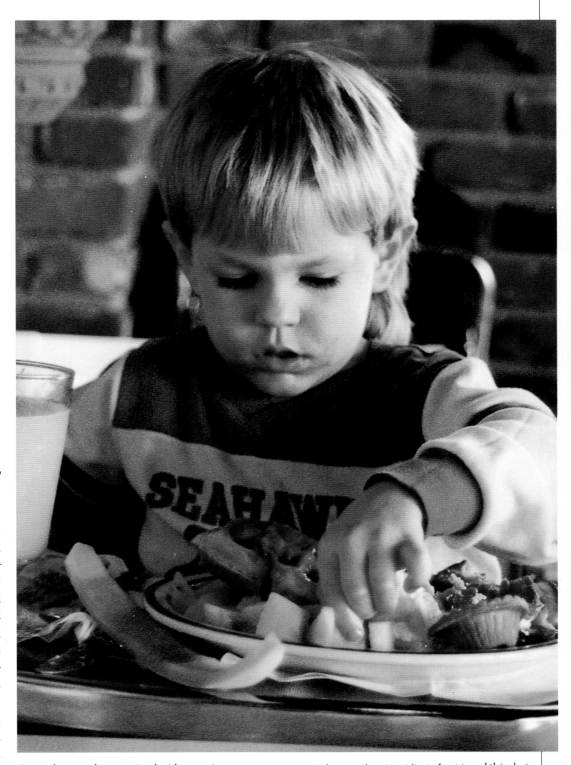

Even when you have a tripod with you, circumstances may not give you time to set it up. I captured this shot of a two-and-a-half year-old grandson at lunch with a 35-70mm zoom lens—despite the weak daylight in this restaurant. Amazingly fine-grained Kodak Ektar 1000 print film (now called Royal Gold 1000) made an exposure of 1/60 at f5.6 possible in the dim light. I've practiced for years hand-holding an SLR steadily at 1/60, a very functional shutter speed for candid shots like this one.

Available light and distance from the subject affect your range of choices for f-stop and shutter speed. You may have to sacrifice some of your zone of sharpness to get the shutter speed you need for the lighting conditions. If you choose a faster shutter speed and a larger aperture, depth of field is not as great as a slower speed and smaller aperture. In this instance the flower in the left foreground is slightly sharper than the one behind it. Shooting from about twelve inches away, at f16 there was not enough depth of field to get both foreground flowers fully sharp and, of course, the background flowers would then be out of focus. With a tripod, I could have stopped down further; but, actually, I like the effect of sharp focus in front and soft focus in back. The lens was a 28-105mm zoom, and I shot at 1/125 on Kodachrome 200 slide film.

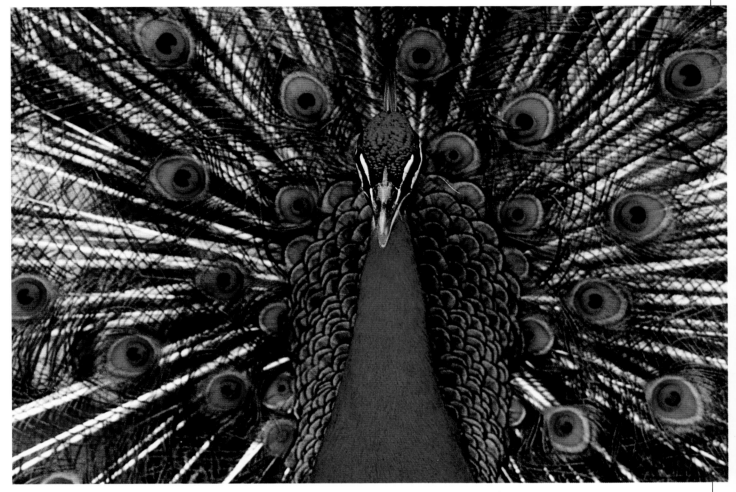

Lisa Duran, a Kodak award winner, had no problem determining the right exposure when photographing this peacock because the combined tones in the image average to a medium gray, the normal exposure standard for reflective meters. She was able to fill the frame of her 35mm camera using a 35-70mm zoom lens. (Photograph courtesy of Eastman Kodak Co.)

tones, buy an 18-percent gray card at a camera shop. Its tonal value represents the actual grayness to which an exposure meter averages bright, medium and dark tones of all subjects through the viewfinder. (Think of colors as tones averaged by the meter.) Choose a subject, compose a picture and let the camera choose the f-stop and shutter speed. Remember it or write it down. Then place the 18-percent gray card in front of your subject in the same light-ing and take another meter reading with the card dominating the view. Compare the two exposures. If they are the same or close, subject tonality is average, and no exposure compensation is needed. If they are different, and the subject would be noticeably over- or underexposed, it is not an average tonal scene.

Because a meter tries to render every subject as 18-percent gray, a scene dominantly bright in tonality, such as snow, will come out look-ing too gray, and a scene dominated by dark tones will appear too light. If you don't have a gray card handy, a gray jacket, skirt or pair of medium-toned blue jeans can be a good substitute.

Exposure meters integrated into cameras read *reflected* light from subjects in a scene. Some photographers carry hand-held meters that read either reflected or *incident* light to backstop their in-camera meters. Meters that read incident light read the light falling on a subject. The meter uses a small translucent dome that gathers and evaluates the same light illuminating the subject to be photographed. Incident readings are most useful with slide film and give very accurate readings when highlight control is necessary. If you plan to buy a separate meter, the most versatile models measure both types of light plus electronic flash.

Exposure Compensation Techniques

An averaging meter reading does not analyze the *dominance* of highlights or shadows in a subject so, for more precise exposures, you may have to override your in-camera meter reading, or a gray-card reading, and depend on your own analysis.

When a bright subject is in bright light, such as a group of shells on a background of sand, bright tones far outweigh the shadows. The dominance of the bright tones causes an in-camera meter to average the tones in the scene incorrectly and give a reading that would result in an underexposed image. Point your camera lens at shells and sand, and you could get a reading of 1/250 (or faster) at f16 with ISO 100 film. If you held a gray card in front of the subject instead, the meter could indicate 1/125 at f16. You would either have to open the lens one stop or reduce the shutter speed one stop to compensate for the dominant brightness.

When you photograph a dark subject in relatively dim light, such as books with dark covers on dark wood shelves where light comes from a distant window, you have the opposite problem. The dark tones dominate and the meter reading usually gives an overexposed image because it's trying to brighten the primarily dark scene into an 18-percent gray. (In bright daylight, dark subjects will have more contrast than in dim light and may require less compensation.) With a dominance of dark tones, a camera meter may indicate f8 at 1/8, while a typical gray

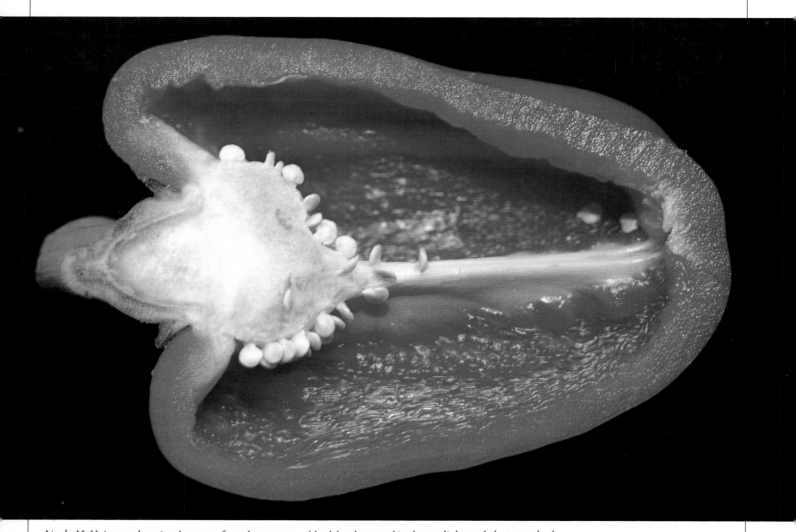

Linda M. Heim made a simple setup of a red pepper on a black background in the sunlight and photographed it with her SLR using a macro lens. She used the in-camera spotmeter's exposure reading, then bracketed her shots one-half stop under- and one-half stop overexposed as a precaution. In this case, the meter's exposure was the correct one, and Heim won an honor award with this shot in the abstract category of an Eastman Kodak contest. Courtesy © Eastman Kodak Company.

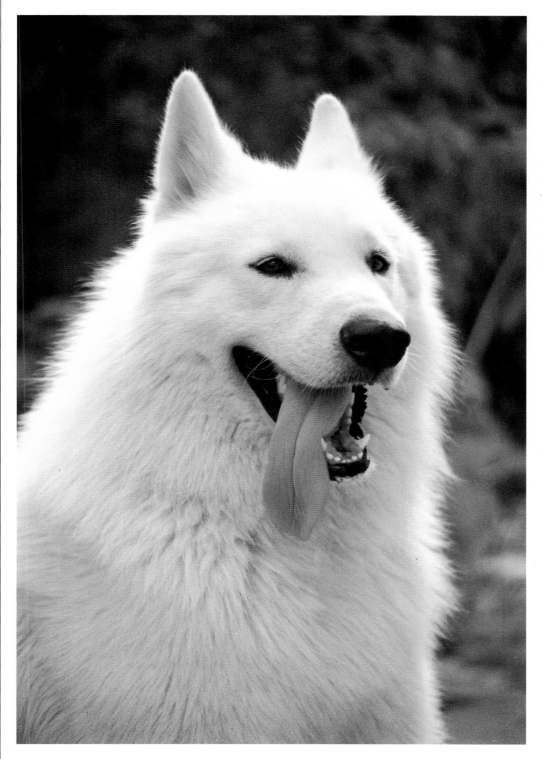

Many close-up photographs are portraits of people, pets and other animals, which are also fun to shoot. Jose Alberto Sastre Alonso of Mexico photographed this eager white dog on color negative film. He exposed one stop more than the reading from his in-camera meter to compensate for the pre-dominant white; note how much detail you can see in the animal's fur. Sastre Alonso used a dark and featureless background for contrast. He won a special merit award for the shot in an Eastman Kodak contest. Courtesy © Eastman Kodak Company.

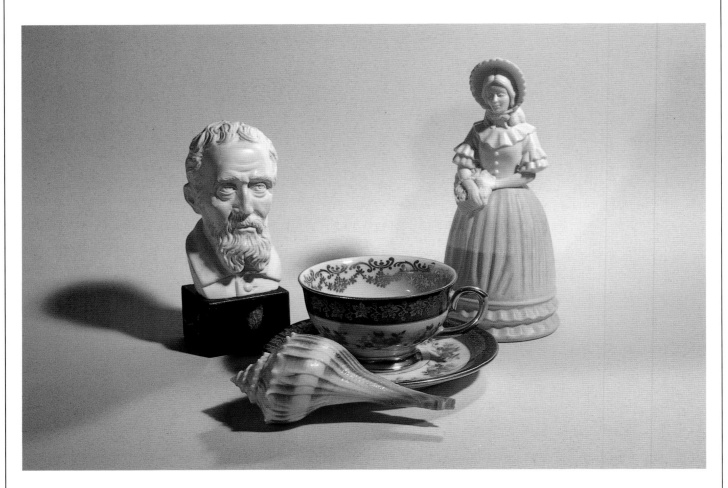

card might read f11 at 1/8.

Use a gray card and bracket your shots in situations dominated by bright or dark tones. Eventually you'll evaluate a subject visually, realize when compensation is needed, and increase or decrease exposure accordingly. Bracket the main exposure (make one or more meaningful variations) by increasing or decreasing from a half-stop to a stop or more, to correct exposure in a tricky situation. While you are learning to discern tonal dominance, bracketing serves as worthwhile insurance.

In addition, you will be photographing close-up subjects with excessive highlights or dark shadow areas that seem to defy logical exposure techniques. You can add more light to brighten shadows with fill-flash or a reflector. Perhaps you can move the subject into lighting with fewer contrast extremes. Or you can make compromise exposures in both over and under directions, and hope one is usable. (See pages 63-64 for a more detailed discussion of these approaches.)

To illustrate how a bright subject on a light-colored background in bright light can affect a meter, I placed a sheet of pale tan illustration board beneath mostly light-toned items I found at home. Two 3200K reflector-flood bulbs were used; the one at the right was directly on the subject, and the one at left reflected from white cardboard. There are dark tones in the cup and the base of the small statue, but light tones dominate. The in-camera meter reading would have resulted in under-exposure. I knew the dominant light, bright tones would cause that to happen, and took an exposure reading with a gray card. This gave a reading of one-half second at f22, rather than the meter's reading of f32, to get proper detail in the highlights and shadows in the slide on Ektachrome Elite 100.

The exposure meters integrated into modern SLR cameras read reflected light and average it into an ideal exposure, according to a meter pattern indigenous to the camera system. When a meter reads a scene with both bright white and dark black tones, a common exposure extreme, it chooses a compromise exposure, as it did here. In order to show some detail in the shadow area, some detail in the highlight area is sacrificed. This was a normal, averaged exposure, which can be adjusted to favor over- or underexposure through exposure compensation. The film was Ektachrome Elite 100, the exposure was 1/80 at f11, and the lens was a close-focusing 28-80mm zoom.

This shot illustrates what happens when you take a meter reading of a primarily dark subject and dark background in soft or dim light. I used two 3200K reflector-flood bulbs and mounted a 50mm Sigma macro lens on my Canon Elan SLR camera to shoot this predominantly dark still life on a black background. I shot indoors with floods to control the light better than I could outdoors in shade or sun. The camera's exposure meter tried to average the dark tones into a middle gray, which would have overexposed the Ektachrome Elite 100 slide. I stopped down from f16 to f22 to compensate. Negative color film can tolerate overexposure well, so compensation might not have been necessary.

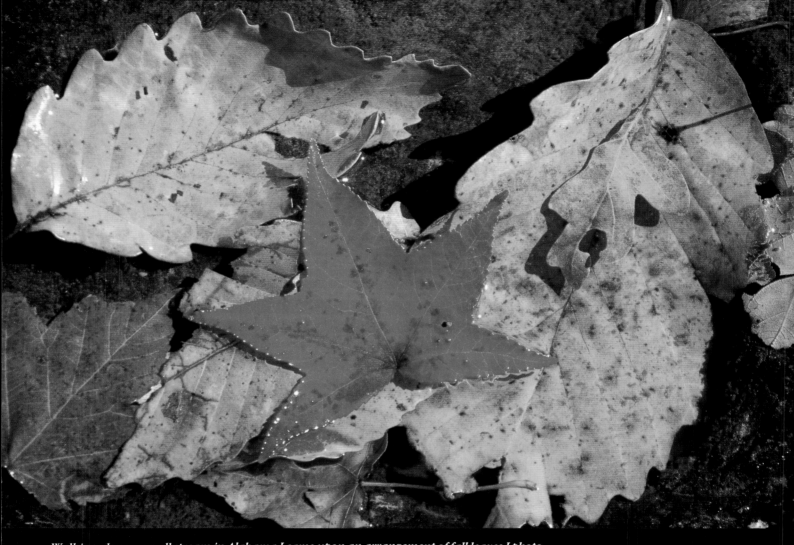

Walking along a small stream in Alabama I came upon an arrangement of fall leaves I photographed in bright sun with a 28-105mm close-focusing zoom on my SLR. I focused almost as closely as the lens allowed, and set the exposure (on Kodak Ektachrome Elite 200) at 1/350 between f11 and f16. I was on a vacation hike without a tripod, so I depended on the ISO 200 film for a fast enough shutter speed to prevent camera shake. Depth of field was shallow but the top leaves were all in focus at the f-stop used.

Cameras, Lenses and Equipment for Close-Ups

USING WHAT YOU OWN

You may already use a single-lens reflex camera and have lenses suitable for close-up work. (If you use a point-and-shoot camera and are satisfied with your close-up pictures, fine.) If not, you might investigate the kind of SLR equipment you need. "Need" is the important word, because we all can be attracted by the ads and test reports for cameras with bells and whistles we don't really need. It's better to stay within a budget, but only if necessary, buy a camera without autofocus or without autoexposure. To save money, check on used equipment that has a reasonable guarantee from a dealer, or ask a trusted friend if he has a camera he wants to sell.

Shoot some test close-ups with your present SLR—if you haven't already—to become more familiar with what your current lenses, especially the close-focusing zooms, can do. Choose a zoom or fixed focal-length lens you want to test, then mount the camera on a tripod. Fasten a yardstick or long ruler to a wall, or aim at an area you can easily measure. Place the camera at the closest distance you can still get sharp focus. In the finder you'll easily see the length and width of the area that a specific focal-length lens will cover. I aimed my 28-105mm zoom at my computer monitor and found it would focus sharply from about thirteen

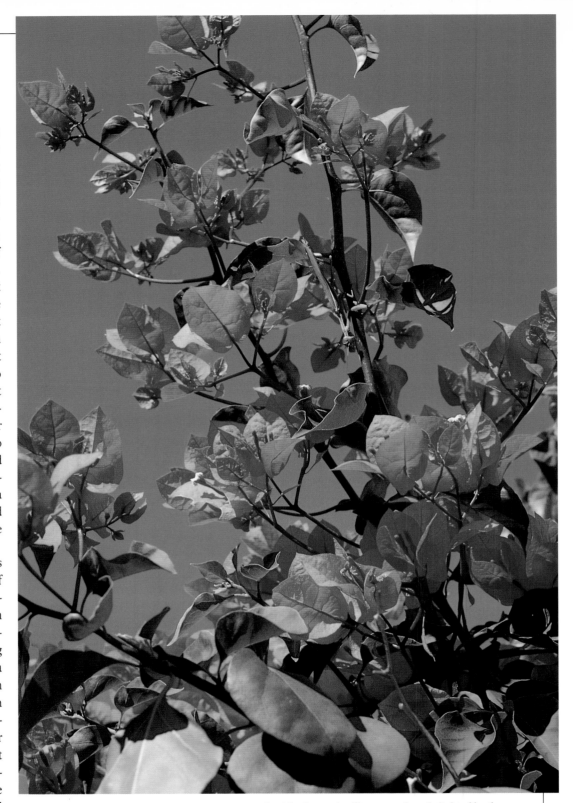

Flowers are a favorite subject for close-up photography. This bougainvillaea was sharply lighted by the overhead sun against an ideal background of blue sky. Such pictures can be taken with a 35mm or medium-format camera, as well as a larger, slower view camera. My favorite camera for shooting close-ups is a 35mm SLR with a zoom or macro lens. The film for this shot was Kodachrome 64, but almost any slide or print film in the ISO 50 to 200 range would be appropriate for this subject and lighting conditions. The exposure was 1/125 at f11, and I was about thirty inches away.

inches. At 28mm the area it covered was about nineteen inches wide, while at 105mm the width was about nine inches. Make notes to help remember the smallest picture area each lens will cover, at several useful focal lengths, and you'll know better which lens is best suited to shoot small flowers, a miniature train or whatever you choose.

If you can't shoot closely enough with your present lenses to suit your requirements, consider supplementary close-up lenses or extension tubes that screw into a lens or camera body before investing in new lenses. Once you know the limits of your present camera and lenses, and have tried supplementary close-up lenses, you'll be better able to decide what other equipment in this chapter will be of value. (A tripod is a necessity, of course, and you'll find some guidelines for buying one on pages 49-51)

CHOOSING THE RIGHT CAMERA

There's no shortage of good cameras to choose from. Each year new models are introduced and/or older ones discontinued. Each camera manufacturer makes a system of camera bodies, lenses and accessories for close-up, and even macro, photography. You may want to limit your investment until you're sure how much close-up work you'll be doing, so research the cameras, lenses and other close-up equip-

ment with features you prefer and that fit your budget.

SLR cameras have dozens of valuable features that make close-up work more efficient, including slow shutter speeds (a few seconds up to thirty seconds), a clear focusing screen, and many lens types and focal lengths from both the camera maker and independent companies. Many 35mm cameras include autofocus, which isn't perfect but works amazingly well. Since accurate focus is especially

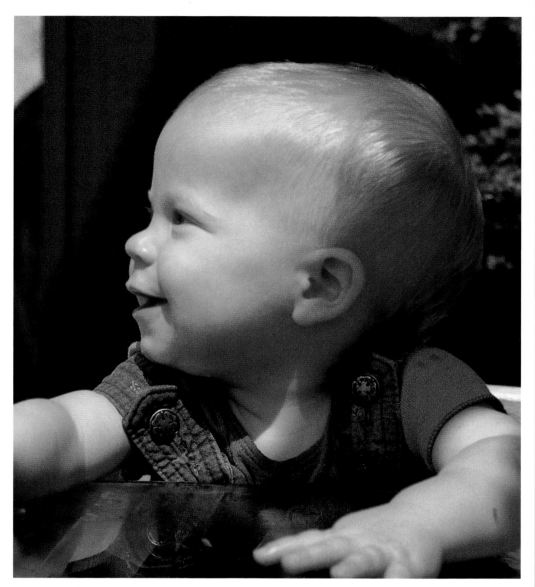

Children may be even more popular subjects than flowers, and photographers get plenty of mental and physical exercise trying for close-ups of their best poses and expressions. A 35mm SLR camera, especially with a zoom lens, is just right for active children. Keep your eye in the finder, ready to snap smiles and other appealing emotions. Keep an eye out for emotional interchanges between parents and children; with versatile ISO 200 film, you can shoot at 1/250 to capture fleeting expressions. Don't be concerned that depth of field is diminished by an accompanying f-stop such as f8, which yields less depth of field than smaller apertures up close, because unwanted backgrounds will be blurred out. This was taken with a 28-105mm lens set at 105mm, on Ektachrome Elite, at 1/250 and f8.

important when shooting close-ups, the autofocus feature can be an advantage, but it may not always focus automatically on the spot you wish. In such situations, a lens can be switched to manual operation to place the sharpest focus just where you want it. If your subject is a child's face, for instance, autofocus using a reasonably small f-stop like f11 or f16 would be convenient and practical. On the other hand, when you want to shoot a small piece of jewelry or a single flower without including other objects around it, manual focus control is helpful.

Other features are valuable for close-ups, and you can evaluate them. Depth-of-field preview is a feature (available on some but not all models) that can help you take better close-ups. A preview button stops the lens down to a chosen aperture so you can observe the extent of sharp focus. When the lens is stopped down between f11 and f32, however, the finder image darkens except in bright sun. The image may be so dark at smaller apertures that you can't tell where precise sharpness starts and stops. In such conditions, you can set a larger aperture while you observe depth of field, and then estimate how much it may increase at the smaller f-stop you then use. Despite its limitations, depth-of-field preview can be a fast and efficient way to estimate image sharpness from foreground to background in bright lighting conditions.

So, where do you start when you decide you need a new camera? When I switched from an adequate but outdated 35mm system to a new model with more features, I began by reading technical reports and ads in photographic magazines and descriptive literature manufacturers will send. I also read evaluations from *Consumer Reports*.

I made a chart of three camera models I found most desirable and affordable, each a different brand. I listed the features that interested me, including shutter speed range, exposure compensation, autofocus (with manual override), viewfinder information (f-stop and shutter speed, especially), built-in flash, custom functions, convenience of controls, body weight and price. I made a list of features at the left side of a page, and listed the cameras across the top. I drew lines to make a grid and filled in the resulting boxes with checks or data. Under autofocus each camera had a check, along with "convertible to manual operation." I noted the shutter speed range, weight, price, etc, for each model, and made checks when a camera included features such as built-in flash, custom functions, etc. With this chart I could see plainly how the three cameras I favored actually compared.

Next I visited a camera store to examine and get the feel of the three brands, and I asked questions, remembering sales people are not always unbiased. I also asked friends how they liked their camera systems. Those who owned the latest models with costly bells and whistles told me they rarely used the esoteric features. I realized from their experience and my own that the most expensive and complex 35mm models were not for me.

I chose the Canon Elan because it has the features I need, and it is reasonably priced. It also had the quietest shutter and rewind,

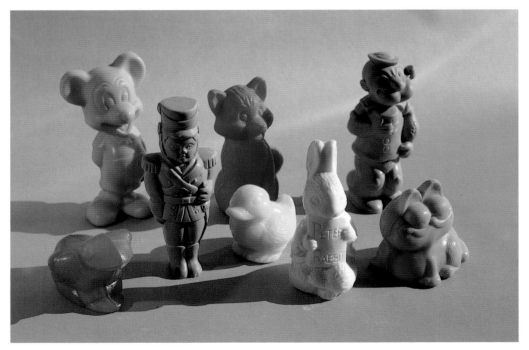

These cartoon figures, all made of soap, were photographed for a magazine story, but would work well to determine the area size a lens covers at its closest focus. With your camera on a tripod, compose as closely as possible, measure the width of the minimum area seen in the finder and keep notes about minimum focusing areas for each lens. Here I used a 28-80mm lens at 80mm and found that the area covered was about twelve inches wide. The film was Type A Kodachrome (ISO 40) balanced for 3400K floodlights, and the exposure was 1/8 at f11.

which is helpful when you shoot close-ups of butterflies or even people. (There's a newer model Elan with even more features I would probably buy if I were choosing now.) Camera bodies are decidedly not all the same weight, and some well-known brands, such as Nikon and Leica, are the heaviest. The Canon Elan feels good in my hands, not too heavy or bulky. These features are important to me because I don't want a burden hanging on my neck on frequent walking trips. When trying to find the right camera for regular or close-up use, be prepared to make practical compromises, but buy the combination of features you feel you will use most. Most SLRs of the 1990s will be reliable long after their warranties have expired, so choose for now and the future.

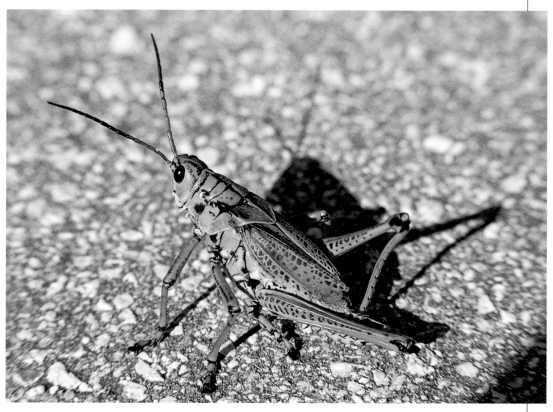

Derald Martin was glad his 35mm SLR camera included autofocus as he followed a grasshopper along a paved walk. He used a 55mm macro lens that would have focused even closer, but the insect might have been scared away. Autofocus systems have become more accurate and more dependable. When you'd rather focus yourself, it's easy to switch to manual mode. Martin used ISO 100 Ektachrome and shot at 1/180 at f11.

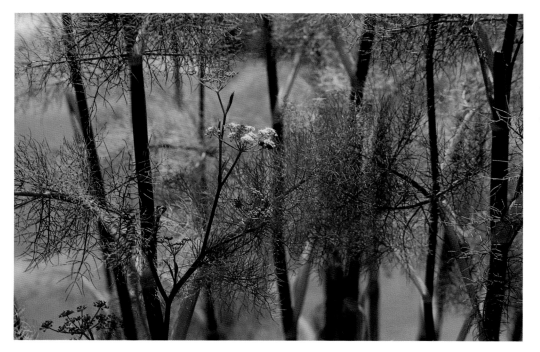

I photographed lacy foliage and delicate flowers along the edge of a bird sanctuary near Greenbrae, California, with a single-lens reflex camera and a 28-105mm lens, on a tripod. I focused on the foreground subjects and stopped down to between f8 and f11 to keep the background out of focus. The dark accent of thin stems helps give the picture impact and leads your eye toward the cluster of flowers. The film was Ektachrome Elite 100, and the exposure was 1/125.

Medium-Format Cameras

Larger and heavier than 35mm cameras, medium-format models are usually more expensive and specialized. Manufactured by Mamiya, Bronica, Hasselblad, Pentax, Rollei and Fuji, these cameras take 1⅝ × 2¼ (4cm × 6cm), 2¼ × 2¼, (6cm × 6cm), 2¼ × 2¾ (6cm × 7cm) or larger pictures. A medium-format camera is a often a beautiful electronic instrument, and many offer automatic film winding, through-the-lens metering, flash sync at all shutter speeds, dozens of lens options and other helpful features. Many camera makers include macro lenses and other close-up equipment in their lines. Some medium-format cameras like the Mamiya 6×7, the Bronica GS-1 and the Pentax 6×7 offer accessory bellows (all pretty expensive), which are handy for close-up work, especially in places sheltered from wind.

Fans of medium-format cameras like the larger viewing screens where detail is easier to see than in a 35mm finder. (A larger finder image is an aid in photographing small or detailed close-up subjects.) Photographers also prefer the larger transparencies and negatives, which hold their sharpness when enlarged better than 35mm slides and negatives, an important consideration when pictures are used for advertising, magazine covers, brochures and other printed matter. Although medium-format SLRs are too

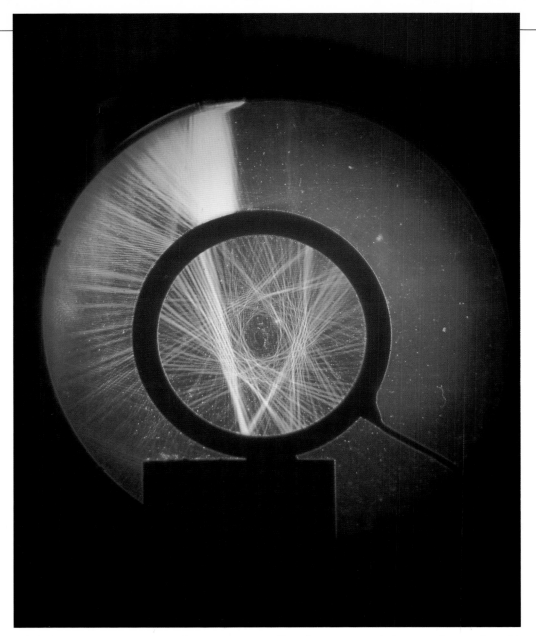

While photographing for an annual report, I set my medium-format camera in a prepared spot to shoot this display of ultrasound waves testing a metal tube. Engineers controlled the lights, and I was told when it was best to expose for one-half second at f22 on Ektachrome 100 film. I used a 135mm lens on a Bronica, because a medium-format camera makes precise composing easier than a smaller 35mm. The job called for both color and black-and-white of each situation, so I shot color, then replaced the camera back and shot with black and white. The film is shielded by an opaque slide when the back is changed.

heavy to be hand-held for any length of time, they adapt well to tripod use in the studio or in the field.

Cameras That Aren't SLRs

View cameras can make lovely close-ups, and are frequently used for commercial studio and fine art photography. Eliot Porter even took his into the field (see the photo opposite at top right). However, view cameras are slow to use, heavy to carry and are best adapted to non-moving subjects. These characteristics make them impractical for regular outdoor close-up work.

Unlike view cameras, 35mm rangefinder (RF) and point-and-shoot (P&S) cameras lack consistency of accurate framing, which is especially desirable when shooting close-ups. RF and P&S cameras make this difficult because the viewfinder view is not exactly what the lens sees. This is a parallax problem, and though Leica

and Contax make expensive precision RF models, I would not plan to use one for close-up work unless you have other, outstanding reasons to own one. For more accurate close-ups and ease of shooting, choose a reflex camera and look through the lens as you shoot.

P&S cameras are better for close-up work than RF cameras, although not as effective as SLRs. Many P&S cameras can focus sharply as close as two feet, which allows relatively large images with a zoom lens in the 90-135mm range. But the parallax correction marks in P&S finders are approximate and may not be reliable for each close-up distance. P&S autofocus and exposure cannot be controlled, nor are f-stops and shutter speeds in the finder or on a dial, so you don't know exactly where the lens is focused most sharply. For close-up work in bright light, you can at least expect the lens to close automatically to a small aperture to create suitable depth of field. Pleasing P&S close-up work is feasible, but frustration is guaranteed. My wife uses a P&S camera that can copy an 11″ × 14″ photo and almost fill the frame using its zoom at 105mm. But I don't recommend a P&S camera for serious close-up work because the results are not predictable enough.

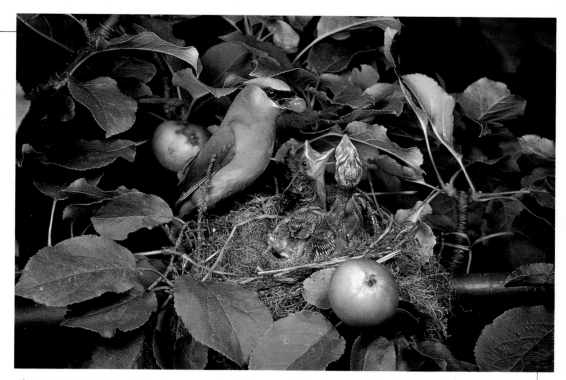

Eliot Porter, an artist with the view camera, took this wonderful picture on Kodachrome with a 4× 5 camera (and Eastman Kodak Co. made it available to me). Two tiny highlights in the bird's eye indicate he used flash, but I'm not certain how he set up a bulky camera and lights without scaring the bird. It is likely a long focal-length lens was used, such as 210mm (equivalent to 105mm on a 35mm camera) so Porter could set up farther from the nest. He was able to stop down to perhaps f32 because the flash was so close to the subject.

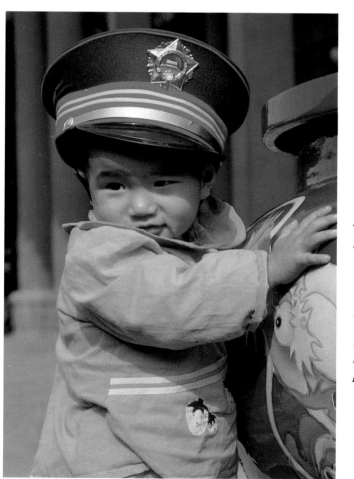

Lydia Clarke Heston traveled with her husband, actor Charlton Heston, to China where he directed The Caine Mutiny Court-Martial *all in Chinese, while she made opportunities to tour Peking with her 35mm SLR. She was delighted to find this youngster adjacent to a huge vase, with a red background as a bonus. She zoomed in for several close shots of which this is the most endearing. Lydia became a professional photographer when her husband starred in* The Greatest Story Ever Told *and the company persuaded her to do publicity stills. Together, the Hestons have worked in or visited more than fifty countries. Lydia shoots color slides primarily, and has mastered a complex computer program to manipulate and improve her best work for reproduction and exhibition.*

LENS SELECTION

Literally hundreds of lenses, from super wide-angles to ten-pound telephotos are made for 35mm and medium-format cameras. But not all are equally good for close-up work. Consider whether a particular lens has the minimum focusing distance and magnification capabilities for the type of close-ups you want to shoot, as well as aperture, weight and focal length. Buy the most efficient lens types and focal lengths for close-up work that also work for other photography you enjoy to get more from your lens dollar.

Comparison shop; read the lens tests, such as those in *Popular Photography* and *Petersen's Photographic Magazine*. Ask other pho-tographers how they like different lenses. You may even be able to shoot test pictures with the lenses you like best and make your own judgments.

Don't be discouraged if your local camera shops carry a limited number of lenses made for popular camera brands. Look for oth-ers in the ads many stores run in *Petersen's Photographic, Popular Photography* or *Shutterbug*. The variety of products listed in these ads is staggering, and the mail or-der prices for a lot of equip-ment are attractive.

Fixed Focal-Length Lenses

These are manufactured in wide-angle (18-35mm), me-dium (40-105mm) and tele-photo (110mm and longer) focal lengths. For close-ups, wide-angles lenses are less useful than longer lenses be-cause it's not practical to shoot large close-ups with them. For example, a 28mm lens focused at its minimum distance would record a cof-fee cup much smaller than a 90mm or 105mm lens would at the same focusing dis-tance. Lenses in the medium focal-length range are the most sensible for close-ups because they can record larger images without distor-tion than wide-angle lenses can. In addition, lenses in this category have been tra-ditionally thought of as "por-trait lenses" because they "draw" the human face in a more flattering undistorted way.

To become more familiar with lens possibilities, ask for literature from camera and independent lens manufac-turers. Compare the close-focusing abilities of those that interest you. If you al-ready own one or more fixed focal-length lenses, shoot some close-up tests with them using a yardstick in the pictures to determine the minimum area each would show. (See page 34 for de-tailed instructions on how to perform this test.) You can increase close-up capability from the lenses you already have by adding a diopter lens (a magnifying lens attached to your lens like a filter) or an extension tube (which lengthens the distance be-tween the lens and the film plane) for a little extra

When I shot this portrait of a five-year-old, I used a 50mm lens that focused to about eighteen inches. During my coverage, I also used other focal-length lenses, such as 28mm, 85mm and 135mm. Al-though those single focal-length lenses were excellent, it is easier and more convenient to use one or more zooms that include those various lengths. The film was Kodak Tri-X (ISO 400), exposed at 1/60 and f8.

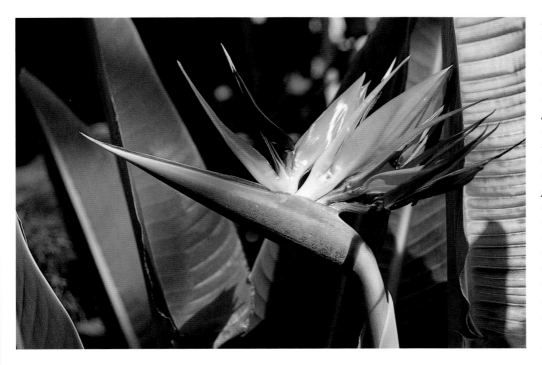

I discovered a bird of paradise in a botanical garden, and used an 80-200mm zoom lens to get closer to it. The greenhouse enjoyed lots of daylight, and it was worth carrying the longer, heavier zoom to get close-ups I couldn't reach with a 28-105mm zoom. The film was Kodachrome 200, chosen to go with the lens so I could hand-hold it to expose at 1/180 and f8. A tripod at this location wasn't feasible because I would have blocked narrow paths. So many zoom lenses are available in a diversity of focal-length ranges that you can certainly find a size and weight that suits you. Lenses such as 70-210mm or 28-200mm are lighter and smaller than could be imagined a decade ago. Macro lenses are also more compact.

money. The only drawback to supplementary devices is the time to decide which one to mount on the lens, but in many close-up situations you're not in a hurry. Fixed focal-length lenses are fine, but I feel having a series of zoom focal lengths at your fingertips, as well as the macro capability built into some zooms, is worth the slightly larger investment.

Zoom Lenses

Some photographers insist that fixed focal-length (prime) lenses are sharper than zooms, which may still be true in some cases, but some high-priced lenses in both categories are made with special low dispersion glass for maximum sharpness. The optical quality of the average zoom lens has been improved so their sharpness is more than adequate for most close-up photography. In fact, many of the images in

this book were shot with zooms.

Some zooms are bulkier and heavier than fixed focal-length lenses, but it is amazing how compact zooms have become, considering their photographic versatility. Zooms from different makers may have the same focal-length range yet vary in size and weight, which can be important to your comfort. Because my Canon 28-85mm lens weighs thirteen ounces, and my Sigma 28-105mm fourteen ounces, I can put one on each of two camera bodies to shoot two different film types at the same time. Mount a zoom on your camera and get the feel of it before you buy it so it won't give you a pain in the neck. Check also if it will fit in your present shoulder bag.

Most fixed focal-length lenses—except macro lenses —are not designed to focus as

closely as zooms, which often have minimum focusing distances of twelve to fifteen inches. But zoom close-up capability varies considerably among different brands and models, depending on the lens design. Most zooms provide the convenience of continuous close-focusing at all focal lengths, although some older models with a button to shift into macro mode may still be on the used market. Check manufacturer specifications for the focusing limits of zoom lenses and test those you already own (see page 34) to determine how effective they'll be for close-up work. (You can add diopter lenses to enhance the close-focusing capability of a zoom that already meets your other photographic needs.)

Most zooms in ranges from wide-angle to telephoto work well for close-ups as well as general photography.

When choosing a zoom, keep in mind that longer focal lengths can make larger images, but they are heavier to carry. Also, depth of field decreases as focal length increases, especially at minimum focusing distances. In some situations you may have to adjust between your desired composition and image size to get suitable depth of field at the smallest f-stops, f22 and f32. When you shoot fifteen inches away from a subject such as a small sculpture (perhaps six inches high) with a lens zoomed to 50mm, the image may be completely sharp at f32.

Wide-Angle to Medium Telephoto Zooms

For close-up work, the most useful ranges in this category are 24-70mm, 28-80mm, 28-105mm, 35-70mm, 35-80mm and 35-135mm. The wide-angle capability of some

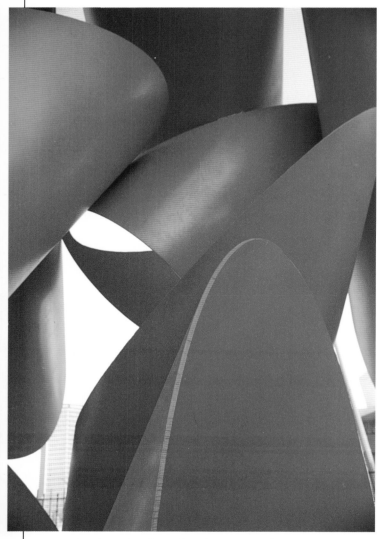

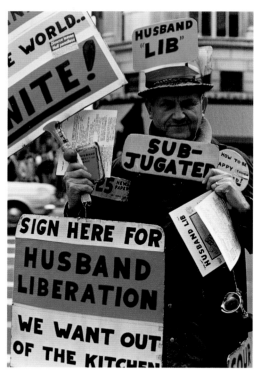

This image was taken by David Fried from a greater camera-to-subject distance than most close-up portraits. He used a 35-105mm zoom to alter his viewpoint quickly without making major changes in his position. Although he also took pictures of just the man's face and two signs, Fried liked best this storytelling, wide-angle version shot with the shortest focal length of his zoom. Eastman Kodak must have shared his opinion because it won an award in one of the company's contests. Although not a typical close-up, this shot illustrates the versatility of a zoom lens in close-up and related situations.

A metal sculpture by Alexander Liberman stands more than a dozen feet high in the gardens of the Los Angeles County Museum of Art. I photographed a section of it using a 21-35mm zoom, but I didn't like the distorted wide-angle view. I switched to a 28-80mm zoom and shot the image here at 45mm by hazy sunlight. While wide-angle lenses in the 21-35mm range can create unusual effects when you have looming foreground subject matter and diminished background subjects, they may warp what you photograph for close-ups. The film was Ektachrome 100 exposed at f11 and 1/125.

lenses is useful for general photography, but they produce noticeable distortion in close-ups. Focal lengths from 50mm through 135mm are practical for close-up work. I find myself shooting close-ups in the 50-100mm range most often because these focal lengths give me the image sizes I want along with reasonable depth of field. The range from 70mm to 110mm is ideal for many portraits and is handy for flowers and other subjects that size. You have a better opportunity to blur an unwanted background with a longer focal-length lens because depth of field decreases as focal length increases at a given aperture.

Medium to Long Telephoto Zooms

These lenses have ranges such as 28-200mm, 70-210mm, 80-200mm and 100-300mm. Lenses that stretch to 200mm and 300mm certainly give you close views, but you may get only partial depth of field. Some lenses in these ranges do offer maximum magnification that averages 1:4. Focal lengths in the 200-300mm range are excellent for close-ups of medium-small objects (five to ten inches wide) from a distance, such as a frog on a rock five feet away in a stream. Telephotos can "reach out" in many situations to give you larger images of distant (often scenic) subjects and are also useful for shooting any subject with a soft-focus background.

Macro Lenses

These terrific lenses, available for both 35mm and medium-format cameras, are specifically designed to focus from infinity to the closeness of life-size with or without additions, depending on the lens design. Some macros focus close enough to make life-size (1:1) images. Others focus to a 2:1 magnification but come with a special extension to provide 1:1 pictures. The extension tube, also called a life-size converter, includes its own optics and maintains all the automatic features of the lens it is made for.

You can use a macro lens for general photography, too, in place of an equivalent fixed focal-length model. Macro optics are corrected for flat field reproduction, which means they make copies of flat subjects well. You can also use a macro lens to make precise 1:1 dupes of color slides.

There are two general categories of macro focal-length lens for 35mm cameras: in the shorter group are the 50mm, 55mm and 60mm lenses; the longer group includes 90mm, 100mm, 105mm, 180mm and 200mm lenses. (Several focal lengths are also available for medium-format cameras; check the manufacturer's specifications.) Why are macros made in a variety of focal lengths? Because you are less likely to be intrusive when shooting large close-ups of subjects such as insects or frogs if you can stay back eighteen to thirty inches where using a macro from 90mm to 180mm is an advantage. A fixed focal-length macro, or a zoom in the 90-105mm range that focuses closely, provides more space between the lens and the subject for lighting equipment to better balance highlight and shadow areas. Shorter macro focal lengths make sense where distance to the subject, such as six to fifteen inches, is less of a factor. This working distance range is applicable for small, still subjects like jewelry, for copying, and for general close-ups outdoors in daylight where perhaps only flash fill is needed. A macro lens in the 50mm to 55mm range is more compact, and may cost less than a longer, probably more expensive, focal-length macro—which may be more convenient in some circumstances.

SUPPLEMENTARY CLOSE-UP LENSES

Single-element magnifying lenses, called diopters, screwed onto a camera lens as you would a filter, increase a lens's close-up capability. They offer a cost-effective way to explore the world of macro photography; you can buy a set of diopters for much less than a macro lens while you decide if you're getting what you expected from close-up photography. Even the more complex, more expensive diopter lenses from camera makers cost much less than macro lenses. Diopters don't add extension and, therefore, don't change the

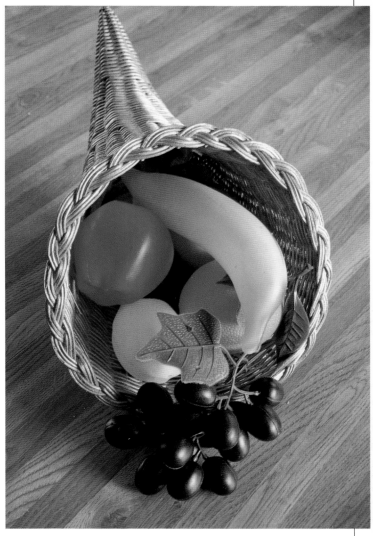

I set this cornucopia with artificial fruit on a tabletop near a couple of windows and photographed it with a 55mm macro lens on my Canon Elan SLR on a tripod. The film was Ektachrome Elite 100, and the exposure was 1/30 at f16. I might have made a similar shot with a 28-80mm zoom, but I chose the 55mm macro so I could also take views that were too close for the zoom, which is limited to about a 1:4 ratio. Short focal-length macros, such as 50mm and 55mm (which focus at 1:1) can be just right when the subject will not be scared away if you are too close. Such lenses are also lighter and smaller to carry.

amount of light coming through the lens, so they don't affect exposure. All camera/lens functions are maintained and, when you add supplementary close-up diopters to a zoom lens, you still have the advantage of the zoom function of the lens to control subject size and composition.

Diopter lenses are sold both individually and in sets in standard filter diameters that fit popular lens sizes, such as 49mm, 52mm, 55mm, 58mm, 62mm and 67mm. They are screwed into the

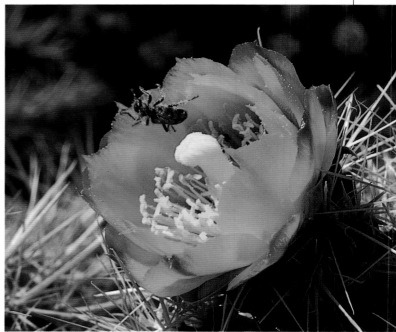

The cactus flower is only about one-fifth life-size (1:5) on the slide, but it is sharp enough to take considerable enlargement in reproduction. I photographed it with a 50mm macro lens and a 35mm SLR on a tripod in the desert sun. I could concentrate on the tiny insect that animated an otherwise passive subject because I had the camera on a tripod. The film was Ektachrome Elite 200 exposed at between f16 and f22 at 1/60.

I set up two floodlights, General Electric EAL 500W 3200K reflector bulbs, to photograph these ornaments my wife bought on a European trip. I used a 28-105mm zoom lens to focus closely enough to achieve about a 1:5 enlargement ratio. I was as close as I could get at 105mm because the figures on film are an inch high and in reality are about five inches high. My 35mm SLR camera was mounted on a tripod, and I used Ektachrome Elite 100 film (with an 81A conversion filter) shot at f16 and 1/8. When you choose a zoom lens in any focal-length range, find out its focusing ratio, and better yet, put it on your camera and learn its closest focusing distance.

front of a zoom or a fixed focal-length lens in identical manner. The strength of a diopter is expressed as a number that describes how close a lens can focus with the diopter attached. The higher the number, the greater the magnification of the lens; the most commonly used diopters are +1, +2 and +4. Tiffen also offers +3, +5 and +6 diopters in various diameters. The mail order catalog of Porter's Camera Store (available by calling 1-800-553-2001) offers a variable close-up lens, a kind of diopter zoom that combines a full range of magnification from +1 to +10. You will need an adapter ring for it, too. Just how a diopter affects the image you see in the finder depends on which focal-length lens it is added to, as well as the focusing distance. Here are sample magnification figures from Tiffen for a set of diopters, given for a 50mm lens focused at three and one-half feet: with a +1 the lens covers a 9¼″ × 15½″ area; with a +2 it covers a 6⅛″ × 9¼″ area; with a +4 the lens covers a 4″ × 6″ area. Many 50mm lenses focus closer than three and one-half feet, so areas covered would be even smaller.

Stacking diopters will en-large an image even more than using one at a time. Try stacking a +2 and a +4 together for surprising close-up qualities, although depth of field may be shallow and the background disappears. Put the stronger diopter first onto whatever lens you use, and add the weaker diopter in front of it.

Moderate cost, ease of use and compactness are the main advantages of close-up diopter lenses, but the optical quality is not quite as high as camera lenses alone. This will be less noticeable when you stop the lens down to f16 or f22 to shoot because diopters are sharper in the center area than at the edges. Magnification from diopters can

make your zoom or fixed focal-length lenses more versatile, and the sharpness I've gotten with diopters (shooting from a tripod) is acceptable enough to make these handy accessories worth having.

EXTENSION EQUIPMENT

When the focal length of a zoom lens increases, lens elements inside it extend farther from the film plane and the image becomes larger.

You can take a picture closer to the subject without moving the camera closer. Diopter lenses achieve their close-up capability just optically. *Extension* tubes place the taking lens closer to the subject, as do photographic bellows onto which you mount a lens. And a *reverse-mount adaptor* allows you to turn a 50mm lens, for instance, backwards and mount the front of it to a camera body. All these accessories help you either to get larger close-up images or to make certain operations, like copying, more precise.

Extension Tubes

Extension tubes are fixed-length tubes or rings, made in various lengths such as 13mm, 21mm, 31mm and 52mm, to fit between the camera body and a lens, which is then able to focus closer to a subject. Tubes of various lengths fit specific camera mounts (bayonet mounts vary from one brand to another), and lenses that fit your camera attach to the tubes to focus more closely than they would otherwise. Since tubes include no optics, the quality of a camera lens is not compromised—unlike diopter lenses that may not be as sharp as lenses to which they're attached.

Most extension tubes connect with the camera's automatic diaphragm and meter operations, but not to auto-focus links. Thus they don't interrupt through-the-lens

This pretty display of foil-covered candy eggs was photographed on a partly covered patio in hazy daylight. At the time I was using a 28-80mm zoom lens that didn't focus this closely, so I experimented with supplementary diopter lenses. From a set that includes + 1, + 2 and + 4, I chose the + 2 lens, which did the trick. The candy covered an area about four inches wide in the dish, and it's about an inch wide on the slide, so the enlargement ratio is 1:4, or one-quarter life-size. Exposure on Ektachrome Elite 100 was 1/125 at f11.

Derald Martin shot a series of roses to demonstrate how gradually increasing the length of extension tubes attached to a 50mm lens enlarges an image. Notice that the background leaves go out of focus as lens extension increases. You could also do a similar series using supplementary diopter lenses with typical numbers, + 1, + 2 and + 4, although a 57mm extension tube makes possible close-ups larger than those you can get with a + 4 diopter lens. On the other hand, diopter lenses don't interrupt the camera's automatic focus and exposure as do the extension tubes. The film was Kodachrome 64 and exposures were 1/60 at f11.

50mm lens with 12mm extension tube attached.

50mm lens with 19mm extension tube attached.

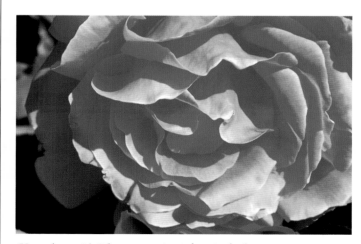

50mm lens with 26mm extension tube attached.

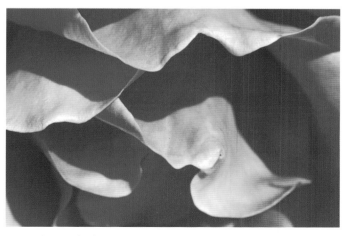

50mm lens with 57mm extension tube attached.

metering and the lens stays open to focus, then closes down to the selected f-stop when you shoot. The lens aperture immediately opens to its widest aperture, as it does when no tube is present. This is called a coupled tube and, while more expensive than an uncoupled type (requiring manual meter and aperture operation), the metering system automatically compensates the exposure for lens extension, making life much easier. Incidently, the viewfinder aperture display disappears when you use an extension tube, but the meter still works.

All your camera lenses can be attached to extension tubes, but tubes are most practical with medium focal-length lenses, in the 50-90mm range. Longer focal-length lenses are heavier, and while they can be used with tubes, there's less strain on the camera body if the lens includes a tripod socket. Or the camera, tube and lens may be mounted on a focusing rail that attaches to a tripod and distributes the camera/lens weight nicely. The actual magnification you get will depend on the length of the tube in millimeters and the focal length of the lens used. With a 50mm lens and a 52mm tube, you can enlarge an image to twice life-size. Individual tubes or sets of tubes are available from camera manufacturers and other photographic suppliers.

A photographer at Olympus America, Inc. laid a leaf on translucent glass outdoors, and placed a portable, shoe-mounted flash unit beneath it. Attached to his Olympus OM-2 35mm camera was an auto bellows that synchronized the shutter and diaphragm automatically at the moment of exposure. The lens was a 38mm Olympus macro chosen because it is specially designed to make images up to 10X life-size. The leaf was enlarged to about 3.5X life-size on Kodak Ektachrome film. Canon and Nikon also make lenses like the 38mm macro, and Olympus makes a 20mm macro for magnification even larger than 10X. Exposure was 1/125 at f22.

Another Olympus America photographer set his OM-4 35mm SLR with 90mm macro lens very close to a beautiful flower, and shot with an Olympus T32 flash unit at the camera. In order to get a 1:1 life-size image with the 90mm macro that focuses only to 1:2, a pair of extension tubes, 25mm and 14mm, were placed between the lens and the camera body. The lens sharpness is not affected with extension tubes as it may be with diopter lenses.

Bellows Unit

A bellows unit on a focusing rail becomes a very efficient close-up tool when mounted on a tripod. You attach a camera body to the back of the unit and a lens is bayonetted or screwed in the front of it. The main function of a bellows is to shoot close-ups larger than 1:1, though it also extends short focal-length lenses to almost 1:1. It is most convenient to use a lens in the 50-105mm range (either a zoom or fixed focal-length will work) because bellows extension is limited, depending on unit size. Using 50-105mm focal lengths, you can conveniently shoot subjects two, three or four times life-size without strain. With longer focal-length lenses, such as 180mm or 200mm, an extended bellows can be awkward outdoors because it may move slightly in a breeze. The longer the lens, the more bellows extension you need to get life-size images of tiny subjects like ants. In general, it's better to use a bellows indoors than in the field. (Some medium-format cameras come with built-in bellows, which is handy for close-ups.)

Many camera manufacturers and independent sources offer bellows units. Not all units provide meter and diaphragm coupling, so you may have to set exposure manually. Some bellows include a double-cable-release system that provides limited automation, and some allow you to rotate the camera to horizontal or vertical positions. With a unit you'll also have to buy front and back mounting adapters for your brand of lenses. A bellows can be an ideal close-up tool for large and precise close-ups, but given the cost and the limitations for field work, be sure you need one before you buy.

Reverse Lens Adapter

In theory, the optical performance of a lens improves when you mount it *backwards*, so its rear element faces the subject. Reverse-mounting a short focal-length or a normal 50mm or 55mm lens, therefore, allows you to focus very close to a subject. If you mount a lens the conventional way, the magnification rate and focusing distance are fixed. When you reverse-mount the lens on a camera, you can focus much closer to get at least life-size images. To reverse-mount a lens, you need a reverse adapter, an inexpensive ring that lets you attach the lens, front first, to the camera body or to a bellows unit. You lose all automatic lens functions with this operation, so you must manually open and close the aperture for viewing and proper exposure. A lens reverse-mounted on a bellows unit (described above) offers even more magnification flexibility.

Reverse-mounting a lens is an inefficient alternative to using diopter lenses, extension tubes or a macro lens. It slows you down while you manipulate the diaphragm and set exposure by hand. Experiment if you wish, and draw your own conclusions. Your main advantage is that the lens you use can perform in its usual quality way—unlike adding diopters. I'd opt for extension tubes over a reverse adapter.

Darlyne A. Murawski, a research associate at Harvard University, is an expert on tropical insects and plants, which she has photographed in many countries. While in Papua, New Guinea, she shot close-ups of mating blue weevils using a 50mm macro lens on a bellows unit, which added to the close-up capability of the macro. She placed a portable flash unit at the left and another at the right with diffusers on them, but used no backlight because it would have reflected on the leaf and caused glare. The film was Fujichrome 100 and the exposure was f22 at 1/60 second.

Manny Rubio is an authority on snakes and other reptiles such as this Tokay gecko. At the Atlanta Zoo an assistant held the animal while Rubio photographed it with one flash above the camera aimed down at a 45-degree angle. He often shoots close-ups and chooses between diopter lenses, extension tubes (or rings as Nikon calls them) and teleconverters, which are optical devices mounted between a lens and a camera body to increase close-focusing capability. A teleconverter multiplies a lens focal length by factors like 1.5X and 2X. Rubio worked with a 1.5X converter and a 60mm macro lens here. Exposure on Kodachrome 64 was 1/125 at f16.

CHOOSING A TRIPOD

As you know, the slightest camera movement is magnified in close-up shots, often making a tripod an essential piece of equipment. You can take relatively sharp close-up pictures with a hand-held camera, but depth of field is likely to improve when you use a tripod. In addition, you are inclined to compose more carefully with a tripod. Once you get the image you want, you can adjust lights or background or wait more patiently for improved lighting conditions because the camera stays where you put it.

I categorize tripods by weight, which influences steadiness, and by the height to which they can extend. Lightweight models range from two to four pounds. For 35mm SLRs, most are slightly less sturdy than heavier models when there's wind, and they're easier to carry. Short legs on a few types allow you to shoot subjects close to the ground. A lightweight tripod will work for a 35mm SLR with a 28-105mm zoom, but it might sway imperceptibly in a breeze with a longer-range zoom aboard.

When I fly on vacations, I use a Focal brand of tripod (from Kmart) that weighs two-and-one-half pounds, is twenty-three inches long when closed, and opens to fifty-eight inches—about my eye level—including a ball head. Some might think it must be frail and therefore almost useless, but mine has proven itself in many circumstances.

I consider four-to-six-pound tripods to be medium weight. They are light enough to carry on hikes and sturdy enough to use with longer focal-length lenses, such as a 70-210mm. My main tripod is a Bogen 3411; it's no longer made, but is similar to current Bogen models 3001 and 3021. Open, mine stands sixty-three inches with ball head; it includes a fourteen-inch centerpost and weighs only four pounds. Although other professional photographers might recommend a heavier model, I have found this medium-weight Bogen to be versatile and most satisfactory in many shooting conditions.

Tripods heavier than five pounds are also popular, especially for medium-format and bulkier 35mm cameras with lenses longer than 200mm. However, they are

I asked old friend Richard Hewett for permission to use this striking photograph from a book his wife, Joan, authored and he illustrated. Titled Tunnels, Tracks and Trains, *the book chronicles building a subway in Los Angeles. An artifact found while digging the subway was held with the sun backlighting it dramatically so Dick could shoot a close-up with his 35mm Nikon F4 mounted on a unipod. The latter has one leg, is lightweight and steadies the camera at shutter speeds of 1/30 and faster. (For slower speeds a tripod is preferable.) Hewett chose an 80-200mm zoom for easier composition from one camera position. The picture was made on Kodachrome 200 exposed at 1/250 at f11.*

A lightweight tripod indoors or a medium-weight model outdoors is especially useful for shooting portraits. With your camera set for the image you want, you can move around to arrange lights, help pose the model or take time out for a snack. The tripod helps guarantee sharp pictures as well as a consistent viewpoint. This portrait was taken with a 105mm lens on a 35mm camera and several 500W photoflood bulbs in Victor reflectors. One of the lights was pointed into an umbrella reflector. The exposure was 1/60 between f8 and f11 using Kodak Plus-X film.

likely to be a pain in the shoulder to carry, and they're more expensive than light- or medium-weight models. For example, the Bogen 3001 (three and one-half pounds) sells for $80-100, while the 3046 "professional" model (eight and one-fourth pounds) costs $190-225. Bogen, Slik and Gitzo all make a variety of excellent tripods.

The centerpost of some tripods can be removed and inserted upside down to shoot close to the ground, but positioning yourself between the tripod legs and managing camera controls in the inverted position is awkward—as you may already know. Another method of shooting from a low position is to buy a tripod with legs that spread out to a low camera position.

As alternates to a tripod, lightweight clamps that fasten a camera to the back of a kitchen chair, for instance, work when no tripod is handy. Another camera-steadying gadget is a leather or denim beanbag. You can make one that flattens to five inches wide and an inch or two high by filling it with dried beans—not too tightly—and sewing it closed. The material must be folded and sewn, so a good seamstress would be helpful. An SLR atop a beanbag set on the sill of a car win-

dow, for instance, should be steadier than hand-holding it, especially with a telephoto lens or in weak light.

Tripod Heads

Some tripods are sold complete with a tripod head, but those that aren't let you choose a separate head to suit your needs. Many tripod heads are the pan-tilt variety with one or two adjustment handles extending from the head—to get in your way. I prefer a ball head with no handles. A ball head rotates in a socket and offers easier camera positioning; a single knob tightens the ball to control pan and tilt. A good ball head allows you to move the camera in any direction, even slightly. You needn't fully adjust tripod legs to level the camera because you can do it by adjusting the head.

There are maybe half a dozen sizes of ball head. The largest are meant for heavy cameras, and the smallest ones aren't suitable for the average 35mm camera. In between, many work well with SLRs. Choose one large enough to match the weight and bulk of your camera— and your budget. The Arca-Swiss Monoball head is probably the best available, but it is very expensive.

There are various tripod head designs, but I find a ball head the most useful. You can tilt the camera in any direction by loosening only one set screw. A tiny ball head might work for a compact P&S camera, but a medium or larger ball head is most practical for the weight and bulk of 35mm SLR cameras. I used a 50mm macro lens on a 35mm SLR mounted on a medium-size ball head about three inches high to photograph this cactus flower. It's about an inch wide, and I placed it in outdoor sun against a black background—a piece of fabric I hung. The film was Ektachrome Elite 100 and exposure was 1/20 at f22.

FLASH UNITS

Various types and categories of flash units are available for close-up work, including built-in and free-standing flash suitable for use in the field or in the studio. The flash integrated into 35mm cameras is relatively weak and has a limited range, but for close-ups it can be very handy for flash-fill. Portable flash units, almost all of which have autoexposure capability through built-in sensors, range from compact models with nontilting heads to slightly larger compacts with tilting, swiveling heads. (You can turn the flash head toward a reflector and the sensor in front still faces the subject to regulate exposure.) These are versatile, especially the complex, expensive types made by camera manufacturers. They'll operate on remote control, their power can be modulated, and they have sophisticated features that even some pros say they haven't tried yet.

Some units are designated *dedicated* flash, designed for specific cameras; they regulate exposure by measuring the light off the film (OTF), and balance ambient light and flash exposures. Camera companies and independents make dedicated units.

Nondedicated flash units with automatic exposure capability, sometimes OTF, are more affordable than dedicated units. They can be regulated to 1/32 in manual exposure mode, which is useful for extreme close-ups. Vivitar, Sunpak, Nikon, Canon, Olympus, Minolta and others make nondedicated units. Both dedicated and nondedicated units operate on batteries, and usually on A/C as well.

The most portable A/C-only flash is one piece, with light and power combined into units mounted on light stands. Because you can often place lights within a few feet of close-up subjects, a portable unit (that can be

Jill Walz used fast ISO 400 Kodak Gold negative color film for this striking image. She set an electronic flash below and behind her model to rimlight the face, which was colored by another flash with a red gelatin in front of it. The smoke was probably tinted blue by a third light covered by a blue gelatin. The black background was perfect contrast for this creative composition, and Jill's distinctive, moody portrait won an award in an Eastman Kodak contest.

positioned atop a camera or off-camera) with a guide number (used to set exposure manually) of 100 for ISO 100 film should be right for you. Thus you can outfit a home studio with a couple of portable flash units—fastened to light stands with clamps—and have plenty of light for most close photography. (See pages 105-107 for more on flash equipment.)

OTHER USEFUL ITEMS

A lot of close-up photography can be done with equipment used for general photography. You need only to add specialized lenses, rings or other accessories to your inventory. Here are a few basic items that you will find handy for close-up work. You'll discover more as you gain experience—but the items mentioned round out the list of basic necessities.

Cable Releases and Remote Controllers

A cable release activates the shutter of an SLR camera to eliminate the tiniest amount of camera shake your finger may cause, even during long exposures. This is particularly important when shooting close-ups because minimal camera movement is magnified when you see a subject closely. Some 35mm cameras have a cable release socket, but some don't. The cameras without a socket may instead offer a remote control unit to fire the shutter without your touching the camera. Remote control ca-

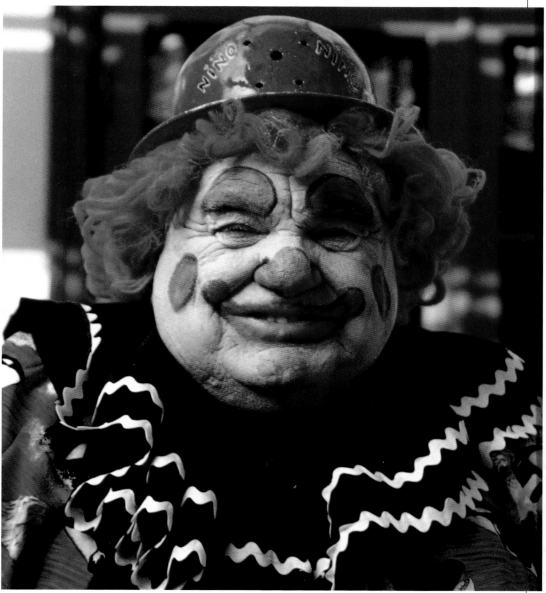

pability is useful, but in some circumstances it's awkward to position yourself properly. With 40 slow shutter speeds, one solution is to use the self-timer and cover the finder window to prevent extraneous light from influencing exposure. Some SLRs include a mirror-lockup feature to help avoid minimum vibration, but I'm not convinced it's necessary.

I met a clown taking a break outside a restaurant where he entertained at children's parties, and asked to photograph him. He was seated in bright shade, so I put a 1A skylight filter over a 28-105mm lens to warm the color that tends to go bluish in shade. The film was Ektachrome Elite 100, a version of Kodak's Lumiere. The latter is designed to be slightly warmer than usual, but I prefer to use the more neutral Elite and add a warm filter of my choice when I want it. Exposure was 1/60 at f8.

Filters

Filters are used in close-up photography mainly to enhance a picture by improving the color or eliminating reflections, or to convert (i.e., correct) a light source to match the type of film in use. I carry a number of filters for general photography, but need only a few of them for close-ups.

Warming Filters

Skylight 1A or 1B filters, and slightly warmer versions, such as the 81B or Tiffen 812, are useful with color slide film to warm the light, mainly on cloudy days or in shadows. I use the pale 1B, which has only a minimal warming effect, over my lenses to protect them from dust and scratches. Because the amount of warming needed for a shot in shade or on an overcast day varies, you need to take test pictures with a 1A, a 1B, the Tiffen 812 and the 81B, both in sunlight and in shade, to compare how much they warm your film(s). Keep a record of which filters were used. Results will be more evident with slide films than with print films because the latter are subject to unpredictable correction during the printing process. Some feel a 10cc magenta filter enhances pinks that might otherwise be washed out where there is a green cast to the light—in a leafy, wooded area, for example.

As a lover of antiques and collector's junk, I spent an elated hour, with the owner's permission, at a Kalispell, Montana, shop. My Canon Elan with 28-80mm lens was on a tripod, and I put an FLD filter over the lens to compensate for the dim fluorescent lighting. With the filter, even using Kodak Ektachrome Elite 200, my exposures averaged one-fourth second at f11. I took a few shots without the correction filter, and there was a green tint on everything, typical of how fluorescent lighting affects daylight color film.

These peppers in the sunlight at a farmer's market were an irresistible close-up subject taken at the 80mm setting of a 28-80 zoom lens on a 35mm SLR. Exposure was 1/125 at f11 on Ektachrome Elite 100. (Individual peppers also make good subjects when you can focus closely enough; see Linda Heim's shot on page 28.) This is a dupe of the original made with an improvised duping arrangement (see pages 131-133) that gives me reproduction-quality dupes. The rig combines my 35mm SLR with a 50mm macro lens, a slide holder and opal glass, behind which is a portable electronic flash.

Color Compensation (CC) Filters

These filters help eliminate slight color tints. For example, a cyan CC filter can correct the reddishness of a subject close to a brick wall. CC filters are also useful to add subtle tints to light-colored skin tones photographed on an overcast day. The CC 30M or FLD filter corrects the greenish tint cast by fluorescent lights on people and objects in color photographs. (Note: CC filters reduce the light coming into your camera and cost you at least part of an f-stop, an adjustment made by the auto-exposure system.)

Conversion Filters

You need these filters especially when you photograph with floodlights and daylight slide films. The 80A filter converts daylight slide films for use with 3200K photofloods. (But keep in mind this filter also cuts the light entering the camera by about one and one-half stops.) The 80B does the same job with daylight color slide films and 3400K photofloods. Using one of these prevents you from having to switch from daylight film, which most of use regularly. These filters are not recommended for use with color print films because color is usually corrected in the printing, but experiment for your own satisfaction.

Polarizing Filters

These eliminate reflections on glass and metal under some circumstances. As an example, when photographing flat metallic subjects, try a polarizer that you revolve while looking through the lens to gain the effect you prefer. Polarizing filters are best known for deepening the color of the sky in both color and black-and-white films. Note that autofocus SLRs work better with a *circular* polarizer, especially when balancing flash and natural light. Polarizers can cause a one- to one-and-a-half-stop light loss, so use slower shutter speeds than usual to match small f-stops necessary for adequate depth of field.

Neutral Density Filters

These filters reduce the amount of light passing through a camera lens without altering color. I carry ND2 and ND4 filters, which reduce light intensity to one-half and one-quarter. Depending on the brightness of the light, with ISO 200, 400 or faster films especially, adding an ND filter enables you to shoot at a larger aperture to reduce depth of field and create a featureless background. You may not want to do this often, but an ND filter can help when you do.

A tank full of moon jellyfish at the Oregon Coast Aquarium, Newport, Oregon, were fascinating. I should have had faster film, maybe ISO 400, instead of the Ektachrome Elite 100 that was in my camera, to cope with the dim light in the display. I was only able to shoot at 1/30, and many slides were blurred. This is a dupe of one of two images worth keeping. I can't afford to have slides lost or damaged—a good reason to duplicate them. Dupes serve to protect the originals when I submit photos to a magazine, book or other type of publication, or for a contest. Sharp dupes with proper contrast are not easy to make, so you may want to use one of the many processing labs that offer duping services.

Few close-ups taken on one type and brand of film would be vastly different if taken on a similar film from the same or a different maker. Study the color shots reproduced in a magazine such as Popular Photography *or* Petersen's Photographic *without reading the captions. Try to guess what film type, brand and speed might have been used. You may be surprised how often you're wrong. After an image has been reproduced by the four-color printing process, many differences, especially subtle color variations, disappear. You'll quickly see how interchangeable films can be, though there are distinct differences between slide and print types. This shot was taken with a 50mm macro lens on Ektachrome Elite 200 in the sunlight, using a white card reflector at the right.*

Film for Close-Up Work

COLOR FILM CHARACTERISTICS

"This is definitely the golden age of color films," said a 1994 *Popular Photography* article, and that's more than media hype. There have never been so many films to choose from and, according to that article, the biggest problem is that "it's now harder than ever to figure out which film to use. . . ." The cause of this dilemma is the similar color fidelity and sharpness of different films. Many film brands with the same ISO—especially negative color films—give you seemingly identical images. Color slide films vary more, though you need to make thorough comparison tests to recognize their color differences. You may choose your favorite film(s) based on variations in brilliance or the warmth or coolness of a particular film's palette.

Color slides are popular with professional photographers because magazine and book publishers and ad agencies prefer them. There are several reasons for this. When slide film is exposed correctly in proper light, colors are usually more accurate than in prints from negative films. The latter are subject to interpretation by technicians who may be unfamiliar with the exact color of a subject. You can make slides from negative film, but the results are not as good as those created in the camera on slide film. Prints made from slides are often as good as those made from negatives, but they cost more.

Each type and brand of film has distinctive but similar color characteristics described in magazine film tests, but to know what a film will really do in different circumstances, shoot with it yourself. If you have two cameras, load each with a different film, and shoot the same subjects. If you have only one camera, try to borrow another one for a few hours of testing. Shoot the same subjects in the same lighting conditions for comparison. In some cases, the

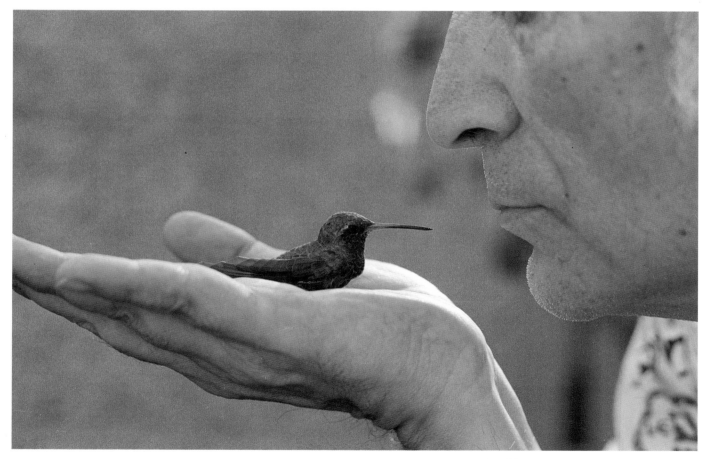

Jose Antonio Romo Fonseca of Queretaro, Mexico, photographed a hummingbird at rest with Kodak Gold Plus 200 print film, and won an award in an Eastman Kodak competition. The daylight was beautiful, and I can only speculate how the man persuaded the bird to sit calmly for a close-up. I received this shot converted to a 4" × 5" transparency by Kodak; although slide film generally makes better transparencies than print film, the results here show how versatile color print and slide materials can be. Courtesy © Eastman Kodak Company.

results may be almost alike, and in others you may decide that one film offers truer color. Notice how each film handles high contrast by comparing highlight and shadow detail.

Although color images had largely supplanted black-and-white pictures for much commercial and publication work by the mid-1970s, in the 1980s publishers and designers rediscovered the power of beautiful contrasts in black-and-white images, in media and in exhibitions. Now, those who prefer to work in black and white, at least part of the time, include more than fine art photographers who choose to follow in the footsteps of masters such as Edward Weston and Ansel Adams. Many people appreciate close-ups and other subjects in black and white for their tonal beauty, often adding elegance to subjects such as portraits and patterns.

Sometimes film choice will be determined by what's available because a limited number of brands, types and speeds are sold by the average store. That's not usually a handicap since the popular films found everywhere give you more than satisfactory results—with correct exposure and printing or processing. To test films you can't buy locally, make a special trip to a large camera store, or order by mail from the photo supply store ads in photography magazines, which may also save you money.

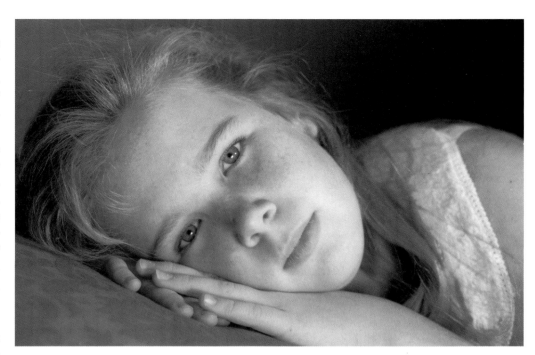

This softly lighted portrait by Carolyn Shamblin is another Eastman Kodak award winner. It was taken on Kodak T-Max 100 professional film, which has fine grain and excellent tonality. The two tiny white spots in the young lady's eye indicate the picture was taken by floodlights, and the soft shadows are probably the result of a diffuser. The medium-format negative was large enough hold good detail in this enlargement. Courtesy © Eastman Kodak Company.

I photographed this flower, which our guide called a "banana orchid," at Kauai's Fern Grotto. It was taken with a 28-105mm zoom lens on ISO 400 Kodak Elite film, because the fast film's color and grain are outstanding. I could have gotten closer, but I wanted to frame the striking flower in its surroundings. I was not carrying a tripod and needed the faster shutter speeds and small f-stops in shade that a fast film offers. The exposure, in bright shade, was 1/250 at f11.

COLOR FILM SPEED AND GRAIN

Film speed is expressed as an ISO number that indicates the film's sensitivity to light. The higher the speed rating, the more light sensitive (or faster) the film is. An ISO 400 film offers you a greater range of exposure options at lower light levels without resorting to flash than an ISO 100 film can. For example, if you are shooting fine detail carved into a vintage tombstone in bright shade, you can probably handhold the camera at 1/125 or faster using an ISO 400 film and get reasonably good depth of field. With an ISO 100 film and without a tripod handy, you would have to choose an f-stop that provided less depth of field in the existing light to avoid camera shake at a slower shutter speed. Were you to switch to flash, the flatness of the light could wipe out delicate shadows necessary to the picture.

In general, slow films are rated ISO 25 to under 100; medium-speed films are designated 100·to 200; and fast films are rated 400 and up. A popular slow slide film is Fuji Velvia, rated at ISO 50, but you should shoot it at ISO 40 (too slow for my taste). Numerous well-liked medium-speed and fast slide films are offered by Kodak, Fuji and Agfa. I'm partial to Kodak Ektachrome Elite 100 and 200, and Fuji makes equivalent films. Medium and fast films help you shoot at higher shutter speeds and smaller f-stops than in many

situations with slow films. Faster films (over ISO 400 especially) offer slightly less contrast and sometimes slightly less brilliant color than slow and medium-speed films. Slow films also offer finer grain for bigger enlargements.

Images on film are formed by thousands of tiny light-sensitive particles called grain, and the size of a film's grain is linked to its speed. The higher the ISO rating, the larger the grain structure, and the more light sensitive (faster) the film is. The faster the film and the larger the final image, the more evident the graininess becomes. If grain is too pronounced, it may lower image quality, but fast, grainy films are usually reserved for weak available light conditions when using flash or other artificial light is not desirable. The viewer expects to see subtle details clearly in close-up photographs, so obvious grain is inappropriate. Use films faster than ISO 200 only when necessary, though ISO 400 films, both negative and slide, are reasonably fine-grained today.

Sharpness is a film's ability to clearly reproduce fine detail and the edges of objects. This is critical for close-ups when you want to record all the minute parts and small areas of a subject. When you are shooting, sharpness is influenced not only by film graininess, but by camera steadiness and subject movement as well. As film becomes grainier, fine lines and

Marilyn F. Auen wound a garden hose compactly around its nozzle to create a striking close-up pattern. The photo, taken on Kodak print film, won a prize in a Kodak contest. The concentric rings of hose are somewhat hypnotic and the single color holds your eye because of the contrasting thin shadows. The film beautifully captures the richness of the green hose and all the subtle color variations in the metal nozzle. A picture like this should be taken on a tripod for sharpness and precise composition; the trick is to straddle the subject without including shadows from the tripod legs in the photo. Courtesy ©Eastman Kodak Company.

Derald E. Martin got close enough to an ornamental cabbage with a 50mm lens and +2 diopter to make a fascinating abstract pattern. Although you can produce very artistic abstract images, try some just for the fun of it without worrying about the end results. (See pages 118-125 for more on abstract images.) Martin used fine-grained Kodachrome 64 for this shot. This film has long been a favorite of photographers because of the way it reproduces fine detail; it even offers enough speed to hand-hold the camera in bright sun. This shot was taken in subdued daylight, so Martin used a tripod.

sharp edges appear less so. Sharpness ratings and the resolving power—the number of lines a film can reproduce per millimeter—are available from film manufacturers if you're curious.

When you want to reproduce your work as large posters, full pages in a book or on a magazine cover, or want to make large prints for

I photographed the wedding of two friends, Terry (her) and Chris (him), on a bright, cloudy day in Kauai. Using a 28-80mm zoom and Fuji Super G 200 print film, I moved in for a close-up as Terry placed a ring on Chris's finger. The picture would have had more contrast in sunlight, but the sun wasn't out. Bright shade is generally considered better for portrait work anyway because diffused light is more flattering. ISO 200 is an ideal speed for both sun or shade, permitting a fast enough shutter speed to help avoid showing the effects of camera and subject movement. Exposure was 1/250 at f8.

Neil Montanus of Eastman Kodak Co. made a dramatic portrait by candlelight using Kodak Royal Gold 1000 film, which is very fine grained for a high-speed film. You can use it in low light without a tripod if necessary. Although I don't have the exposure data for this shot, the depth of field from the candle to the model suggests that he shot at 1/60 and f11. If you try this, shoot quickly when the model is in place to avoid causing discomfort, but bracket your shot with exposures over and under the one indicated by your meter. Courtesy © Eastman Kodak Company.

display, choose a slower film with finer grain. However, manufacturers have greatly reduced graininess in modern negative and slice films, so concern about grain should not inhibit you from shooting ISO 200 films when faster shutter speeds and/or smaller f-stops are an advantage for hand-held close-ups.

In practical terms, the best prints usually come from ISO 100 or slower film, but you can get excellent prints up to 8″×10″, or even 11″×14″, from most negative films rated ISO 100 and 200. You might also experiment with enlargements from film rated ISO 400 just to be familiar with grainier prints with slightly less contrast and color brightness. Slide films rated at ISO 50 and 64 give you lovely, sharp images with very fine grain that can be greatly enlarged. Use a tripod when shooting because these films are too slow for hand-held photography in lower light levels. Actually,

the quality differences between the slowest films and those in the ISO 100 category are disappearing, and grain and sharpness in ISO 200 films are now similar. You'll find various slide films in the same speed categories, so shoot your own tests with films you prefer, in the same lighting conditions, and compare results.

Lighting and subject choice will affect which film speeds you choose. When I'm visiting new places, I walk a lot looking for good picture subjects. ISO 100 is the slowest film I find practical under hand-held circumstances, and when shooting from a tripod, ISO 100 slides are easily good enough for full-page magazine or book use. I also carry some ISO 200 speed slide film for use on cloudy days or whenever the light level requires too slow a shutter speed or too large an aperture for comfort with an ISO 100 film. Some pros prefer using ISO 50 and 64 slide films

because they trade off longer exposure times for slightly higher contrast and finer grain. For prints, however, both ISO 100 and 200 negative films are good choices, and it's hard to see much difference in 8″×10″ prints. In shade and with flash, ISO 200 print films excel, and in sunlight they permit smaller f-stops for greater depth of field.

COLOR FIDELITY

Color fidelity describes a film's ability to reproduce colors realistically—to capture what the eye sees. Major film manufacturers have had great success rendering accurate color from negative

film in recent years, and you will get nearly equivalent results with different brands of film. The color fidelity of slide films is also amazingly accurate, but due to differences in color chemistry, slide films have more individual color characteristics than negative films. It's harder to distinguish differences in the latter because processors can often make look-alike prints by expert filter manipulation.

Test several brands and speeds of slide film to determine your favorites, noting the accuracy of red, blue, yellow and green. Shoot the same subject in the same light on different films for

When testing film characteristics, pick a colorful subject that will let you experiment with compositions, and shoot in sunlight to judge the film's color accuracy. Because sunlight's color spectrum is well matched to daylight film emulsions—except in early morning or late afternoon when the light is warmer—it ensures an apples-to-apples comparison of films. This is part of a geometric sculpture I made by taking apart a radio-tape player that died. Its mass of little details provides fascinating material for close-up exercises, such as the one you see here. The film is Fuji Sensia 100, which has good color fidelity, although I feel that bright colors seem slightly muted. I used a 35mm camera with a 50mm macro lens on a tripod and exposed at f16 and 1/60.

Not every close-up situation offers strong color and contrast. This close-up of a decorative wall in Alabama by artist Howard Finster was taken by Kathy Jacobs using ISO 200 Fuji Super G print film. The sun was bright, but the subject's colors are pastels and gray. While there are light tones, contrasting shadows are subordinate in the composition.

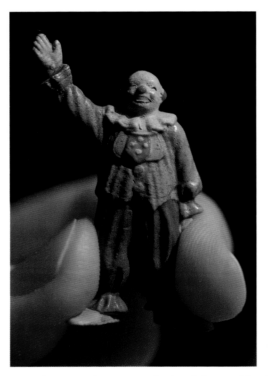

Ken Whitmore, a longtime professional photographer, likes the contrast and color fidelity of Kodachrome 200. "In sunlight on my patio I hung black fabric and draped it down over a table," he explains. "With my SLR on a tripod I held the figure in my left hand, which was supported on the table, and composed the shot in the finder using a 60mm macro lens." A similar effect could have been created using one electronic flash unit indoors with the same film, or with even a slower film, such as Kodachrome 64, since the one-one thousandth second of electronic flash would have been short enough to avoid any movement of Ken's hand. Using ISO 200 film, Ken could shoot at 1/250, fast enough to keep his hand sharp.

proper color comparison. Reds may come out more or less vivid than in the scene; blues may tend a bit toward greenish or purplish; yellows may lean toward orange; and green may not be bright enough, especially in foliage. Except in the case of portraits where true color reproduction, especially of skin tones, is critical, how much color fidelity is enough is a matter of personal taste. Others may like the color prints or slides that you find unsatisfactory.

Color slide films are identified by emulsion batch numbers on the paper box the film comes in. Ordinarily, color fidelity does not change perceptibly from one emulsion number to another, but keep an eye on batch numbers so you will know why color may seem slightly different from one roll to another. The closer a film gets to its expiration date, the warmer it may become. It helps to buy film in quantities, as many as twenty rolls at a time, to avoid surprises, and many pros test an unfamiliar emulsion number before doing any photography in which color fidelity is critical. (My experiences with Kodak Ektachrome Elite show enough uniformity between batches to avoid testing new batch numbers for close-ups.) Changes in light sources can also affect color fidelity, so if you shoot subjects with daylight slide film in artificial light, use a filter from the 80 series.

Color negative films are capable of excellent fidelity even when two stops overexposed, if prints are made

properly. (Careless printing may wipe out details in highlights.) However, one stop of underexposure can result in prints that lack some contrast, and several stops of underexposure can produce muddy-looking color. Such prints can't be fixed, but today's automated camera exposure greatly reduces the chances of exposure flaws. If you don't like the color in your prints, and you can see reasonable detail in negatives that are not excessively opaque or transparent, ask the processor to reprint the negatives. If reprinting doesn't correct your pictures, you might try another processor to see if color print quality improves. If there is still no improvement, it's probably exposure or lighting conditions that the film or the processor couldn't deal with. When you shoot color negative film in artificial light, or if you shoot unusual night lighting, you might notify the processor to avoid prints being automatically corrected to nullify the effects you want.

Color Saturation and Contrast

These terms describe the vividness of color in pictures. Lower saturation means that color is less intense than it seemed in reality, and highly saturated color may be realistic or slightly more intense than in the subject. Some color films are made to intensify color saturation because many photographers prefer chromatic drama. One such film is Fuji Velvia, a popular slide film, which is often too vivid to suit me. Other Fujichromes and many Kodak slide films have enough color saturation for me, but do try Velvia and see for yourself.

Precise exposure is more important in achieving color saturation in slide films than it is in print films. Slide films cannot be easily manipulated and after it's processed color correction requires sophisticated computer programs and skills. Overexposing slides is taboo because it tends to wash out color. However, slight underexposure, such as one-third to one-half stop, can sometimes improve color saturation. To test a slide film, in sunlight shoot at least five different exposures of a colorful subject, like flowers, without too many bright whites or dark shadows. Shoot at the meter reading, then one-half and one full stop over it, and one-half and one full stop under it, and compare the slides. You are likely to prefer the normal exposure or the shot that's one-half stop underexposed, but in most cases you'll dislike the overexposed shots. In any situation that is predominantly bright or dark, be prepared

The contrast in this shot is greater than usual because the background is black. Had there been direct sun on the boy, contrast would have been even greater and harder for the Ektachrome 100 slide film to handle. Soft light reflected from a bright wall opposite the youngster helped improve the picture. I used a 35-70mm lens on a hand-held Konica FT-1 (no longer made) and exposed at 1/60 and f8.

Kodachrome 64 provided good contrast and subtle color when I photographed the back panel of a junked Pepsi truck in Indiana. The owner of the junkyard wondered why I was taking this picture, and it wasn't easy to explain. But the composition looked like an abstract painting to me, and sun on one side accentuated the rough texture. I took my time with the camera on a tripod. There is a broad range of tonal values from the dark rusty spots to the areas of pale, blue-white paint. The film captures that range as well as the contrast between the reds and the blues. The side lighting accentuates the texture. Exposure was 1/30 at f22.

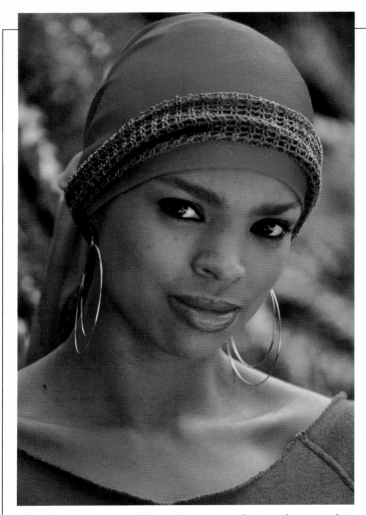

I found a fascinating old bowl while visiting a relative and placed it on a white table in open shade to record it close-up. My camera was on a tripod, and I put a 1A skylight filter over the 50mm macro lens to warm the color slightly. Because shady daylight has a higher Kelvin temperature than sunlight, it tends to be cooler. The filter corrects what might otherwise have been a faint bluish tint. I shot Kodak Ektachrome Elite 100 at 1/15 and f16.

A lovely portrait was made by a 3M company photographer using their Scotch ATG 400 film at 1/30 and f3.5. This film is fine grained with moderate color saturation and is good for portraits in natural light as well as for parties and sports at night. The portrait was taken with a 300mm lens from a tripod outdoors in bright shade. ISO 400 print and slide films have improved considerably in the last decade. Their color is brighter, and their grain is hardly noticeable even in a 8″ × 10″ enlargement such as this was.

At the Oregon Coast Aquarium, Newport, Oregon, the display tanks are illuminated with artificial light, but I took a chance on Kodak Elite 100 film with no filter. It doesn't matter that the images are slightly warm because the subject colors are warm, and the artificial light tends to enhance some warm colors. The spotted anemone's color is realistic; the plant actually resembles a weird floating strawberry. Using a 50mm macro, I shot this and other sea creatures from a tripod at relatively slow speeds, such as 1/8 at f16 and 1/4 at f11, because the light level was low. I took a number of slides and tossed out the blurred ones.

to bracket, which means making alternative exposures at one-third to one-half stop over and under the meter reading. When testing negative color films, skip the underexposures and shoot the normal exposure, then overexpose one-half stop and one full stop for best results.

There are two types of contrast, film and scene, that affect the color in your images. Film contrast is the measure of the film's ability to record tonal detail within highlights, shadows and middle tones in a scene. A high-contrast film usually shows less gradation within a color area, with lower shadow and highlight detail than a low-contrast film. Although a more contrasty film can help when a scene is flatly lighted—with little inherent contrast—a medium-contrast film is more often useful. Since we photograph far more average-contrast scenes and subjects than high-contrast or low-contrast ones, a medium-contrast film

usually offers a happy compromise. Fujichrome 100 and Kodak Elite 100 are examples of medium-contrast slide films that adapt well to close-up subjects. Among color negative films, I've found that Fuji and Kodak ISO 100 and 200 films offer excellent overall contrast.

Scene contrast describes a scene's brightness range from the darkest shadows to the brightest highlights. A high-contrast scene has a range of ten f-stops or more, while a low-contrast scene has a range below five f-stops. Neither slide nor print film can completely handle high or low extremes in scene contrast. In such a situation, you may have to choose an exposure where shadow detail may be minimal to accommodate detail in the highlights, which are often the important areas of faces and other light-colored subjects. In black-and-white photography the axiom is, "Expose for the shadows and develop for the highlights," but color film cannot be manipulated as easily as black and white.

Exposure latitude, the tolerance in a film's chemistry for under- and/or overexposure while still producing acceptable image quality under normal processing, varies with the type of film. Slide (positive) films have the least exposure latitude of the main film types, about plus or minus one-half stop, because colors and tones can't be easily manipulated after the film is processed. Color print and black-and-white nega-

tive films offer far more exposure latitude. Color negative film has a latitude of about one stop underexposure and two stops overexposure, which generally applies to black-and-white films as well. Slightly overexposed color negatives are often preferred for better prints, and black-and-white negatives can be matched to at least five contrast grades of paper.

Color Temperature

The color temperature of a film is the measure of how a film is manufactured to reproduce colors according to specific types of light. Color temperature is rated in Kelvin (K) numbers: daylight and electronic flash are rated about 5500K, and photographic floodlight bulbs are either 3200K or 3400K. Most slide and print films are color balanced for daylight, although there are several tungsten-balanced slide films—distinguished from the daylight versions by a T (tungsten) in the name—for floods or other artificial lighting. How different light sources affect color pictures is seen most clearly in slides and less often in prints, even when film is shot in artificial light.

Color prints can adapt to mixed daylight (or flash) and artificial lighting to a degree. During processing, the color is corrected, though the warm tint of room lights or floods may not be fully eliminated. Fujicolor Reala print film (ISO 100) offers very accurate color reproduction in

When Kathleen Jaeger visited Notre Dame Cathedral in Paris, her camera was loaded with Fuji Super G Plus 400 print film with which she shot a hand-held picture of votive candles. "I made several exposures," she explained, "because the stark black background and bright little flames offered an unusual exposure situation. Of course, color negative film does well with overexposure, and that was a break. I shot at about 1/30 with the 105mm lens almost wide open at f5.6."

Accompanying some relatives who took their children to see Santa Claus, I loaded my camera with Kodak Ektar 1000 print film that let me shoot at about 1/90 and f6.3 hand-held. The film, now called Royal Gold 1000, has been improved; it has finer grain and slightly higher contrast, making it excellent for available light situations. I couldn't get close enough with a 35-70mm lens to focus more tightly on the faces of my subjects to better capture their expressions, the preferred composition for this type of close-up, but the candid shot makes the most of the opportunity I had. I wanted to keep my distance so the child wouldn't be aware of being photographed. A zoom that goes to 105mm would have been better, but I didn't have one with me. Now a 28-105mm zoom is my most frequently used lens.

fluorescent lighting because of an added cyan-sensitive layer in its emulsion. Daylight slide films, which show color temperature variations easily, should be corrected while shooting, with conversion filters, such as 80A and 80B for indoor lighting situations. (See pages 54-55 and 63-64 for more on color correction.)

COLOR PRINT FILM SUGGESTIONS

New versions of familiar color films may be introduced at any time, but the latest revised films are closely related to previous versions. Read the evaluative articles and charts published by *Popular Photography* and *Petersen's Photographic* to keep up. Editors at these magazines continually test and use many kinds of film, and they have the judgment and facilities to make comparisons to save you time and headaches in the field.

Kodak and Fuji are the two best-known names in photographic films; you can find their products almost everywhere in the world. Many photographers use these brands in part because they can find consistently good film anywhere they need it. Konica, Agfa, Polaroid and 3M also make good products with more limited distribution in the United States. We'll look briefly at recreational, and then at professional print films, grouped by ISO ratings.

ISO 25 to 50 Print Films

Kodak makes Royal Gold 25, which has very fine grain for extreme enlargements. Kodak Ektar 25, Agfa Ultra 50 and Konica Impressa 50 are made for professional use. These films are popular because they promise the finest grain and/or the best color brilliance, but often cost more than standard films. Try one or more to see if they're worth the extra money.

ISO 100 Print Films

I'm most familiar with Kodak Gold Plus and Fuji Super G Plus, which offer fine grain, accurate colors and versatility. Kodak Royal Gold boasts very high sharpness for enlarged portraits. Fujicolor

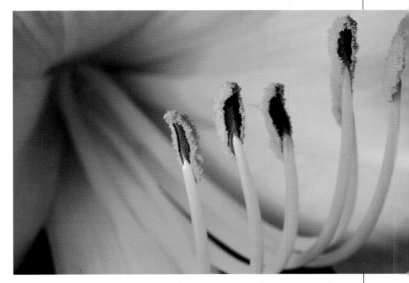

John Knaur of Olympus America shot a 1:1 flower close-up on Fuji-chrome 100 D using a 90mm macro lens and two extension tubes, a 14mm and a 25mm, which made the life-size image possible. The camera was an Olympus OM-4 fitted with an Olympus T323 Flash in the camera's hot shoe. There was a reflector to the left to soften shadows. Knaur uses a variety of his company's close-up equipment and several different slide films to maintain his familiarity with them.

On a tour of a whiskey distillery in British Columbia, I was attracted by a pile of multicolored palettes piled in a geometric design. Using a 35-70mm zoom on my Canon Elan camera, I shot several compositions and ran to catch up with the tour. In retrospect, I wish I had had the time to experiment further. The exposure in hazy sun was f8 at 1/250. The slide film was Kodak Ektachrome 100, which has now been replaced by a new version with slightly better color saturation and more neutral balance (no bluish tint!).

Reala also offers excellent grain and sharpness as well as accurate colors, and it adapts well to mixed light sources including fluorescents. Other admirable films in the 100 class are Kodak Royal Gold, Vericolor HC and Vericolor II. Pro films include Kodak Ektapress Plus, Agfa Optima 125, Fujicolor NPS 160, Ektacolor Gold 160 and Kodak Vericolor III.

ISO 200 Print Films

My experience is with Kodak Super Gold and Fuji Super G Plus, adaptable films well suited for many kinds of close-ups. Kodak Royal Gold 200 has been reviewed as a fine people film with sunlight and flash. Polaroid, Konica and Agfa also offer versatile films in this speed class. There's one pro film, Agfa Optima 200.

ISO 400 Print Films

I've used Kodak Gold Ultra and Fuji Super G Plus. The prints don't seem a bit grainy until enlarged bigger than 8″ × 10″, and I have no complaints about their color fidelity. Other top general-purpose films include Kodak Ultra 400, Fuji Super XG 400, Royal Gold 400, Agfacolor HDC 400, Konica Super XG 400 and Polaroid High Definition 400. Fujicolor 400 HG was designed for wedding and portrait photography, and its sharpness and grain have been described by reviewers as exceptional in this speed category. Kodak Pro 400 MC was also designed to please wedding photographers. Kodak Ektapress Plus 400 has exceptional latitude. You can rate it at ISO 100 to 1000 and get "good results," says Kodak.

COLOR SLIDE FILM SUGGESTIONS

You may find more significant variations in color rendition between films in the same and different ISO categories among slide films than print films. If you like a particular film, especially one of the lesser known brands, carry more rolls than you think you can possibly need when traveling. Having to order the film you prefer from distant sources can cause you to miss out on great moments or force you to take chances on the qualities of a film you're not as familiar with. Kodak and Fuji are always safe choices for shooting at and away from home since these films are so readily available.

ISO 25 to 64

Kodachrome, the original slide film, is still sold in ISO 25 and ISO 64. The film is fine grained with bright colors and, because of its unique chemistry, Kodachrome slides have a lifetime of at least fifty years before beginning to fade. Other slide films may have a lifetime of twenty-five to forty years. Slides made from negatives may have a shorter lifetime. While Kodachrome can produce beautiful pictures, few labs process this film. Kodalux, a Kodak service, has labs only in New Jersey, Texas, Georgia and Illinois. In addition, there are non-Kodak labs in Los Angeles and New York City. Inquire from your local photo shop about how long it takes for Kodachrome processing, as opposed to Ektachrome and Fujichrome processing (E-6), which is available in hundreds of cities and towns. There is also Kodachrome 40 Type A made especially for shooting without a filter using 3400K flood lights.

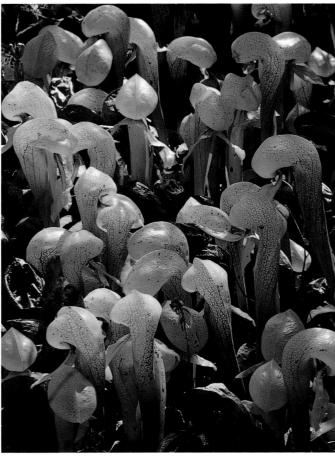

I was startled by the snake-head forms of these cobra lilies near Florence, Oregon. Insects are lured into openings under the cobra hood, where they are confused and trapped in a tube to be eventually digested and absorbed. I used a tripod to assure sharpness and to let me compose more precisely. A 28-105mm lens on my camera was focused closely. The exposure meter in my Canon Elan averaged the bright plants and dark spaces between them to give me an exposure of f16 at 1/30. The film was Ektachrome Elite 100, which I often use in bright sun because it offers fine grain and bright colors.

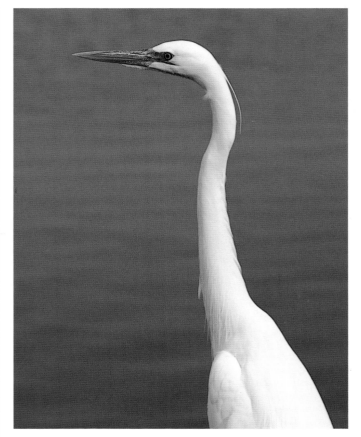

The great white heron, a spectacular bird, is plentiful in Florida, where I caught this one with an 80-200mm zoom on Kodachrome 64. I didn't have time to set up a tripod, so I shot at 1/250 to avoid camera shake. I now prefer 100 and 200 ISO films to get faster shutter speeds for hand-held shots. I have also used Ektachrome Elite 400 with pleasure on cloudy days.

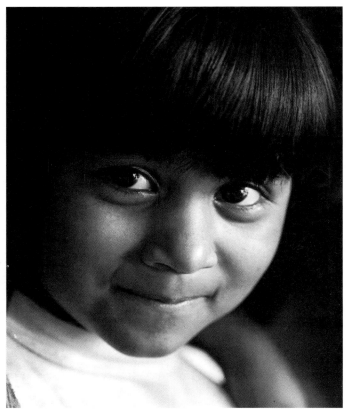

Ron Contarsy won an Eastman Kodak award for this beguiling portrait of a boy taken by daylight coming through a nearby window on Kodak Plus-X black-and-white film (ISO 125). Plus-X has been a popular black-and-white film for decades because of its good contrast and fine grain. Note the good tonality in the highlights—even the boy's shirt is not bleached out—and the blacks are strong. Black-and-white films have even more latitude than color print films, which means they handle contrast extremes well.

All other popular slide films are designated E-6 types, meaning they are processed in E-6 chemistry. In this slow category are Kodak Elite 50 for the general market, and the rest are pro films. Most of these are aged at the factory to the optimum color quality, which must be maintained by storing the film in the refrigerator. (Standard, popular films are designed to survive long-term storage in far from ideal conditions.) Many photographers swear by Fuji Velvia; its greens are terrific, but its warm colors are exceedingly vivid and occasionally seem unreal to me. Ektachrome 64 and 64X (slightly warm balance) are excellent slow-speed films.

ISO 100, 200 and 400

Kodak and Fuji E-6 films in this medium-speed category are popular with photographers because they reproduce well in magazines and books. For general use from Kodak are Ektachrome Elite 100 and 200, and from Fuji, Sensia 100 and 200. Many pros use Ektachrome 100, 100 Plus and 100X (slightly warm balance) and Ektachrome 200, and Lumiere 100 and 100X (slightly warm balance). Lumiere is the pro version of Elite. Lumiere X is slightly warmer than Elite, but for warmer images in fashion now, simply add a 1A or 1B filter over your lens to achieve a similar effect. The 1A is the familiar skylight filter; 1B is a harder-to-find, paler version that I leave over the lens for protection from scratches and occasional rain. Ektachrome Elite 100 and 200 are my current choices, but make your own tests to help distinguish Ektachrome differences.

Fuji offers pro films Fujichrome 100D, a favorite for its good color saturation and grain, and Provia 100, appreciated for its bold colors and very fine grain. Sensia 100 and 200 are recreational versions of Provia.

Kodak, Fuji, Agfa and Scotch all offer slide films rated at ISO 400, 1000 and 1600. I've enjoyed doing close-ups occasionally with Ektachrome Elite 400, but I avoid faster slide films for close-ups because of their graininess. However, when you wish to shoot close-ups in low light without flash or tripod, an ISO 400- or 1000-speed film can be a lifesaver.

For photography with tungsten floodlights, or other situations with appropriate artificial light, try Kodachrome 40 type A, Kodak Ektachrome 64T, 160T or 320T or Fujichrome 64T, all color balanced for artificial light; no conversion filters are needed.

BLACK-AND-WHITE FILMS

There are fewer black-and-white films, most of which are made by Kodak, Fuji and Ilford, than color films. (You'll probably find black-and-white films only at well-equipped camera shops.) Kodak's T-Max films are popular, but other companies make equivalent films. Black-and-white photography is a very different discipline from color work, so devote some time to learning the special shooting and darkroom techniques. Exposure manipulation combined with matching developing times are practiced by black-and-white enthusiasts in their own labs or using custom labs. Thus black-and-white negatives can be printed on various paper contrasts, or with variable contrast filters, for pictorial controls. Similar controls are available in color printing, but they are trickier and the paper and chemistry are more expensive.

Black-and-white photography is a more personal medium than color. The average photographer is often happy to have color films processed by a lab to avoid the painstaking, time-consuming work. But black-and-white shooters tend to take pride in developing their own film, manipulating exposure and development to suit their pictorial needs. To many it's important to make one's own prints because that's where the true artistic challenge lies. Fortunately, black-and-white film

The pattern formed by these buoys at the harbor in San Pedro, California, was an irresistible subject. Using Kodak Plus-X (ISO 125) and a 28-80mm zoom lens on my camera, I shot three or four variations, all dramatized by backlighting. Exposure was 1/125 and f16. I have developed and printed my own black-and-white pictures since I started in photography. Printing is exacting and sometimes tedious, but the creative feeling is worth it.

Dilly was a young trained chimp hired (including its trainer) by author Jon Madian and me to illustrate a children's book we had written. I shot a number of close-ups of the chimp alone and with two children who portrayed characters in our book. I used Kodak Tri-X film (ISO 400), which has been a photographer's favorite for decades because it handles many types of contrast well. We were shooting in bright shade, and the film gave us good detail and tonality. The lens was a 35-70mm zoom. Unfortunately, we never sold the book.

has more latitude than color film, which means that interpreting a subject while printing can be quite creative—or frustrating if negatives are too far over- or underexposed.

Both black-and-white and color can be aesthetically challenging, but each requires a different type of seeing. Black-and-white photography takes more imagination to envision the effect of a subject rendered in many tones of gray, plus white and black. I often squint my eyes to reduce a subject to fewer tones, which allows me to better evaluate a potential picture. Careful lighting is important in black and white photography because tonality is all you have to separate and show forms clearly.

Close-ups can be as rewarding to shoot in black-and-white as color. However, you will have far fewer sales of black-and-white nature and wildlife close-up pictures than you'll have in color. Black-and-white is more often reserved for fine art photographs, including close-ups of people. For one reason, black-and-white prints properly processed will last one hundred-plus years. Whether you prefer black-and-white or color films, choose a brand or two, become familiar with the ones you like, and enjoy.

In this picture, different forms and colors blend to be become a coherent composition, called a
"visual mixture." Reds and related colors dominate, while whites and yellows are important sub-
ordinate elements of the design. Your eyes follow the broken line of reds from left to right diago-
nally across the image because red is the strongest and darkest color. I shot these snapdragons in
Buchart Gardens, Victoria, British Columbia, on Kodachrome 64, using a 28-80mm lens.

Close-Up Composition

YOU CAN MAKE GREAT COMPOSITIONS

No matter how close or far the camera is from a subject, good composition is an important key to taking pictures with visual impact. Close-up composition requires special awareness about arranging pictures in the finder because you are so close. Concentrate on the details to assure an effective composition. While creating a close-up, helpful camera movements may be in inches or fractions of an inch. The colors and patterns of the piece of petrified wood shown in the photos on this page offered many possible compositions. As you can see, viewing the subject from several distances and carefully observing detail resulted in three different, effective compositions.

Keep in mind that composition is the way we see. The success of your prints and slides depends on *what* you frame and then how carefully and aesthetically you arrange what you see in the frame. Composing a picture entails finding the strongest or most prominent features of the subject, and making them dominant, and at the same time positioning the camera so other elements of the subject will harmonize with the main one(s). This means being as precise as possible viewing through the finder so the angle and distance at which you shoot are the best. "Best" might also be ex-

This is a vertical view of the approximate center of this rare circular slice from an ancient log taken from about eighteen inches away. The ancient grain pattern seemed to approximate a sunburst. The white streak dominates this design, with the red and ochre-colored areas strongly subordinate, and pulls the eye into the pattern. I made one other vertical composition, but this was more graphic because I was closer to the subject.

I was looking for several compositions in one subject for a series of images when I spotted this amazingly colorful piece of petrified wood during a gem and mineral show held in Quartzsite, Arizona, every January and February. The suitability of colors and pattern for close-up work attracted me to this subject, and I first made a composition from about thirty inches away from the yard-wide piece. All three compositions of the petrified wood on this page were taken with Fujichrome Sensia 100, using the same 50mm macro lens and an exposure of 1/125 between f8 and f11.

Here is another view of the beautiful subject, which I took from the center portion of the overall shot from the opposite side. I chose this view from about fifteen inches away for its strong rhythmic design. I wish I had taken time to find at least another shot closer than any of these because the possibilities are there for a further dramatic view. I don't think a closer picture would have been better than these, but I should have taken advantage of the opportunity. Try your own series of close-ups from a single subject. Find a series of small objects, such as hardware hanging in a store or any varying pattern that offers close-up details. Shooting variations on a theme encourages you to explore a subject more thoroughly and to exercise your visual imagination.

plained as "most appealing" or "most stimulating." Think of composition as your personal way of making what you see look as attractive as you can on film. Call upon your instincts for design: the talent you'd use to arrange the decor of a room, or plan and set up a workshop that looks good and is practical.

A natural aptitude for design and an eye for color help, but finding and composing attractive close-up shots can be learned by shooting lots of pictures and analyzing how to improve your images. Something as simple as discovering that if you position a chipmunk slightly farther into or away from the center of the finder may result in a more active, interesting photo can take your photography a step ahead. (You can also study the basics of composition and design in classes or books.) When a subject is still and the light is right, analyze whatever you are photographing and maneuver the camera meticulously. However, when the subject is in action, such as a bear cub in a tree, taking numerous pictures as carefully composed as possible should result in finding one or more good compositions among many.

Thoughtfully observe the work of photographers, painters and other artists that you admire in museums, galleries, books and magazines. The more images you study, the more sensitive you will become toward the role of composition when you're

shooting. Decide why some pictures appeal to you, while others do not. Discuss composition with photographer friends, but don't let your conversations bog down into what's "right" and what's "wrong," because these are often subjective decisions. Through study and dialog you will develop personal pictorial tastes that evolve from aesthetic concepts that are part of you.

When you find a subject worth shooting, make a tentative composition in your mind, usually to suit the format of the film, a process Ansel Adams called *previsualization*. Or as a less effective alternative, simply adjust the camera up and down, back and forth, until you see a composition you like—which may not happen at all. Visualizing the subject as it would appear in the finder helps you make smart design decisions in your camera maneuvers. Such decisions include adjusting the camera-to-subject distance, moving the camera to simplify the background, and rearranging the subject—if possible—to create a more pleasing composition.

You may have heard about "rules" of composition for photography or other pictorial art. I don't like the word "rules" in connection with creativity because rules infer being rigid. You should be able to successfully break so-called rules to suit your unique, artistic vision, which may change over time. I prefer the word *guidelines*,

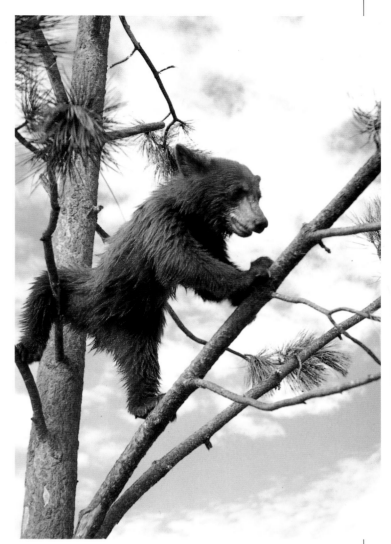

Close-ups of animals or people in action are tricky. If the subject moves just a few inches, it can move partly out of your viewfinder. To be sure you get worthwhile shots of moving subjects, take numerous pictures. You can get quality out of quantity. I used a 28-105mm zoom to catch a bear cub at Bear Country, an animal farm near Rapid City, South Dakota, and shot at 1/300 at f8 on Ektachrome Elite 100 film.

which infers flexibility to fit various pictorial approaches. A rule, for example, may be, "Never place the most important part of a subject in the center of the picture." The corresponding guideline would be, "Placing an important part of a subject in the center of a picture may result in a more static composition,

but try it to see how you like it; then shoot an off-center variation for comparison." Sometimes a centered main subject calls attention to itself in a harmonious way, and comes off more dramatically. It pays to stay flexible in composition, and at the same time, adhere to visual disciplines that *feel* right.

VISUAL ELEMENTS OF COMPOSITION

When you frame a subject in the camera finder, decide where the main component of the image should go in relation to its surroundings. When the main subject is the largest, or most brightly colored, or closest to the camera, or most animated, it's not difficult to decide it will be the most important element. As you decide how close you want to be to the subject(s), such as a puppy, you have to be aware of its surroundings and avoid things such as someone's hand that is large and annoyingly prominent. Closeness to a subject also depends on how much of it you want to feature, such as one flower or a group of them. Also determine if the subject seems more strongly horizontal or vertical in orientation. In my photographs of the cactus flower on page 79, showing the base of the plant calls for a vertical format, while a closer shot of the flower itself is naturally horizontal. Try to visualize subjects both ways when their shapes are adaptable. (All the design and pictorial elements discussed in this chapter, except color, apply equally to black-and-white and color photos.)

Awareness of the visual elements of composition—lines and shapes, textures and color tones and space—helps you make design decisions more effectively. You arrange these elements through the camera finder to make pictures that capture

Random patterns are a challenge to creativity because you must push your imagination to find the best designs. These red stones in a box at the gem and mineral show in Quartzite, Arizona, seemed a jumble at first. Then I began to see a pattern, a cluster of forms and irregular lines. I visualized this arrangement and its horizontal orientation carefully in my mind and then in the camera finder. I was about twelve inches from the stones and used a 50mm macro lens to shoot at 1/250 and f11 on Fujichrome Sensia 100 slide film.

Another image of the same red stones, lighted by the sun coming from the right corner of the shot. Shadows in this, and in the horizontal image, contribute to their pleasing designs. I did not brighten the shadows with flash or a reflector because I wanted a contrasty look. The camera was closer than in the horizontal picture, between eight and ten inches away. Compare the two shots and you'll see that fewer stones are included here. Shadows define the forms, which are arranged in mainly diagonal irregular lines. The exposure was 1/250 at f11 on Fujichrome Sensia 100 film.

A young palm tree in my backyard made an attractive subject because it had an interesting variety of lines and shapes. The contrast between the thin white lines and the darker palm fronds (shapes) makes the image interesting. A situation like this can seem a jumble until you focus on one segment at a time to find an orderly design and a harmonious background. The exposure was 1/125 at f11 on Kodachrome 64 film.

and also interpret what you saw. Think of the role played by visual elements such as the *lines* created by the fronds of a palm, the *shapes* of stones, the *texture* of a woven rug, the *color* of a flower, and the *tones* and *space* in a stack of dishes in creating effective compositions.

Line, Shape and Texture

Most subjects are made up of lines and shapes. These elements not only define what we see but can also determine where and how we look at subjects. In each of the photographs of red pebbles shown at left, there is a cluster of forms, all of which are arranged in irregular lines. Squint your eyes and look at each photo; certain lines of stones appear among the irregular jumbles. To simplify the composition, I eliminated the background—the box they were in—by focusing seven or eight inches from the stones in it. (When you can't eliminate the background without ruining the rest of your composition, throw the background out of focus by using a large lens aperture.) I framed the arrangement of red pebbles both horizontally and vertically, and believe that each composition has its merits. I wanted the viewer's eye to move from bottom left to top right in the horizontal and from top left to bottom right in the vertical. Is that how you look at these pictures?

In the photo of palm fronds above, the strong tapering outlines are the dominant elements in the composition. Note there are more fronds on the left side of the front fan shape than on the right. The lines of the back fronds do not exactly mirror those in front. If the palm fronds in front and back had been lined up the same way and were the same size, the design would have been monotonous. A variety of shapes and lines creates a visual change of pace, which is more effective than a repetitious arrangement (except for pattern shots in which repetition is expected).

Texture

This sort of visual decoration is worth looking for. Objects with distinctive *surface* textures, such as a roughly woven rug with a prominent

I enjoyed photographing textured patterns of roughly woven carpets displayed at a street fair. It took a few minutes to isolate a section worth photographing because the jumble of ornamental designs was confusing. I used a 28-80mm lens and + 1 diopter to shoot about eight inches from the subject. The film is Kodachrome 200, which facilitates sharp hand-held exposures such as this one of 1/350 at f11 in bright sun.

texture and a colorful pattern, are good close-up subjects, because the camera up close captures detail the casual glance misses. Notice how, when the sun is low, surface texture is accentuated, as in the bark of trees or furrows in sand. There is also *subject* texture, such as a mass of golden flowers whose individual shapes blend into their intertwined group. The variation in shape and color within the group adds interest to the subject.

Color, Tone and Space

Color is a strong, defining quality of what we photo-graph and is a key element of composition. Color can be a fascinating influence in photographs, so it helps to be aware of how color affects viewers. Red, orange and yellow, *advancing* colors, quickly attract the eye. Blue, brown and other cool colors are *retreating* colors, which means they are seen after the warm, bright colors. Pastels, paler tints of bright colors, are usually seen before the retreating colors and after the advancing colors. When setting up photos, or when you shoot very close details of objects, it's wise to choose things with both warm and cool colors for greater viewer interest. When you photo-graph in color situations you cannot control—a fact of life for those shooting close-ups outdoors—you might include something colorful as part of a composition. Perhaps you can move an autumn leaf to a spot where its brilliant color contrasts with cool green grass or dark water. You can also affect the quality of color by using direct bright light (color is more vivid) instead of softer shade or reflected light (color is more subdued).

Tone

This word represents a tint or shade of color, described as light, medium or dark toned. We see and work with color tonality in photography almost unconsciously. The hue—or property of color from which it gets its name in the spectrum—is what we identify first. Tonality modifies color so that a dark red, for instance, becomes subdued, and a bright yellow tone is equal to white in attracting the eye. Color tones create pictorial contrast, which often shows off a subject best.

The varied shades of gray in black-and-white pictures serve a purpose similar to the various color tones in color photos. Contrasts of tones in

black and white serve to define shapes, lines and textures, and help create mood. When a black-and-white picture has beautiful gradations of gray plus bright white with discernible detail in it, and dark grays that blend into pure black, we see shapes and lines well and we are likely to admire the beautiful tonal scale.

Space
The feeling of space in close-ups is often minimal because so small an area is included in the picture. Perspective in a photo usually provides a sense of separation between the foreground and background; perspective is limited in a close-up because there is separation without much space. If a subject has geometric lines that recede into the background, a spatial sense, also called a feeling of perspective, is created and may add drama to the photo. Be aware of how the eye will go from foreground to background objects, and take care that they overlap without confusion of shapes. Smaller objects in front and larger ones behind enable us to see both clearly. Wide-angle lenses tend to exaggerate perspective, making subjects and objects within the frame seem farther away from one another than they actually are. But using a wide-angle lens isn't a good solution to the problem of shallow perspective. Some wide-angle focal lengths may also distort or enlarge foreground subjects.

DESIGN ELEMENTS OF COMPOSITION
Design elements of composition are guiding principles for using the pictorial elements of composition (described above) in creative ways. Apply these elements to taking your own photos and use them to determine how satisfied you are with the results. Over time, good composition becomes more automatic, and you can begin to interpret composition in personal ways to suit your own aesthetic taste.

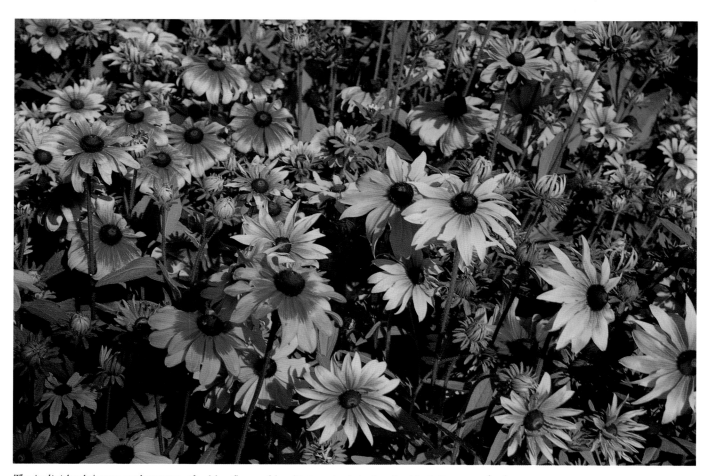

The individual shapes and textures of golden flowers blend into a single textural subject. Once you find a mass of flowers you feel are worth shooting, take your time making a close-up composition with impact. Here I looked for a pattern of larger flowers in clumps, a number of which dominate the image. Try to find a variety of sizes and arrange them in the finder so some are dominant and some subordinate. Exposure was 1/125 at f11 on Kodachrome 64 film.

A retired locomotive was a wonderful close-up subject, and black-and-white film suited the situation well. In fact, black and white can do a superior job with such aging metal monotone forms. The range of tones from deep black to pure white sets off the forms clearly and dramatically. (Even in color, this would have come out black and white.) I shot on an overcast day with a 4× 5 view camera using Kodak Tri-X film rated at ISO 320, which helps counter slow shutter speeds at small apertures. Exposure was one-tenth second at f45, the sky was bright clouds and, of course, I used a tripod because the view camera has no finder when loaded with film.

Steve Kelly of Eastman Kodak Co. chose plastic plates and a cup in three strong colors, plus one white plate and a paintbrush with a touch of blue paint, to demonstrate the vividness of Kodachrome film. The background was darkened to better display the dynamic colors of the plates. The composition was carefully crafted to keep your eye moving through it. You see the yellow and white plates first, followed by the red and green. This still life was lighted by electronic flash and was shot with a view camera, which is often used by studio photographers. Courtesy © Eastman Kodak Company.

Kathleen Jaeger's own legs became the foreground of an image that makes good use of space and distance in her Ektachrome slide. The playful shot, taken with a 28mm lens, demonstrates that a wide-angle lens does not always distort foreground subjects. In fact, its exaggerated perspective is an asset here. Kathleen focused on her legs so the background is out of focus, and shot at 1/250 at f8.

Eye Flow

Eye flow refers to the path a viewer's vision is likely to follow when looking at a picture. The eye may start at any edge and then travel to the center of interest—the most compelling or outstanding element of the image. Your vision may then flow from the center of interest toward other parts of the image in a curved, angled or straight path. There is no single formula for successful eye flow, but the paths our eyes take influence the impact of a composition. We are not usually conscious of eye flow as we take pictures, but it plays an important role in editing images. When you evaluate your pictures, notice how your vision flows over and through the compositions and determine if you have achieved the effect you want. Store your impressions to call upon when you are shooting.

The Dominant Element

The largest, brightest, most colorful or most favorably placed object or shape—or group of objects or shapes—is the dominant element in a composition. It is also the center of interest. In a portrait the eyes are often the dominant element. A nature close-up may be dominated by a single flower or group of flowers (shared dominance). For example, even if one rose of three in a vase is larger than the others, all three are still seen as a group that shares a dominant, central position. Close-ups are often composed tightly with fewer objects detailed because the closer you get to a subject, the less you can include.

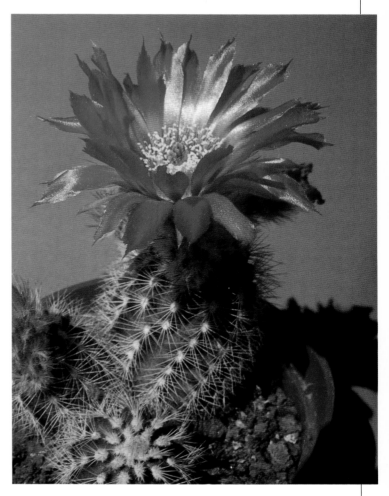

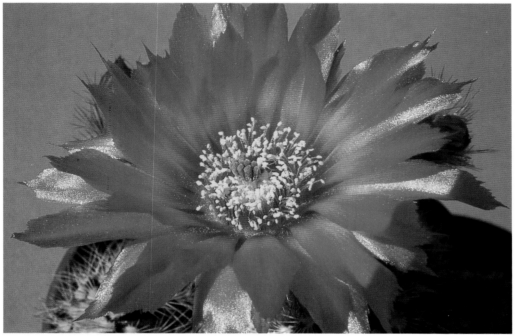

These two images of a small cactus illustrate how changes in composition can affect eye flow. The plant is about eight inches tall. In the vertical shot, you look first at the beautiful flower, then your eye is drawn to its prickly base with its contrasting textures. In the horizontal shot, eye flow starts in the flower's yellow center and moves out, probably in a circular fashion. Having the bright yellow spot in the center of the image isn't a handicap because the irregular shapes of the flowers and the variations in color move the eye around the image. Both photos were taken in sunlight on Ektachrome Elite 100 film with a 50mm macro lens on a tripod-mounted camera. The lens was twelve inches from the flower in the vertical, and about seven inches from it in the horizontal.

The Subordinate Elements

Supporting the dominant element are the remaining, or subordinate, elements of a composition. These may be shapes, lines, colors or textures. In some situations subordinate elements have nearly equal importance within the picture's frame, but their visual priority is less than that of the dominant element. In others they are definitely secondary because of their size, shape, color or position, or a combination of those factors. In a portrait, the rest of the model's face frames the eyes, the center of interest. In a close-up shot of a vase of roses, the stems, vase and background play supporting visual roles to the flowers. There are countless variations of effective subordinate elements in composition, depending on the subject matter, the lighting and your personal interpretation of what you see.

A good composition helps tell your story and show off your subjects dramatically, or clearly, or interestingly, or all three. Many elements work together in a good composition. Study the relationships and arrangements of subjects in your own pictures. Is there a center of interest? Do dominant and subordinate elements compete or harmonize? Does eye flow help make the picture interesting? Avoid compositions where objects of almost equal size are almost equidistant from each other. Such a picture can easily be static or boring.

The first place you usually look in a portrait is at the subject's eyes. With women it's often effective to have the hair frame the face, which is then seen as a single entity. This shot was taken with a 35-70mm zoom lens on Kodachrome 64 in late afternoon sun, which is warmer light than at midday. I didn't need a reflector because the deck of the swimming pool reflected some light into the model's face. Exposure was 1/125 at f8.

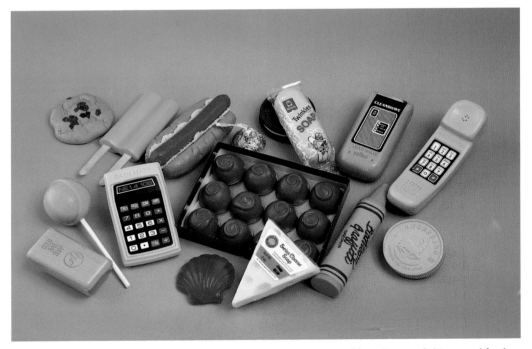

I took this shot for a magazine article about a shop that sold soap resembling dozens of objects and foods, such as the calculator, radio, cheese and hot-dog shapes shown here. The box of bonbon-shaped soap is dominantly centered, but the rest of the soaps are placed at varying positions and angles to avoid a static composition. The Swiss cheese soap covers part of the bonbon box to reduce its dominance. The picture was taken by floodlights, GE 3400K reflector bulbs in sockets mounted on clamps. I used Type A Kodachrome film, which is balanced to match standard 3400K floodlights. The lens was a 35-70mm zoom and I used a tripod for a 1/8 exposure at f11.

Simplicity

Pictures with strong, simple compositions become memorable images that can be read quickly like posters. In other words, less is more. The opposite of simplicity is confusion, when conflicting elements in an image are arranged in a haphazard way. It's all too easy to photograph an attractive subject and later discover your pictures are not well organized, or that the background or something else is distracting. As you previsualize a shot through the camera finder, reduce the subject to as simple an arrangement as possible. As a simplicity theme song, remember, "Accentuate the positive, eliminate the negative." In close-up photography, this translates as: Accentuate the dominant and its subordinates, and eliminate or avoid all nonessential pictorial elements. Simplicity is achieved by altering the camera angle, the distance from the subject, the focus or the lighting.

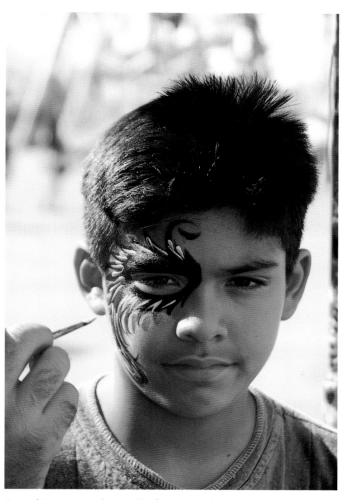

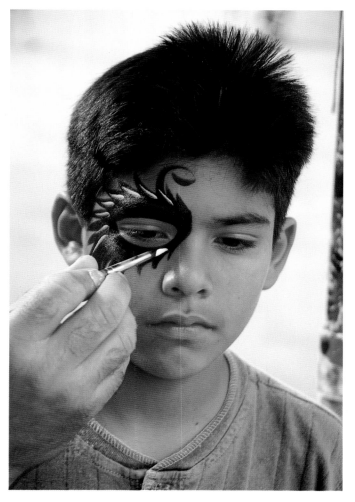

I saw this youngster having his face painted with a decorative pattern at a county fair. Although I kept the objects in the background soft-focus, they're still a distraction in the photo shown above. The patches of sunlight falling on one side of the boy's face and hair also pull the viewer's eye away from the center of interest. I shifted the camera to find a plain background and asked the young man and the painter to move a few inches into the shade. The result was an image that is simpler and reads faster, as you can see in the picture at left. Both pictures were taken with a 28-105mm zoom lens on Ektachrome Elite 100. The first shot including the sunny area was exposed at 1/125 and f6.3. The second in the shade was also taken at f6.3, but at 1/60, and I was a few inches closer.

Balance

There are two forms of balance in composition, symmetry and asymmetry. A perfectly symmetrical picture has components placed equally on both sides of an implied center line. (A friend calls this the "dead center syndrome.") Such a composition may be static compared with a more dynamic arrangement with more important subject matter above center than below, or not equally divided on both sides of the center. In general, inequality of size, position, color or contrast—asymmetrical balance—produces a more pleasing photograph than one where everything has equal visual weight. A well-balanced close-up may include different sizes, such as a collection of small seashells positioned to balance a single large seashell that dominates the composition.

Photographers for years have relied on a guideline called "The Rule of Thirds" for achieving pleasing balance. Imagine a frame of film divided by two vertical lines and two horizontal lines into equal thirds. Position subjects where the lines intersect to create visual interest. This device evolved from the "Golden Mean" of Classical Art, namely the ratio between a whole and its parts that seem most pleasing to our aesthetic sense. The Golden Mean is achieved by dividing a line (or area) so the smaller part approximates one-third and the larger part two-thirds of the total area.

The arrangement of objects in the still life shown at top, with equal spacing between the components, is static and tends to be boring. Just rearranging the three objects makes the composition more interesting, as shown in the shot shown above. Unequal spacing creates a more pleasing pictorial balance. The principle that favors inequality applies to almost every close-up composition. Both pictures were shot with floodlights in an improvised studio at home using Ektachrome Elite 100 and an 81A filter to match the 3200K artificial light to daylight film.

Contrasts in tone and color add to the pictorial impact of a collection of small cactus, and a black background augments the drama. Notice how the colors and textures offer pictorial change of pace that makes the shot more appealing. The strong contrast could have been softened with a flash or a reflector to brighten the shadows, but this approach has more punch. I hand-held a 35mm camera with a 28-80 lens about fifteen inches from the plants, and shot at 1/125 and f11 on Ektachrome Elite 100 film.

I found this collection of coffee mugs displayed on a blanket at the edge of a canal in Bruges, Belgium. To me the mood of the picture is melancholy due to the grayed light, the subdued colors and the discarded look of the cups. The cup pattern arranged in ragged lines appealed to me as a symbol of how we cast off souvenirs that once seemed important. The film was Kodachrome 64 and the exposure was 1/60 at f8.

PICTORIAL ELEMENTS OF COMPOSITION

Photography techniques can be so absorbing that you don't notice everything in the viewfinder. Especially in close-up work, until you stop down the lens, only a small portion of many images are sharply focused. Therefore, visual and design elements of composition help you be more aware of the whole image area and its other pictorial elements. Decisions about mood, tonality and backgrounds are as subjective as color, eye flow and simplicity. Successfully blending the visual, design and pictorial elements of composition requires personal judgment developed through experience.

Experience is the best teacher for shooting good close-ups consistently. Making mistakes is valuable because you'll learn from them. Get out and take pictures and solve photographic problems because that's where the fun is. Study everything you see in the viewfinder so you are as conscious of the pictorial elements as you are of color, dominance, balance and all the other elements of composition.

Contrast

Contrast is essential in most good pictures; without it, images would be bland and monotonous. It is sometimes stark, sometimes subtle. Contrast distinguishes between shapes, accentuates texture, and creates mood. There can be contrasts of size, color and tonality, such as a light area contrasting with a dark one, or a large object with a small one. In black-and-white photographs, tonal contrast emphasizes form within the image and makes subjects stand out against their surroundings. Colors on opposite sides of the spectrum, such as red and green, contrast when adjacent to each other. Contrast in each of those categories can help emphasize the center of interest in a photo, and varying contrasts help move the eye through an image.

Bright and dark tonality as well as contrasting colors catch the eye in color photographs. Color jazzes up even less interesting subjects. On the other hand, it is worth developing an appreciation for bright or quiet pastel colors or winning combinations of pastels and more intense colors. The soft blue of a robin's egg would contrast well with the blossoms of a pink carnation. A close-up of the face of a pale tan dog would contrast well with a dark green or bright rust background. A medium-gray

background would not provide enough contrast, and the photo would look flat.

Mood

Mood is the emotion created by a photograph; it may make you happy, sad, peaceful or fearful. Mood is often created by the direction and type of lighting and, with human and animal subjects, their actions or expressions. A close-up of a woman's pensive face may seem melancholy, while a close-up of a playful chipmunk may create a cheerful mood. Mood comes mainly from color and lighting in other kinds of close-up photos. Bright colors and lighting create a positive mood; a close-up of a beautiful butterfly or a flower on a sunny day conveys a bright, cheerful mood. Dark colors and lots of shadows create a doleful mood. The shot of a display of coffee mugs for sale on a sidewalk in Bruges, Belgium, shown on page 83 is somewhat somber because of the subdued colors and flat lighting. Think of a huge close-up of a sea turtle photographed under blue water, its soulful expression making it seem thoughtful.

Backgrounds

Although the background is not the main element of most pictures, a clutter-free background helps make a photograph simple and graphic—and often award-winning. The trick is to compose the main subject(s) and remain conscious of the background at the same time. It's easy to

Close-up portraits may be taken to gratify the subjects when lighting and expressions are pleasing, or they may become fascinating documentary images. Lydia Clarke Heston often hires guides in foreign countries to help her understand peoples' customs and the places they live and work. In Bangladesh where her husband, Charlton Heston, was working in a documentary film sponsored by a world charity, Lydia was taken to Daeope village where these women had been flailing rice. Flash on the camera was the only expedient light in a relatively dark spot, but she was able to retain some of the mood of the location through the expressions and poses of the women. The camera was a Canon A2E and the film was Fujichrome 100. Lydia used a 135mm lens and this appealing photo was cropped from a horizontal print.

get caught up in what interests you most and forget about the potential distractions behind or beside it. When necessary use an aperture large enough to make the background an out-of-focus blur. The longer the lens focal length, the easier this becomes. Try a +1, +2 or +3 diopter on a zoom lens set between 80mm and 105mm, for instance, for useful background control.

CAMERA ANGLES, FORMAT AND CROPPING

Start to develop an awareness of camera angles and the format of your images. Learn how to position your camera in different ways to alter your perspective on successful images. Change the camera viewpoint frequently to improve composition.

Camera Angles

Many photographers shoot from obvious angles because it's easiest. Sometimes the straight-on, eye-level, frontal view is right. But in arranging an effective composition, look at the subject from several angles until you find one

with visual impact. Sometimes the direction of the light dictates how you angle your camera. For instance, flowers in full sun are usually most photogenic when sidelighted at a 45-degree angle. Backlighted flowers may be dramatic, but you need flash fill or a reflector when shooting outdoors to achieve detail in the shadow areas. Deciding on a camera angle also means choosing a background that's not distracting. If you can comfortably or safely do so, lie on the ground or stand on a rock to capture delicate foliage and other pleasures of nature. In some locations you must be energetic and agile.

I was fascinated by the color of a loaf of green bread my daughter-in-law baked for St. Patrick's Day and decided to use it for a still life. I combined the bread with a rose and a decorative tray on a sheet of colored board as a background. When I pointed the camera down toward the setup, the bread became an unidentifiable lump beneath the rose.

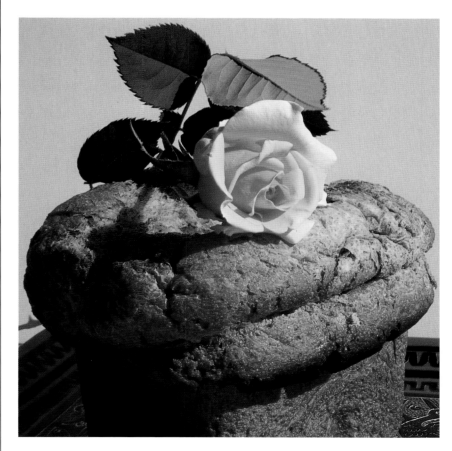

When I lowered the level of my camera (on a tripod) with its 28-80mm lens and a + 1 diopter (to focus down to about fourteen inches with this lens), I made a more appealing composition. At this lower angle, the bread and rose are now both recognizable against the plain background. Both pictures were taken on Ektachrome Elite 100 slide film in sunlight at f16 and 1/60.

Format

There's a natural tendency to hold a 35mm camera horizontally and, therefore, to make horizontal compositions. So, you have to condition yourself to think vertically when a subject lends itself to that format. A still life of jewelry arrayed on a pleasant background will likely be horizontal, while a shot of a bunch of grapes may call for a vertical format. A flower with petals displayed beautifully is going to be horizontal, but if you want to show the same flower with its stem and green leaves, the shot will be vertical. As an exercise, frame and shoot some close-up subjects that lend themselves to framing both ways and decide which is better when they are developed. Some subjects can be equally appealing horizontally or vertically. When shooting the weathered end of a redwood log in Northern California, I shifted the camera in both directions using the 90mm setting of a close-focusing 28-105mm zoom lens on a tripod. I like both versions shown below. Your experiments may prove equally interesting.

The dried end of a redwood log forms a neat abstract pattern in both vertical and horizontal formats. Try to view close-up subjects in each direction, and shoot both; then you can choose the format you prefer later. These were taken at 1/30 and f11 with my camera on a tripod on a bright cloudy day, using a 28-105mm zoom lens and Kodak Ektachrome Elite 200 film. For each view I was about fourteen to fifteen inches away from the bark.

Cropping

It's not smart to shoot carelessly, knowing you can crop later to get rid of extraneous stuff. But, even if you take care, you may still need to crop. Get in the habit of framing as closely as possible. Most 35mm SLR camera viewfinders show only 92 to 95 percent of the subject to prevent picture edges from being hidden under the edges of a slide mount. The edges of negatives are usually cropped during mechanical processing. Finished slides can be cropped using special thin tape along any or all of the edges. Adjust the tape precisely until you like the effect. Prints can be cropped using L-shaped pieces of white or black lightweight illustration board, adjusting their positions until what's left is a better picture than when you began. To guide whoever enlarges the picture, mark the new cropping with a red china marker that writes on glossy surfaces. Keep in mind that cropping in the camera is the best policy. In the case of portraits, it is essential that slides be carefully framed so no cropping is necessary, though prints can be cropped to improve them during processing.

The 3M Company gave me a color print of a man at his workbench to show off its fine-grained ISO 400 film. I found the left side of the photograph somewhat cluttered and could have physically cropped or trimmed the print. I've used it to demonstrate how L-shaped pieces of illustration board are used for cropping.

The 8" × 10" print was mounted to keep it flat as I copied it in sunlight, using a 50mm macro lens on my Canon Elan camera. (See pages 128-133 for more about copying.) I adjusted the cropping Ls to eliminate the clutter for a composition I preferred shown in this picture. Using cropping devices offers a second chance to view a picture before cutting and matting it or simply mounting it in an album. Smaller cropping Ls work well with slides on a lightbox used for viewing.

I've heard some editors, art directors or designers reject slides that are cropped, even when done precisely with the proper tape, because they feel something is "wrong" with the image. These buyers apparently prefer to work with someone who can solve all photographic problems in the viewfinder. I've been selling to all sorts of clients for four decades and have never had a carefully cropped slide rejected. I assume a buyer understands that I improved a picture when circumstances were not ideal in the field. However, where close-up still-life work is concerned, cropping should not be necessary because all the aspects of background, lighting and composition should be controllable.

Manny Rubio plans a book on spiders, scorpions and centipedes, which will continue to challenge his ability to photograph the world from a close-up point of view. As you can see from this photo of a cicada, made outdoors where he happened upon it in Georgia, he'll have plenty of opportunities. Because it was an overcast day, Rubio used one direct flash, the diffused reflection of which can be seen in the insect's eye. The image of the cicada in the slide is about an inch long, an image half life-size, or 1:2. Rubio keeps his equipment to a minimum so he can concentrate on his subjects and not be technically distracted. He used a 100mm macro lens and Fujichrome 100 film. Exposure was 1/125 at f16.

Close-Up Photography Outdoors

EQUIPMENT FOR OUTDOOR CLOSE-UPS

Many close-up subjects can be captured outdoors in daylight. (You can also shoot by daylight on porches or indoors near windows.) In this chapter I want to make you aware how the brightness, subtlety and direction of light can enhance close-up pictures. Although the quality and color of natural light varies, we can work with it, though the light at certain times of day or in certain conditions can be challenging. Sometimes, however, it will be necessary to create artificial sunlight by using flash outdoors, and you'll find examples here of how to do that.

Most outdoor close-ups can be made without filters. The two main types of filters you occasionally may need are warming and polarizing filters. A skylight 1A filter or a warmer version, such as the 81B or Tiffen 812, is usually necessary when shooting with slide films in shade conditions. The 1A filter reduces the slightly cool, blue cast produced by shade without noticeably altering the color of the subject. I use the Tiffen 812, an even warmer filter than the 1A, in deep shade and in some cloudy situations. Evaluate the effect of these filters yourself by shooting the same subject with each type of filter under different light conditions. Depending on the slide film you use, you may like the effect of one or another filter

The still life, arranged on a black background to make the fruit stand out, was taken in bright shade. (I also shot several variations, some with dark grapes and without the leaf.) My camera with 50mm macro lens was on a tripod about fifteen inches from the strawberries. My 1A skylight filter provided a warm tint in the shady light without altering the colors of the fruit. I used Ektachrome Elite 100 at f22 and 1/30. If you're using color print film rather than slide film, shoot with and without a warming filter and compare the shots. A noticeable difference can be due to the processing. Not all automated color printing equipment is calibrated in the same way, so colors that one processor sees as normal, another may filter for a slightly warmer or cooler result. If you're not satisfied with the processor's color interpretation, explain why and ask for a reprint.

better for bright sun, shade and deep shade. Although polarizing filters are best known for deepening the color of a blue sky, they can help to eliminate surface reflections in close-ups.

Special effects filters that tint or creatively distort, such as starbursts or diffusers, are available if you feel the urge. Remember, however, that realistic depictions of natural subjects are most in demand. Creative interpretations are sought primarily for fine art and some interpretive editorial or advertising work. If

you do want to experiment with special effects lenses, check out the selection at your local photo store or in the Porter's and Spiratone catalogs.

I've concentrated on presenting shots where basic close-up equipment—close-focusing zooms, macro lenses, diopter lenses and, occasionally, extension tubes—has been used. You could also use a bellows or a lens reversal adaptor in many of the same situations, but those tools can be slow and clumsy outdoors. You should still try other

equipment before deciding what works best for you. For example, a few medium-format cameras, such as the Mamiya RZ67 and the Pentax 67, come with a built-in bellows that eliminates the hassle of adding and removing the bellows unit.

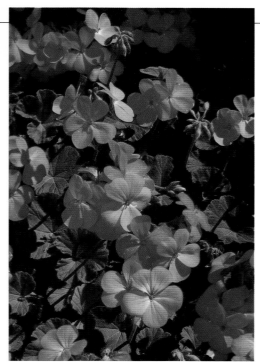

Here is the same shot taken in sunlight. You can see by the shadow pattern that the sun was slightly overhead and to the right. Compare this shot to the one shown at left. You can clearly see that the colors are brighter and warmer. The green leaves are now clearly visible, even in the shadow areas. These sunlit flowers have more sparkle, but the shady flowers have a moody, pastel charm. This shot was made on Ektachrome Elite 100 at f22 and 1/125.

I shot a few exposures of these geraniums in the shade created by the tall bushes behind them. It took awhile to find a composition I liked in the random flower pattern. I used a 50mm macro lens with the camera on a tripod about fifteen inches away. Even though I had a skylight 1B on the lens to slightly warm the shot, the geraniums appear to have muted, pastel colors. The shadow areas are dim and without detail. After I finished making this shot, I covered the camera with a light-reflecting towel to keep it cool, and waited for the light to change. Exposure on Ektachrome Elite 100 was f22 at 1/60.

BRIGHT SUN VERSUS SHADE

When you take the same picture in sunlight and in shade, the color of your subject on the film changes from bright to pastel in most cases The most dramatic example of this is the cold blue light of an overcast day after sunset (see the photo on page 143). Try this exercise to see what happens. Set your camera on a tripod and select a colorful subject, such as flowers, to shoot in both sun and shade at different times of day. You can also place a subject, such as a pot of flowers, first in shade and then in the sunlight, but shoot the same or similar composition from the same distance each time. When you compare the two pictures, you will see that the hue and brightness of the subject's colors vary under the different lighting conditions. Pinks become muted, whites have a bluish tint, reds may take on a slight purplish hue, and yellows may appear a bit greenish.

Shady light has a higher color temperature than sunlight and, therefore, colors seem cooler in the shade. Colors appear brighter and more vivid when you photograph them in direct or even hazy sun than they will when muted by a cloudy sky or full shade. There is, however, a difference in light and color quality between *diffused* sunlight and light in the shade. Sun diffused by thin clouds, creating an effect similar to that from a screen type of diffuser used by studio photographers, produces light brighter and somewhat warmer in hue than the shady light on a porch or under a tree.

In general, diffused sun is preferable for portraits or delicate subjects because it's softer than direct sun. Open shade is a yet softer light with less contrast, and more sheltered shade has the least contrast between tones, which is less desirable for many close-up subjects. I prefer the more vivid colors and stronger contrast I get from shooting in sunlight. Become more familiar with the effect of light differences by making comparison pictures of the same subjects where only the light changes from bright sun to deep shade. The resulting prints or slides will help you anticipate the outdoor color you can expect on film.

DIRECTIONAL LIGHT

Outdoors we are dependent on natural light most of the time. This light may be coming from above, at the level of, in front of, at the side of, or behind the subject. The direction of that light helps to show the texture and form of the subject and/or to add drama and clarity to the photo. Front light tends to flatten a subject because it washes out shadows. Sidelight shows most forms well, and shadows can be filled by a reflector or with flash. Backlight, coming from an angle that doesn't shine directly into your camera, can dramatize a subject; fill light is usually needed to bring out details. Top light from in front may be good for subjects such as sculpture that have undercuts in the form revealed by shadows, although fill light from flash or a reflector is often required.

When you can't move the subject, shift the camera position and/or wait for the light to change to improve the effect. When you can move the subject, you can choose light direction if the background is acceptable. I use a table or lightweight wooden box (about 3′ × 3′ × 3′) on rollers as a movable base for a still life when I need to change the light direction on my setup. I curve a sheet of poster board from the top of the table up behind the subject when the table or box is against a wall and the light is right.

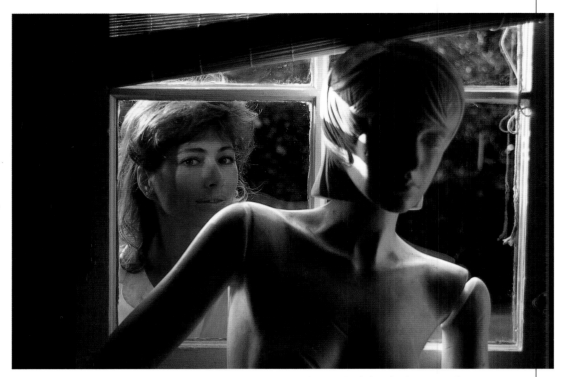

I tried to create a sense of mystery by placing the artist outside her studio behind a foreground mannequin. Backlighting heightens that mood by obscuring details that light from the side or front would reveal. For that reason I chose not to use a reflector or flash on the camera to soften the shadows. I took this shot about two-and-a-half feet from my subject with a 35-70mm zoom lens on my Konica, using Kodachrome 200 film at 1/60 and f8.

I was on a short tour of an obscure island in the Florida Keys when I came across this unusual spider. I chose to shoot it backlighted because the web and insect would be accented against the dark background. The pale spots are typical when light shines into a lens, where it creates small images of the iris diaphragm reflected on the lens elements. Lens coating reduces, but cannot eliminate, this effect. I shot the spider with a 55mm macro at 1/250 and f8.

The artist was adding texture to this wooden figure of a bear at an outdoor demonstration when I arrived. You can see from the shadow created by the tool that the sun was overhead. I would have preferred sidelighting to accent the texture being incised into the wood, but I couldn't control how the artist held the bear to work on it. I shot from about fourteen inches away using a 28-80mm zoom lens on Ektachrome Elite 200. Exposure was 1/250 at f11. I find ISO 200 film especially useful in such situations because it lets me use faster shutter speeds when I must hand-hold the camera.

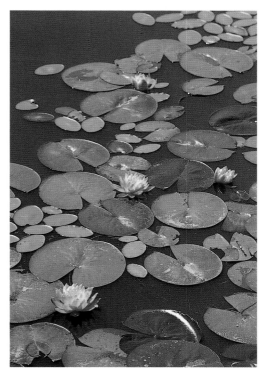

Toplight in summer often makes harsh shadows, especially on people's faces, but the lily pads and flowers are relatively flat and contrast well against the dark water, so toplighting was effective here. (This light would have caused shadows on a subject a foot or two high, and detail would have been lost.) I used a 28mm lens and Kodachrome 64 and took an overall meter reading for the average exposure of f11 and 1/125. The scene was approximately an 18-percent gray as the meter viewed it.

Sidelight brightened one side of actress Marj Dusay's face, and light reflected from the tree fills the shadow areas. Sidelighting is popular for portraits because it helps define facial features and is often more interesting than flat, frontal lighting. I used a normal 50mm lens as close as it would focus, about eighteen inches, and exposed at 1/125 and f8 on Ektachrome 64 film.

Low front light came from the left on this picturesque collection of antiques at a show in Quartzite, Arizona. If the sun had been directly in front, my shadow would have been in the picture. Light from this angle shows the forms well. The film was Fuji Sensia (ISO 100), and the lens was a close-focusing 28-105 zoom. Exposure was 1/125 at f11.

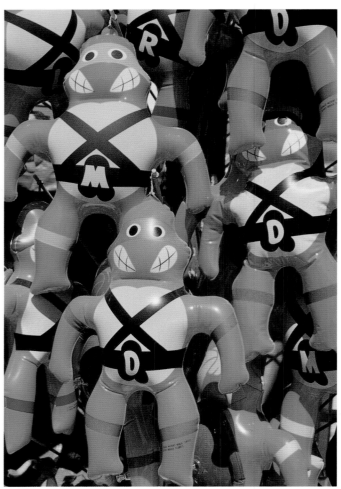

Front light here came from the winter sun, which is lower in the sky, especially at midday, than it is in late spring and summer in the Northern Hemisphere. I maneuvered my camera with a 28-80mm lens until I found a composition I liked in a group of inflated toys hanging at a county fair. Front light is sometimes boring because it flattens form, but it brought out the color and design of the bright green Teenage Mutant Ninja Turtles. The exposure was 1/250 at f11 on Ektachrome Elite 100 slide film.

Sidelight was just right for this prickly pear cactus in bloom because it made the berries stand out against their own shadows. Although the shadows group together at bottom right, no important details are obscured. Notice the contrast between the dark background, green pads and red berries, which draws attention to the berries. This was taken on Kodachrome 64 with a 35-70mm zoom lens in macro mode. Exposure was f8 at 1/125.

ACCENT SUNLIGHT OUTDOORS

At times outdoor lighting needs a boost from electronic flash or from reflectors. On an overcast day a portable flash unit can simulate sunlight, fill shadows or accent existing light. Without direct sun, shadows are diminished and contrast between or within close-up forms suffers. Popping a small flash mounted on the camera or held off to one side during the exposure intensifies the light, strengthens shadows and often makes small highlights appear on bright surfaces. A small electronic flash, such as the one built into an SLR camera, is enough for many close-ups. Exposure can be based on flash unit or camera automation.

Manny Rubio, a magazine and sports photographer from Atlanta, Georgia, learned close-up photography on his own by reading a few books, scouring photo magazines and experimenting a lot. Although he discovered years ago that there was more money in shooting sports than in zoological subjects, he became an expert at photographing snakes, turtles, lizards and other reptiles for his own enjoyment—and for magazines and books. Rubio says, "I had telephoto lenses, and a good sense of timing from sports, so I adapted some equipment and applied

Manny Rubio often travels to take the photos of sports events, especially baseball and football, for which he is so well known. He also travels in pursuit of photos of snakes, lizards, turtles and other reptiles. This green lizard (sceloporous formosus) was photographed in Mexico on a section of rock. "The lizard felt isolated, with no place to go," Rubio says, "and it sat still awhile." What looks like sunlight was produced by one flash above and to the right of the subject for a realistic sun shadow. The black background was created by using a small f-stop with bright light on the foreground and none in the back. The camera was a Nikon with 100mm macro lens, and the exposure was 1/125 at f11 on Kodachrome 64.

my experience to my bent for natural science."

He has tried all kinds of equipment but prefers to keep his techniques simple by using macro lenses and diopters on other lenses when needed rather than be slowed down by extension tubes. For fill or accent light outdoors he prefers to use a single portable flash unit.

WIND, WATER AND BACKGROUNDS

Outdoors you cannot control a subject's environment the way you can in the studio. Often you must contend with elements you don't want—a breeze that causes your subject to move or an unattractive background, for example. At other times the scene will lack just one thing to make it a perfect shot; dew or raindrops on flowers or a spider web will enhance many images, but you can't make it rain on demand. In this section we'll look at ways to cope with these challenges in the great outdoors.

Wind

Wind can move the subject and produce a blurred image on your film. When the wind is blowing the grass or flowers you want to photograph closely, your first approach is patience. Get ready to shoot, and wait for a lull in the breeze. It's easier to be patient when your camera is on a tripod, and you don't have to worry about your tired arms moving and ruining that perfect composition. With medium speed or fast film—ISO 200 or even 400—or when the light is fairly bright, try to capture a moving subject at a shutter speed between 1/250 to 1/500. The short exposure can freeze the action and eliminate blur. When this kind of blur is unavoidable, shoot anyway—it can be decorative. If you later discover the image isn't effective, discard the slide or print.

I was afraid the bee would get away if I took time to set up my tripod, so I moved as casually as possible to get the camera with its 50mm macro lens within eight or ten inches of the flowers. The bee stayed in one spot long enough for me to shoot at 1/180 and f16 on Ektachrome Elite 100. Although there was a breeze, the shutter speed was fast enough to prevent any subject blur as well as to capture the elusive bee. On my Canon Elan, 1/180 represents a half-stop, which is helpful to maintain a little more depth of field than lower shutter speed would allow at a given aperture.

This is natural dew on the flower that was my first subject after I got a 55mm macro lens. I was excited to be able to focus within inches of something, and I used a tripod to test lens sharpness carefully. There was a slight breeze, and I was using Kodachrome 64, so I exposed at 1/60 and f11. I knew there would not be enough depth of field to get the leaves sharp, so I concentrated on the flower. Had I missed the morning dew, I could have put mist from a spray bottle on the flowers to simulate dew.

I wandered happily around a wonderful rose garden in Portland, Oregon, for several hours with my camera and a 28-105mm zoom lens. The day was cloudy and I had no tripod with me, so I shot at 1/125 and f8 on Ektachrome Elite 100. I looked for flowers with dark backgrounds because the contrast between subject and background makes roses look more elegant. I knew the background would be out of focus because the lens was zoomed to 100mm from only fourteen inches and depth of field would be minimal.

Water Spray

Raindrops or early-morning dewdrops glisten on flowers and leaves, adding a glamorous note to close-up work. When it's dry, spray water on your subject(s) with an atomizer or spray bottle. Although some nature photographers may not admit it, many of the dewy pictures you see in books and magazines were given a boost with a spray bottle.

Backgrounds

Backgrounds are a common hazard in close-up photography; try not to let them spoil your images. For example, you find an appealing subject and try to compose that great shot you've visualized, but you discover elements of the background you don't like. You may reduce that annoying background to a soft-focus blur or eliminate it entirely by exposing the shot for shallow depth of field. Focus on the foreground and choose an f-stop, generally f8 or larger, to restrict depth of field and sharpness to your subject, softening the background.

Inevitably you will find lovely close-up subjects with annoying backgrounds that can't be avoided or eliminated. I try not to show unsuccessful pictures in my books, but there are many unsatisfying pictures in my files. There's one shot of a lizard on a rock with messy grass in the background. A photo of a black oystercatcher looked good in the viewfinder, but when I reviewed my slides, I noticed a busy-busy log behind it. Then there was that vase of pretty roses on a piece of upholstery cloth that seemed harmonious at the time but turned out to be very distracting in the print.

I discovered two ram's heads, executed in different media, in Borrego Springs Desert State Park in California. For the stained glass ram I made an exposure of 1/60 at f8. The glass was opaque and not much light got through. The bronze head was exposed at the meter reading of 1/60 and f8 and then underexposed half a stop, between f8 and f11. This darker than average subject might have been overexposed at the normal reading. However, I couldn't outguess the meter, and the underexposed shot wasn't as good as this straight one. Both pictures were taken with a 28-105mm lens on the camera using a tripod and Ektachrome Elite 100.

IDEAS UNLIMITED

Outdoor subject choice for close-up photography is limited only by your creativity and photographic vision. Develop the habit of looking closely at everything around you when you're shooting, even if you started out with some other kind of photo in mind. (Remember you can use a macro lens for both macro and general photography instead of the equivalent fixed focal-length model.) If cloudy skies deprive you of the sunrise shots you set out to capture, take advantage of the diffused light and early morning dew to capture some beautiful close-ups instead.

Natural subjects for close-ups include seashells, animals, birds, feathers, leaves, insects and flowers. Details of man-made subjects, such as sculpture, buildings, cars or anonymous found objects, also make good close-ups. You can even take advantage of natural light to create and shoot lovely still-life close-ups outdoors. The images you see here are only a small sampling of the creative ideas waiting for you. Make these ideas the springboard to pursue your own exciting close-ups in daylight.

Although most of the close-up photos you see are straightforward, naturalistic renditions of subjects, there is also room for the offbeat image. Barry Jacobs used a 15mm fish-eye lens for this candid close-up of several school friends. A fish-eye lens isn't often used for close-up work because it easily distorts subjects, even though it does offer excellent depth of field at f8 or f11. If you own a lens in the 15mm to 18mm category, try it for close-up pictures, but I wouldn't recommend buying one for that purpose.

While walking in the mountains of North Georgia, Manny Rubio made a little arrangement of leaves in bright shade and shot it from several angles. He told me, "I take pictures like these leaves because I enjoy doing it. Occasionally this kind of shot will sell, but natural history and nature photography is more personal than commercial to me." (More of his work appears on pages 102, 107 and 108.)

A long row of tall jars lining a small museum courtyard in the Los Angeles area became a curiously interesting art subject. This is just one of three different compositions of them I shot. Close-up photography lends itself readily to creating different visions of a single subject. Look for those subjects that can be interpreted in several ways. Exposure was 1/180 at f11 on Ektachrome Elite 200 film.

Underwater close-up photography requires special skills gained only from experience. It also requires specialized equipment, such as the Nikon Nikonos with 35mm lens and 1:3 extension tube that Vincent Reed used to shoot a large sea turtle in Turtle Bay, Oahu, Hawaii. Vince told me, "Parallax is often a problem, but here the turtle's head suddenly moved toward me. A special viewing frame inserted atop the camera comes with the extension tubes, but precise composition is tricky. I use a lighting setup with an electronic flash unit on each side of the camera all mounted to the same base. Here I shot on Ektachrome 200 slide film at f8 and 1/90, though the extremely fast flash really determines exposure." Close-ups are a mainstay of underwater photography that Vince enjoys as an avid hobby.

Each card in this arrangement features a close-up photograph, all taken or chosen by graphic designer Charles Eames. You may be able to tell these still-life pictures were photographed indoors by reflected light because there are soft shadows or none at all. I arranged the cards in a geometric pattern on a piece of black posterboard and photographed them with a 50mm macro lens on a 35mm camera, using one 500W floodlight on each side.

Indoor Close-Up Photography

GETTING STARTED INDOORS

For a long time, I regularly shot still lifes and portraits and made copies of prints outdoors in sunlight or bright shade, which matches the daylight slide and print films I use. I avoided shooting still lifes indoors—it was a hassle to switch to tungsten film to match the flood lighting, and my electronic flash equipment was limited. Not to mention having to improvise a home studio every time since I didn't have the space for a permanent setup. Eventually I decided copying prints and shooting still lifes outdoors was as inconvenient as changing film and learning how to light a shot indoors properly. So, I made some experiments with filters and small studio setups, and now I'm as comfortable shooting close-ups and other subjects indoors as out.

There are some important advantages to shooting close-ups indoors. You have more control without the interference of wind and weather conditions. Artificial (tungsten) light—floodlights and quartz lights—and electronic flash equipment can be arranged more easily than sunlight and can be adapted to various films. You can set up a variety of backgrounds, even re-create natural settings, and work at your own pace without worrying about clouds or nightfall. If you want the effect of natural light, you can sometimes photograph close-up subjects by daylight near a window, using reflector boards to brighten shadows.

You can create a home studio with your camera, tripod, a table and lighting equipment. Choose the table according to the types of lenses you'll use and the sizes of setups you'll shoot. The shorter the focal length of your close-up lens, the more you'll need to keep your backgrounds farther from the subject and out of focus. Leave room for the lights between the subject and the camera on its tripod. A table about three feet long and between one-and-a-half to two-feet wide should satisfy your requirements.

It can be helpful to place your table against a wall. You can lay posterboard, fabrics or other materials such as grass or leaves, on the table as a base for your close-up subject. If your background—posterboard, paper or suitable cloth—can be curved from the table's surface to the wall, it avoids a line in the picture where horizontal and vertical pieces meet. You can usually tape a curved material onto the wall. If your background material isn't large enough to cover a table and won't curve high enough against the wall, try using an ironing board as a base because of its narrower width. The height of an ironing board is easily adjustable, and I've found it convenient for small close-up subjects.

This chapter focuses on working in a temporary home studio, which isn't necessarily a handicap. Renowned sports and natural history photographer Manny Rubio has even created a naturalistic set on the patio of a motel when he's traveling. If you do have permanent studio space or occasional, affordable access to it, you'll still be able to take advantage of the techniques and ideas presented here. Simply adapt them to your types and amount of equipment and your physical arrangements.

Manny Rubio prepared for this close-up by keeping about fifteen Eastern box turtle eggs warm for about two months until they all hatched within hours of each other. The indoor setting includes moss and dirt. The pleasant lighting came from one flash in a diffusing box. "Soft light helped control the contrast between the turtle and the eggs," Rubio explains. He used his favorite 100mm macro lens on an SLR with Fuji Provia film. There's a small white knob on the end of the turtle's beak; it's an egg tooth, which the turtle uses to slice its way out of the egg.

LIGHTING EQUIPMENT

When you shoot indoors you can—and must—create the lighting you need or want. The lighting equipment you use will depend on the subjects you want to shoot, the physical space in which you work, and your budget. Established professionals and large commercial studios have amassed over time substantial and expensive collections of equipment to suit the variety of clients they service. You can start out, however, and shoot successful saleable images with much less. Studios must have large strobes that produce enough light to shoot large areas, groups of people or products; but the kinds of close-up subjects featured in this book can be handled nicely for a small investment in lighting equipment. Manny Rubio expertly imitates the effect of daylight with a 1000 watt electronic flash, often in a reflector box with diffusion material in front, to simulate the sun on the reptiles he enjoys photographing. Do research, ask questions and then buy the equipment that fits your needs. The essential items are the lights themselves. These fall into two major categories: tungsten lights and electronic flash.

Tungsten Lights

Photofloods and quartz lights, also called "hot lights" because they get very hot, provide constant illumination from a glowing tungsten filament suspended in gas

I chose the seashells and bougainvillaea leaves and petals for this still life because of their varying color and textures. The background paper covers a small table and curves up a wall in the back. I used two 500W, 3200K reflector floodlights in clamped sockets. The arrangement is backlighted by the main light, placed at the right slightly behind and about thirty inches above the setup. The second light was lower at left to illuminate an 11" × 14" white posterboard reflector to lighten the shadows. I used a 28-80mm zoom with a + 2 diopter on it, and Ektachrome Elite 200 daylight film with an 80A correction filter. Exposure was one-half second at f22.

While experimenting with exposure and miscellaneous still-life materials, I took this shot with a single flood-light reflected from an umbrella at the right to show how predominately light-colored objects can be dramatized by using a directional light. To emphasize the effect, I didn't try to brighten the shadows in order to see more detail. This lighting creates a stronger sort of character to emphasize what may be seen as a forlorn mood. The lens was a 50mm macro on my Canon Elan SLR, and was shot at one-fourth second and f22 on Ektachrome Elite 100 slide film.

that's enclosed in glass. We talk in terms of color temperature in degrees Kelvin ("K") when matching films to light sources. Sunlight at noon, for example, is rated 5500K. The higher the Kelvin number, the colder the light appears on film and vice versa. Photofloods are available with color temperatures of 3200K and 3400K, although 3200K is more common from quartz lights. Since tungsten lighting has a much lower color temperature than sunlight, you must use tungsten, instead of daylight, films when shooting by it. Tungsten 3200K floodlight bulbs last much longer than regular photofloods because of different filaments. Standard 3400K photofloods may last six hours and will become slightly opaque, while 3200K photofloods last about five times longer, do not discolor, and are more expensive.

Aluminum floodlight reflectors are the basis for good hot lights. They're sold in different sizes with wires attached and with the clamps or aluminum sockets (and set screws) to fasten them to light stands. You can screw in the photofloods of your choice. Check with your local photo store, Porter's Photo Catalog (1-800-553-2001) or the Freestyle Sales Co. catalog (1-800-292-6137) to see what's available.

A quartz light, which is a quartz bulb in its own compact reflector, is also a good source for hot light. They come in 500W, 600W, 650W, 750W, 1000W and 1200W

I arranged a collection of miscellaneous stamps in a casual design on a sheet of background paper. One reflector flood was aimed at about 45 degrees at the bottom right, and it provided small shadows. Another reflector flood was positioned as a fill light at the left farther away than the main light. I used an 80A correction filter in order to take the shot on Kodak Ektachrome Elite 100 daylight slide film. In the slide the stamps are about one-seventh or one-eighth actual size, as shot with a 50mm macro lens. Exposure was 1/30 between f11 and f16.

Graphic designer Kathleen Jaeger was intrigued by the doll's head one of her nieces was playing with. She took a close-up picture of it using color negative film and a 50mm macro lens on her camera. "I shot the head vertically, too, but the horizontal has a startling sense of animation the eyes seem to give it," she said. Jaeger placed a floodlight reflected from an umbrella on the right, and another reflected floodlight on the left, farther away.

sizes. Some quartz lights are fitted with barn doors, metal flaps that attach to the light rim to control the amount and direction of the light. Check your local photo store for available equipment, or try one or both of the two catalog outfits mentioned. My

own compact 600W quartz lights, rated at 3200K, are twenty-five years old and I have replaced the quartz bulbs in them several times.

The smallest quartz lights— 500W and 600W—are suitable for close-ups, but they get very hot and are more ex-

pensive than floodlight bulb/ reflector combinations (described below). Quartz lights as well as photofloods work well with umbrella reflectors, collapsible reflectors used to soften the light falling on a subject. Umbrellas may have a white surface (low con-

trast), a white and silver surface (medium contrast) or a silver surface (high contrast). An umbrella reflector clamps to a light stand with lights clamped to point into it. (See pages 114-115 for more on diffusers and reflector boards and umbrellas.)

You can begin experimenting with indoor lighting with only an aluminum reflector with a photoflood plus a clamp to attach it to a stand. You can even clamp the reflector to the back of a kitchen chair. Two floodlight bulb/reflector combinations and homemade reflector boards make it easy to begin shooting indoor close-ups.

My own relatively simple system relies on reflector flood bulbs. I attach about twenty feet of wire to ordinary bulb sockets with integral switches and fasten sturdy clamps to the sockets. I screw 500W General Electric EAL 3200K reflector flood bulbs into the sockets. They taper out to form an internal reflector with a conventional filament inside. Reflector flood bulbs cost between sixteen and twenty dollars, but they last as long as 3200K photofloods and are more compact and convenient to carry than ten-inch or twelve-inch aluminum reflectors. My lights clamp to standard telescoping light stands, available in many sizes. A stand that extends to six or seven feet high is lightweight and adequate for most close-up work.

Exposure with all types of artificial lighting described

The pill box is about half life-size (1:2) in the slide. I included the ruler to indicate the box's size and to show how close I was with a 50mm macro lens. One 3200K reflector flood bulb was reflected from a white photo umbrella clamped to a standard aluminum light stand, and another 3200K reflector flood pointed into an umbrella farther away at the right to soften the shadows. Exposure on Ektachrome Elite 100 with an 80A filter was 1/8 at f22.

is easy using the meter in your camera or a separate exposure meter. Manual adjustments for predominantly bright or dark subjects and backgrounds may be necessary.

Electronic Flash Equipment

Many professional photographers prefer electronic flash, often called strobes, in a wide variety of sizes and types. Strobes have several advantages over tungsten lights: They are powerful, cool, fairly compact, draw fewer amps, and the light color is correct for daylight film. Large studio strobes are expensive and work only on A/C. But in your home studio you need only one or two

portable flash units with guide numbers such as 80-100 for ISO 100 film. Such units allow you to shoot close-ups at f16, f22 or f32, depending how closely they are placed to a subject.

These are only general figures; you'll need to experiment with one or two flash units for close-up shots with the lights set at various distances. You can synchronize a second light with one wired to the camera by using a photoeye, which activates the off-camera flash simultaneously with the one on, or wired to, the camera. It's helpful to have a modeling, or pilot, light, such as a 75W reflector flood bulb next to the flash unit that becomes a guide for positioning your

strobes. Once you're satisfied with the effect of the lighting on the subject, you can shut off the modeling lights. If you have a Polaroid camera, or a Polaroid film back for your camera, you can take a quick shot to check the lighting effect before you begin the actual shooting. Use black-and-white Polaroid film for tests. It's less costly than color film, and it is suitable for strobes and modeling lights.

You can expose for close-ups using an automated unit, preferably one with variable light output to prevent overexposure. You can also make close-up exposures using guide numbers. A useful portable strobe may offer guide numbers such as 70

Electronic flash is almost a necessity to take the kind of close-up Marge McGowan got on 35mm Kodak Gold 100 print film, which won her an award in a Kodak competition. The closer the average flash unit is to the subject, the faster its flash and the smaller the f-stop you can use. Notice the catchlights—highlights—that bring out the eyes. They indicate the flash was just above the camera and centered. When you analyze lighting in portraits especially, catchlights suggest where the lights were and how many were used. Courtesy © Eastman Kodak Company.

(ISO 100), 100 (ISO 200) and 150 (ISO 400). A guide number, devised by a flash unit's manufacturer, is a figure into which you divide the light-to-subject distance in feet to obtain the proper f-stop for a specific ISO film speed. For example, divide five feet (light-to-subject) into seventy and the answer is fourteen, which translates to f14. Run some photographic tests and keep notes about distances from flash to subject and f-stops used before you rely on guide numbers for exposures. Aim the strobe at a white reflector board or umbrella, and you lose two stops so place the flash closer to the subject or switch to a faster film.

For confidence with electronic flash, make some aperture and distance tests. Try this: Mark six-inch increments on a piece of durable string attached to a flash unit. Make a close-up arrangement, and place one strobe at 45 degrees and a white reflector board on the other side to reflect light into shadows. Shoot a series at different f-stops as you change the light-to-subject distances measuring with the string. Keep a record of distances and f-stops for one or more ISO speeds of film, and you will have a reference to help make it easier to determine close-up flash exposures.

If you do a fair amount of indoor shooting, a separate flash meter may be worth the investment. These meters can be found in photo stores and in catalogs. In 1996 flash meters are priced from about $150 to more than $450. You

may also choose to depend for exposure on a dedicated TTL flash unit made for your camera. (For a point-and-shoot camera, you might use a Morris midi slave flash, available at Porter's, that fires a second light when the camera flash is used.) The Porter's and Freestyle catalogs are sources of electronic flash equipment as are many camera shops. Other catalogs for strobes are available from White Lightning (1-800-443-5542), Photoflex (1-800-486-2674), Photographer's Warehouse (1-800-521-4311) and Studiomate (1-800-283-8346). For reflector umbrellas and enclosures try Larson Enterprises (1-800-227-5533).

Macro Ring Lighting

The type and brilliance of artificial light you use contributes directly to the success of close-up pictures. A macro ring light is a specialized tool for very close photography, used alone or to augment other kinds of lighting. When it's difficult to position the camera and make room for conventional flash or flood lighting for small subjects, especially when the lens is only inches from the subject, a ring light can be handy. This specially designed electronic flash circles the front end of the lens and offers soft, even light for close-ups. You can also use more elaborate units that include flash tubes within a diffusing ring that can be fired together or separately. Some macro ring lights are expensive, but I saw two for less than $100 in the mid-1996 Porter's Catalog.

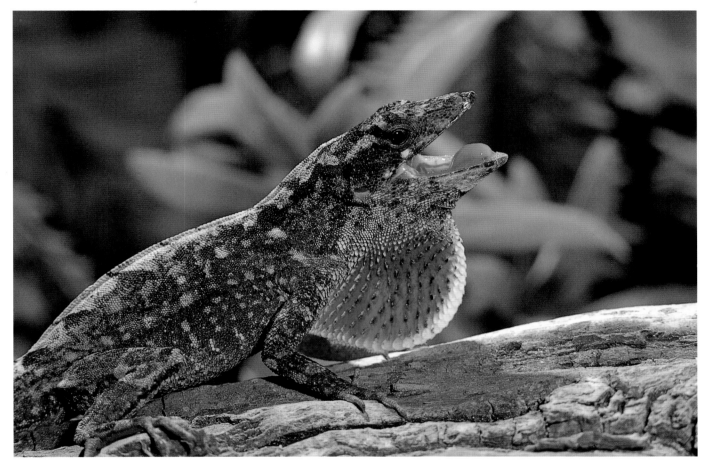

Manny Rubio has learned the art of simulating daylight to photograph reptiles in natural settings. This brown anole, displaying his puffed-up dewlap, or sack, was photographed on a small log on a tabletop with a 100mm macro lens. The anole's mouth is open because, says Rubio, "He was riled." Two flash units were used: one in front, above and to the right of the camera, and the other behind the anole off to the left. The backlight helps separate the four-inch creature from the natural-looking background. "I usually work in a darkened area, and the animals can't see me because of the lights on them. They sit there in what they may think is the sun." Exposure on Kodachrome 64 was 1/125 between f11 and f16. Rubio can also create the appearance of nighttime in his studio. "When I photograph a night effect," Rubio explains, "I use just one flash because that's the way you'd see an animal in the field—by flashlight with a dark background."

FILMS FOR STUDIO WORK

Tungsten-balanced color slide films are made for use with quartz lights and photofloods, which usually have color temperatures of 3200K and 3400K. (Daylight-balanced films match light at 5500K.) Tungsten films have additional blue in the emulsion that counteracts the amber color of a photoflood's light. Kodachrome Type A 40 matches 3400K light. Type B films, which include Ektachrome 64T, 160T and 320T, Fujichrome 64T, and Scotchchrome 64T match 3200K light. If you are using strobe lights, however, use daylight film because a strobe's color temperature is 5000K to 5500K.

Tungsten films are sometimes harder to find than the more commonly used daylight type, so you may be reluctant to load a roll of tungsten film to shoot only a few indoor pictures. You don't have to. If you won't use up a full roll of tungsten-balanced film in a session, you can shoot with your usual daylight slide film and use a correction filter to convert it for tungsten light. An 80B filter is used for 3400K light sources and an 80A filter for 3200K sources. After shooting indoors, you can use the rest of your film outdoors or with flash without the conversion filter. Remember that you lose about one-and-one-half stops with a correction filter, but slower shutter speeds and small lens openings are fine for subjects that won't move. Autoexposure cameras handle exposure through a filter effortlessly.

Shooting color negative film with tungsten light can produce unpredictable results at the average processing lab. Print films are color-balanced for daylight, and machine-made prints will usually be too warm (or orange-tinted), unless you correct the color with an 80A or 80B filter. However, your prints may then come out blue-tinted. I suggest you note "some pictures shot with 80A or 80B filter" (depending on which one you used) in the space provided for special instructions on film processing envelopes. When you don't get satisfactory results from machine processing, try a custom lab and ask for advice about using a conversion filter with tungsten light.

ARRANGING A SETUP

Shooting still lifes, also called tabletop photography, is a stimulating way to practice close-up photography of relatively small objects. Making good compositions is a primary challenge. There is a wide choice of still-life subjects and backgrounds available in your home, through swap meets or waiting to be bought, borrowed or improvised. Popular subjects include fruit, flowers, small sculptures, decorative china, children's blocks and toys, antiques of all kinds, candles, dishes, foods (odd-shaped pasta that can be spray painted, colorful candies, etc.), personal belongings, jewelry or small tools. Try tight shots of hands holding or working with small tools for a change of pace.

Close-up portraits of someone working at a hobby, such as mounting stamps in an album, carving wood or sewing, combine tabletop and portrait photography.

Imaginative photographers like Manny Rubio are able to make electronic flash lighting look smooth. This person worked in a research lab at a laser bench aligning instruments. Rubio placed one flash unit off right with a blue gelatin in front of it for a touch of mystery, and another softly diffused flash unit in front. Elegant close-up lighting doesn't call attention to itself. Exposure on Kodachrome 64 was 1/60 at f11 with a 100mm macro lens.

This was taken with Kodachrome Type A 40, a tungsten film made to match tungsten lighting. The tomatoes were arranged on a tinted background, and one umbrella was placed above and behind them for soft, even lighting. I used two 500W, 3400K reflector floods pointed into the umbrella to increase the light for better depth of field. Exposure was one-fourth second at f16 with a 60mm macro lens.

This approach not only gives you the chance to communicate more about your subject, it also helps distract the subject from the camera, often resulting in a better photograph. Concentrate on the person and the activity, and arrange tools and what's being worked on to complement the subject. As with any portrait, take care that the background does not distract from your model. Be sure that the subject is comfortable, and advise her about posing gracefully, but be prepared to photograph impromptu action and expressions. The portrait may profit if the subject's hands, working on something, could be fairly close to his face to allow a larger, more dramatic close-up.

You can create realistic, naturalistic setups in a home studio. Manny Rubio has photographed many kinds of reptiles close-up. "I try to capture nature as realistically as possible," he told me, "especially in close-ups, which offer a microworld people don't usually see in such detail." He prefers not to shoot snakes, lizards or other reptiles in the field if he can create a natural environment in small sets he builds in his studio. "I need extensive depth of field and considerable control over small animals, which, incidentally, I don't anesthetize, and re-creating outdoor environments—nature-faking I call it—can look very realistic."

This country-style clock my wife bought in Germany was an excellent still-life subject. I put a sheet of green paper on the edge of an ironing board. (For more on the advantages of working on an ironing board see page 102.) The background was black posterboard. One floodlight was placed at the right, beamed into a reflector umbrella, and another flood was in front of and a few feet above the clock. The film was Ektachrome Elite 100 with an 80A correction filter for 3200K tungsten light, and the lens was a 28-80mm zoom. Exposure was 1/50 at f22.

When I shot a detail of the clock, I used the same lighting. Note the two tiny reflections in the birds' eyes from the lights. I moved closer to the birds and switched to a 50mm macro lens because the 28-80mm zoom would not focus closely enough. The exposure changed from 1/15 to 1/8 at f22 because the lights were a little farther away to make room for the camera.

I found this attractive example of a close-up done by a professional studio in a Levenger "Tools for Serious Readers" catalog and asked to use it here. The photo displays merchandising illustration with charm exemplified by the careful positioning of the books, the inclusion and placement of the branch of ivy, and the use of the wire-rimmed glasses. It was taken with a 4×5 view camera with which you compose on a ground glass, which is covered by a film holder as the picture is taken. The photographer used transparency film and diffused electronic flash. The main light was toward the back at the left, another light was placed above the books in front for fill, and a third light created a highlight on the table to simulate reflection from an unseen window. The front and left-hand lights were diffused, while the one in back was direct for accent.

LIGHTING YOUR SUBJECTS

You can control how a picture will look by changing what the light does to emphasize the subject's form, its surface characteristics, the beauty of its texture or design, or to create a mood. Lighting direction and contrast help to achieve these goals. Soft reflected light is often flattering to people and can make inanimate things more appealing, too. Reflected light is popular for portraits, though the kind of shadows you allow—soft and bright or darker and sharper—depend on the subject and purpose of the picture. Publications may prefer more contrast in portrait lighting than individuals prefer for their personal photos on the piano. Strong light from a 45-degree angle can help separate objects because the shadows come between them in a functional way. Light directly from the front usually flattens form, but it can be appropriate for infants, for example, making them appear softer and more innocent. It is a real revela-

tion to light one or two different subjects, like a still life and a face, in a variety of ways. When you compare the slides or prints, you may be surprised at the types of lighting you like best.

A still life is good to experiment with because you control what is included. Choose objects that let you study the effect of different lighting arrangements on specific colors and forms. It's fun and satisfying to position lights higher, lower and at angles to create different pictorial effects. Whatever your close-up subjects, unless you are doing an assignment with specific instructions from a client, try a range of lighting and don't be afraid that some effects won't work. You'll remember your mistakes and capitalize on them later.

When you're experimenting with and studying the effects of lighting, don't set up your lights one way, take a shot and promptly move on to another subject. Make several exposures, altering the light and rearranging the subjects as you go along. Keep a watchful eye on the shadows you create. You don't want them to be too large or prominent. Lighten shadows with reflector boards or an additional light if you wish. Make careful notes on your experiments so you remember what produced a pleasing lighting effect and what didn't. Then apply your new knowledge to future shots. You could also use a second camera to take a few snaps of your setup for future reference.

Many commonplace objects can be transformed into arresting still-life subjects. I arranged a group of oranges on a table, and after trying several views I made this composition in the finder of my 35mm SLR camera. I used one floodlight directed into a white umbrella aimed from the top left slightly forward of the camera. Another floodlight and umbrella were in front beside the camera to softly illuminate shadows. The shot was taken with a 55mm macro lens at 1/8 and f22 on Kodachrome 64. I used an 80A correction filter.

Some time after shooting the arrangement of whole oranges, I extended the series with a plate of orange slices arranged in a harmonious pattern on a blue-and-white plate chosen for its color contrast. A floodlight was the main light aimed into an umbrella and placed at the right above and away from the fruit. It was low enough to emphasize the surface texture of the oranges. This is a moodier interpretation than the shot of the whole oranges because of the lighting and dark background. I used Ektachrome Elite 100 with a 50mm macro lens and an 80A correction filter. Exposure was 1/15 at f22.

You can change the appearance of your subject and often the mood of your pictures by changing only the lighting. The subject and composition, an array of designer Charles Eames' cards designed to fit together, in the shots on this page remains the same, but the lighting changes. All four photos were taken on Ektachrome Elite 100 slide film with a 50mm macro lens; an 80A filter corrected the lighting for daylight film. For this shot, one reflector flood bulb shone directly from an overhead front position, and another floodlight pointed into an umbrella reflector to brighten the shadows from a low spot at right front. In this shot and the next there is a darker moodiness than in the other two, which are more brightly lighted. I also wanted to show how the display of cards is seen more clearly in some lighting than in others. Exposure was 1/15 at f22.

A direct floodlight was positioned slightly to the right above the cards, as you can see from the shadow on the ocean liner card at left. At the front left and lower, a sheet of white posterboard reflected the main light to slightly brighten shadows. There is more contrast in this shot than the first one, but shadows are not bright enough. I purposely did not use a second light to demonstrate the effect of direct and reflected light from one source on tungsten lighting. Exposure was 1/8 at f22, one stop more than the previous shot in which there were two lights.

The direct main light from the second shot was switched to the left side of the cards, almost directly above them as seen by the shadow of the front card. A second flood was aimed from in front of the setup at a 30″ × 40″ sheet of white posterboard to brighten shadows. This lighting is more cheerful because the background is brighter and because two lights were used rather than just one in the previous picture. The lighting was not intended to make all the cards equally illuminated; I wanted to illustrate the effects that the same two floodlights (or strobe) can have in different arrangements. Exposure was 1/15 at f22.

I positioned the same white posterboard used in the other shots above the cards, and reflected a 500W, 3200K floodlight from it to illuminate the cards and background as well. The light in this photo is softer than in the previous one where the 500W flood was aimed directly at the cards, because reflected light has a diffused quality. The exposure, 1/15 at f22, was the same as for the previous shot. Reflected light from the same location as direct light has about half the intensity, depending on the type of reflector. A typical umbrella would have reflected slightly more light than the sheet of posterboard because of its shape and reflective surface. The effect here is a brighter mood than the first two lighting arrangements, but not quite as snappy as the previous one.

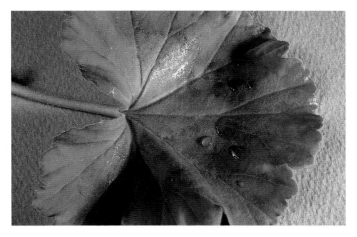

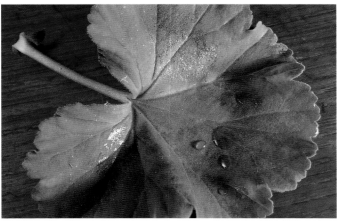

Both photos show the same leaf with drops of water on it, lighted by the same low-level 500W reflector flood bulb at the same exposure and f-stop, but I changed the background. The effect of the blue paper is subtle with less contrast, which may be preferred for more delicate subjects or effects. The wood-grained Formica background makes the leaf stand out more dramatically than against the blue paper. I prefer this rendition because the leaf color and shape are more interesting. Whenever possible, vary the backgrounds on which you shoot a subject. You'll never know what you might have missed if you don't try it.

Another outstanding example of studio lighting from the Levenger "Tools for Serious Readers" catalog is this still life of small objects alongside a laptop computer. The arrangement was made on what appears to be a table or desktop that contrasts nicely with the business travel accessories illustrated. The main light comes from above slightly to the right, and serves as a backlight that handsomely emphasizes the objects shown. Slightly diffused electronic flash behind frosted acetate softened the light. Another light was deftly placed at left. Some shadows were not brightened by fill light to help give the image more impact. The photograph was made with a 4 × 5 view camera, and a flash meter (that indicates correct f-stop and shutter speed) assured proper exposure.

Background Lighting

In many cases the background is lighted by lights aimed at the subject itself. However, when shadows from your subject(s) fall on the background in a pattern that confuses or disrupts your composition, you can try several approaches to correct the problem. You can raise or reposition the lights; rearrange your subject(s); diffuse the lights by reflecting them into an umbrella reflector, thereby softening the shadows; or adjust the camera position to make shadows less prominent. If your setup is deep enough, lighten or eliminate background shadows by aiming a light on just the background. You have to do this carefully so the light doesn't spill over on the subject(s), perhaps by using a small spotlight or a floodlight with barn doors.

Another method of background lighting involves lighting the background separately from beneath and behind a table. Place your paper or fabric under the still life, and let it extend only to the back edge of the table, which should be a foot or two from a wall. Mount posterboard or paper on the wall; you can use a different color from the material under the still life for visual variety if it seems appropriate. Place one light beneath the table line and behind the table where you can adjust it to illuminate only the background. If you don't want a horizon line behind the still life, soften it by adjusting the f-stop to throw the line out of focus.

DIFFUSERS AND REFLECTORS

Floodlights or electronic flash aimed directly at a subject create definite shadows. Placing a material such as fiberglass or frosted acetate in front of or over the light diffuses—softens and spreads—the light, thereby softening the shadow edges. Always choose a diffuser made of a material, such as spun glass, that doesn't burn in front of hot lights. Inquire at a photo supply store about the sizes and materials available.

Reflected light is a more versatile form of diffused light because it can be used as a main light or as a secondary fill light. A fill light is a supplemental light source used to lighten shadow areas without casting secondary shadows. Photographic umbrellas and other reflectors cut light intensity in half as it becomes softer, and some close-up subjects, such as glass objects, lend themselves well to soft lighting. Reflector boards, or cards, also bounce light back into areas of the subject. Fill boards or cards, terms often used interchangeably with reflector boards or cards, are used to lighten existing shadows. Check local photo stores and the major catalogs for umbrellas in a variety of sizes and prices.

In your home studio you can easily and inexpensively improvise poster board reflectors. I use one that's 11″ × 14″ and another that's 16″ × 20″ for still lifes and portraits. With lights and camera relatively close to a subject, you can hold the piece of posterboard in front of a light as a reflector yourself, or ask someone to hold it. Working alone, I hold my smaller posterboard reflector while exposing the picture with the camera's self-timer. These reflectors and techniques work well with hot lights or electronic flash for directional and soft lighting for indoor close-up pictures.

Working With Form and Shadows

Photographing sculpture is an excellent test of your light modeling capabilities. Because sculpture is not uniformly created, its forms require more care to make the work look best. For sculpture I use floodlights in reflectors or reflector flood bulbs. Reflecting materials to lighten shadows can be white poster board or umbrellas. The latter should be mounted to a light stand using a dual-purpose clamp designed to hold the umbrella at an angle while fastened to the stand. For sculpture larger than about eighteen inches high, if you have no umbrella, you can anchor a piece of posterboard about 3′ × 4′. Puncture one hole at each vertical end of the board and slip the light stand through the holes. This becomes an improvised reflector you can place where you need it. (You can also make successful pictures of sculpture outdoors in sunlight using reflectors; depending on the season and the sculpture, choose a time of day with the sun at about a 45-degree angle.)

Proper camera angles and lighting or even subtle adjustments of the lights can improve the appearance of most sculpture. It helps to have the sculptor there when you shoot to discuss lighting and camera views. This can be a gratifying cooperative effort because many sculptors have never seen their creations look as good as they will when you light them thoughtfully. Sculptors are often more appreciative of your efforts than painters for whom you have made copies because sculpture may seem improved by sensitive interpretation.

Portraits

I've turned a corner of a living room with plain, light-toned walls into a temporary portrait studio. I moved a few

Photographing sculpture is always a challenging kind of close-up photography because each piece deserves its own custom lighting arrangement. This shot of the seven-inch-tall sculpture, "Mother and Child" by Mark E. Sink, was taken with a 50mm macro lens using floodlights; a direct light at the right, a light reflected into an umbrella at left, and a third behind the sculpture to brighten the background. I used Ektachrome Elite 100 film indoors by correcting the color of the floodlight with an 80A filter.

Either photofloods (hot lights) or electronic flash are suitable for lighting portraits and still life indoors. I'm partial to hot lights because I can see lighting effects clearly before I shoot. Large AC-powered flash units include pilot lights to indicate lighting effects, but with smaller flash units you can place floodlights next to the flash for a lighting preview. Lighting this informal family picture, I used flash-fill from the camera to augment existing light. Taken with a 28-80mm zoom lens on a 35mm camera loaded with Kodak Gold 200 film, the exposure was not recorded.

Bob Clemens, an Eastman Kodak staff photographer, made this beautiful studio portrait to demonstrate the fine grain and color of 35mm Ektapress Plus 100, favored by professionals for its color stability. Bob chose a black background to set off her golden hair, and one rectangular reflector box with two flash heads mounted in it, covered with diffusing material soften the shadows handsomely. Diffusion units (softboxes) for home use are available from camera shops and catalogs such as Porter's (1-800-553-2001). Courtesy © Eastman Kodak Company.

pieces of furniture to make room for three light stands, a tall stool or kitchen chair (the back should be low enough not to show in pictures), and my camera on a tripod. If you have such space available but the walls are patterned or dark-toned, consider covering a portion of the background wall with light-colored heavyweight paper or fabric or a large sheet of thin posterboard. Also consider mounting white paper as a light reflector on the wall beside the sitter. The closer you place the subject to the background, the less the area behind her will show when you shoot. However, at least

three feet of room behind the subject is useful to position a background light that's not in the way. When your subject is far enough from the background, shadows from the lights may not be evident on the background.

Lighting techniques and equipment for portraits are similar to those described in this chapter for still life (see above, pages 110-113). You need a main light at an angle from one side or the other, perhaps a foot or two higher than the subject's head. If the floodlight or flash is direct, shadows will be relatively sharp-edged. But soft light and shadows make more

flattering portraits, so use reflected light instead unless you want harsh lighting for a particular mood or effect. You will also use a fill light in most cases to brighten shadows, and an umbrella reflector is a good idea. An additional light, such as a 250W photoflood in a reflector, on a stand focused on the background behind the subject helps add a sometimes glamorous touch and can neatly separate the person from the background.

Set your camera on a tripod to create and preserve a precise composition while you move around arranging lights. A close-focusing zoom lens,

like a 35-80mm or 28-80mm, offers portrait versatility. Load the film you prefer (use an 80A or 80B conversion filter with daylight films), and establish a rapport with your subject. Persuasive psychology works along with creative photography to assure pleasing, dramatic or dreamy portraits. Be sure to vary the lens-to-subject distance to get some shots in which a face alone fills the 35mm frame. Adjust the lights with care, making sure that shadows are in harmony with the effect you want. (Don't let shadows crisscross a face and distort it.)

Kathleen Jaeger searched out a kaleidoscope large enough to tape onto a narrow table in front of a window. Using a tripod for her 35mm SLR, she positioned her 50mm macro lens at the front of the kaleidoscope and manipulated the changing design until she had this colorful pattern. Jaeger made the setup with daylight slide film and shot half a dozen variations.

Close-Up Designs and Patterns

While hiking at the edge of a California desert, I came upon an abandoned house with a crumbling wall. Such subjects are immediately appealing to me, but it's a challenge to make a worthy composition from what is often a random assortment of shapes. I studied the possibilities with my camera and 28-80mm lens on a tripod about six feet away. After patient observation, I discovered this pattern composed of cracks and holes and shot it in low afternoon sunlight. The film was Kodachrome 64, and the shot was taken at 1/30 and f11.

LEARNING TO SEE DIFFERENTLY

We're familiar with the many functional purposes for close-up photographs, such as illustrating the attractive or interesting details of a subject, showing the character of a person's face or capturing the beauty of flowers. But photography doesn't have to be literal and realistic. It can be fanciful and abstract. For instance, a huge close-up of a cell or a molecule taken through an electron microscope is a mysterious design. An insect shot at life-size becomes a giant, startling monster. Photographers have even taken such artistic close-ups of peeling paint on rusting cars that the viewer wouldn't believe a piece of junk was the creative impetus.

Step beyond the functional to the fanciful by exploring the myriad close-up patterns and designs around you. They will open up a whole new world for self-expression, expanding your vision, exercising and stretching your creativity. Stimulate your photographic originality by looking at things old and new through a close-up lens to find art in whatever unconventional way is comfortable for you. Seek out such close-up subjects as ripples on water, autumn leaves on the grass, geometric forms in rocks, trashed clothing at a paper factory, or distorted portraits seen through imperfect glass. A list of pattern and design images also includes colorful, ambiguous reflections; geometric stacks of lumber or pipes; groups of pebbles, accidentally or intentionally arranged; a section of a feather; and the pattern in or the texture of a bit of cloth.

That's no ogre, that's my wife—as seen through distorting glass we came upon at an outdoor art show. Her face was in overhead sun, which the glass diffused as it did playful things with her features. Trick mirrors also distort people and objects in amusing ways. Try a self-portrait by aiming the camera from your waist or at arm's length, and shooting a few frames. Experiment with mirrors and different types and colors of glass when you shoot portraits or still-life subjects to discover new creative effects.

Scott Shaw found a mysterious, abstract pattern in crumbling paint, a padlock and what looks like the top of a fence. Making the shot a tight close-up eliminated normal visual points of reference and produced the intriguing design of this composition. He won an Eastman Kodak award for this picture, which was taken on Ektachrome with his camera on a tripod.

No Limits

You have only yourself to please with your subject choice or approach to taking pictures or how much film you shoot. If your images don't fit the needs of photo buyers or other clients, you won't sell many, but that point should not restrict your creative vision. Be happy when your creativity flows, when you discover the un-usual or the incongruous and get stimulating photographs. Keep your visual attention flexible, and consider even bizarre ideas or subjects before discarding them. In other words, keep a fresh eye. Consider design and pattern close-ups as an op-portunity to expand your creativity and possibly to in-trigue many people who view your images.

Explore the close-up pos-sibilities in commonplace subjects. Examine patterns and designs in nature. Begin to look at man-made objects more closely. Best of all—to me at least—are man-made items that have been marred by weather and time. I see such artistic junk as photo-graphic gems waiting to be uncovered.

SOURCES OF VISUAL INSPIRATION

I've found that familiarity with modern painting, photography and graphic design has boosted my ability to discover close-up pattern and design subjects. Some inspirational examples: The geometric combinations of Piet Mondrian (1872-1944); the rendering of conventional objects as graphic interlocking forms and lines by Cubists Juan Gris (1887-1927), Georges Braque (1882-1963) and Pablo Picasso (1881-1973); and Stuart Davis's (1894-1964) simplified geometric visions of streets and signs have given me some of my favorite photographic inspirations. William Harnett (1848-1892), a lesser known painter but well worth discovering, painted still lifes so realistic that his work looks photographic. Harnett's compositions, often close-ups of everyday objects, are strong designs that will give your imagination a lift. Georgia O'Keeffe's (1887-1986) wonderful close-up paintings of flowers straddle a fine line between the representational and the abstract.

The painters who have been cited here represent only a handful of the many great modern artists whose works can be seen in museums, galleries, libraries and bookstores. A museum gift shop is a wonderful source of books on the works of not only great photographers, but painters and designers. Within these bound treasures

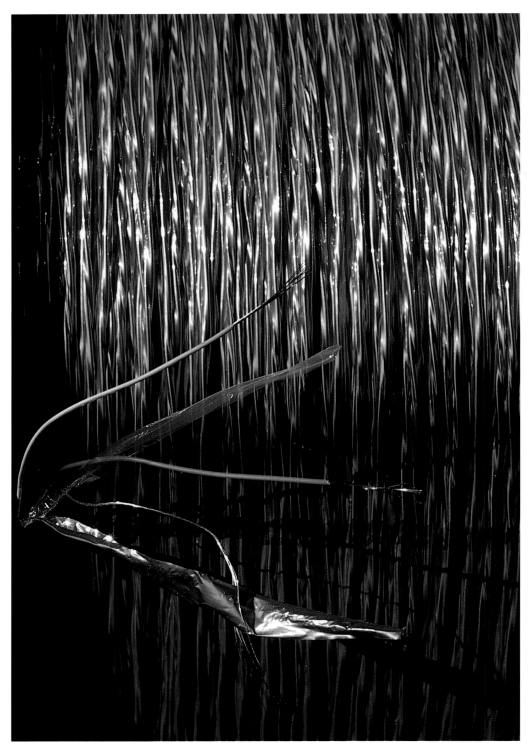

Veteran photographer Ken Whitmore, who specializes in corporate annual reports and stock photography, is so well respected that he often selects his own subjects at a manufacturing plant. To please both his client and himself, he lighted a large reel of wire using electronic flash with a blue gelatin in front of it. He added a creature made from an electrical connection to complete an eye-catching illusion. Whitmore shot on Kodachrome 64 professional (aged at the factory) with a 90mm macro lens.

you'll find many images to excite you and lead you toward new adventures and discoveries in close-up photography.

Many photographers have explored the designs and patterns of close-up subjects. Going through my own library, I found *The Mineral Kingdom*, a book by Paul E. Desautels of the Smithsonian Institution with photographs by Lee Boltin, a master of close-ups. Many of his photos show minerals and locations that become patterns and designs as well as records of gemstones and raw materials. This book was published by Madison Square Press, a division of Grosset & Dunlap, in 1968 but is now out of print and will be hard to find. Another book in my library that contains wonderful close-up illustrations is *Roots of Art* by Andreas Feininger (Viking Press, 1975), which is a treasure trove of macro photography, including patterns and designs. Check bookstores, especially among remaindered (often bargains) books for more recent examples of exemplary close-up photography.

There are other photographers whose work illustrates the creative role of patterns and designs: Edward Weston (1886-1958), who was a poetic master at making art out

Kathleen Jaeger created this imaginative pattern close-up by placing a patio chair against a black background. The high sun nicely backlighted the webbing. She carefully composed the shot to create the pattern reminiscent of the paintings of Piet Mondrian, whose work she likes as much as I do.

of close-up details; Wynn Bullock (1902-1975), who saw natural scenes with wonderful simplicity; and Frederick Sommer (1905-), who has photographed broken toys, dead birds, trash piles and other souvenirs of passing time. Aaron Siskind (1903-1991) found mystery in reality; and Charles Sheeler (1883-1965), a photographer and painter, turned industrial scenes into beautiful abstract patterns, occasionally shooting close-ups, but always producing wonderfully graphic images.

The list of photographers above is necessarily brief, but I hope it will inspire you to take the time to look in museums, galleries and books for work that excites your fancy for whatever reason. While you're at it, look in used bookstores and swap meets for collections of photographs, designs or illustrations that will expand your creative vision. Many types of subjects help open your mind to new ways of seeing close-ups.

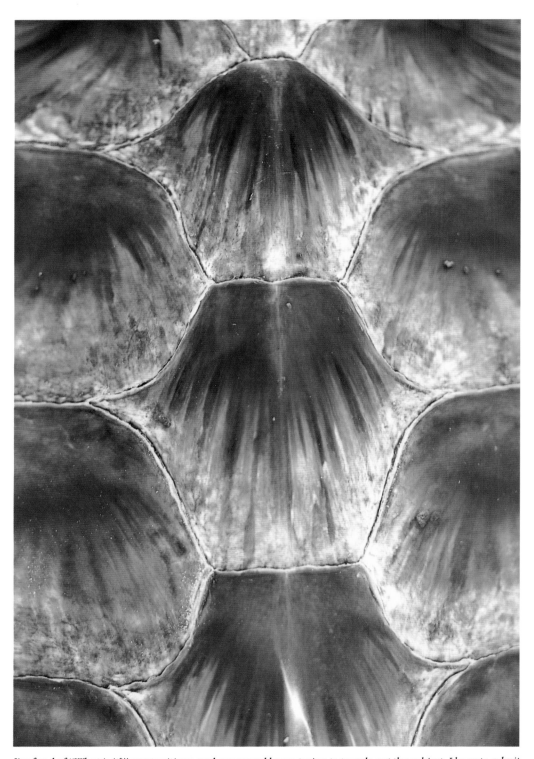

I'm fond of "What is it?" compositions and can spend hours trying to puzzle out the subject. I have to admit this shot by graphic designer Kathleen Jaeger stumped me. Is it shells? Or some sort of honeycomb? The pattern is actually part of an antique lampshade with the light on behind it. Would you have guessed that? Would you have been attracted to this subject? Being able to look at commonplace things in different ways, to be willing to go beyond the expected, makes the difference between a good image and one with that creative something extra.

VISUAL EXERCISES

With an active imagination and an understanding of the kinds of designs and patterns that appeal to your aesthetic vision of close-up photography, develop ways of seeing ordinary subjects as photographic and imaginative impressions. Search for assorted objects you can see and photograph in several ways from varying distances and angles.

Learning to see the world around from a different perspective can help you grow as a photographer. Fortunately, it's also fun to do. Try looking at things from an unusual angle or getting unusually close to something normally photographed from a bit of a distance. Half-close your eyes when studying a potential design or pattern subject and see how your perspective changes. Look at groups, rather than units, in search of subject texture. Study the patterns and textures of fabrics. Study several styles of abstract painting and then try to apply that kind of vision to subjects you photograph. You'll find ideas in both natural and man-made things. The photos of an electronic construction that you see below and on the next page illustrate how a single source can inspire varied images.

I find art in junk; it's a photographic challenge. With practice, artistic close-ups of junk are only slightly harder to envision than good

I made this construction from a tape recorder that no longer worked. It's a kind of electronic sculpture, an example of an avocation I enjoy. I began this exercise in close-up composition by including nearly the whole construction with a sheet of red paper behind it in the high afternoon sun. The shadow below the rod emerging at the top of the white panel indicates the sun's position. I placed a + 1 diopter over a 28-80mm zoom, chosen to vary the composition without moving the camera. I shot a series of three pictures on Ektachrome Elite 100. Exposure was 1/90 at f16.

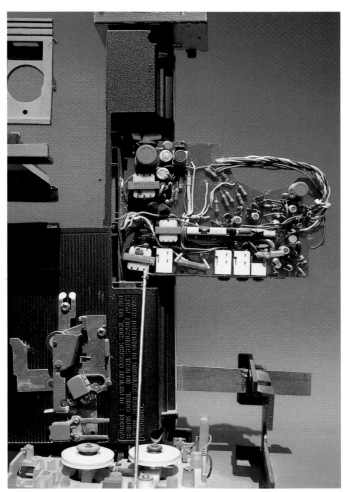

After I took the shot shown at left, I replaced the + 1 diopter over my 28-80mm lens with a + 2. By moving the camera and tripod closer and adjusting the zoom, I found another composition with a geometric source I liked. A subject such as this electronic sculpture is welcome for visual exercise because it challenges the imagination. Exposure was 1/90 at f16.

Finally I focused on this section of my construction using a + 3 diopter over the same 28-80mm lens. At this point the zoom was probably at 70mm. Throughout the series, I changed the focal length to show only portions of the subject I wanted to shoot, an easy way to explore different compositions quickly. I like this shot better than both the ones shown at the bottom of page 123 because it's the most abstract, although recognizable transistors and diodes are clearly seen. Shadows in the design separate the components. Exposure on Ektachrome Elite 100 was 1/90 at f16.

James R. Williams won an Eastman Kodak contest several years ago with a mysterious close-up design. The silhouette may be a hand, but I'm not sure how he created the delightful, colorful shapes in the background. They may be overlapping translucent pieces of plastic that Williams backlighted, but your guess is as good as mine. This unusual photo is a triumph of imagination over reality.

scenics. Essentially, I look for abstract patterns, the kind one sees in modern painting, the kind nature designs in an infinity of clouds, the kind that is inherent in a torn and tattered billboard. Nature may already have begun to transform patterns of junk or textures in worn paper or fabric into abstract designs you can photograph in your own way, making art from what others may choose to ignore.

Junkyards, especially those devoted to old cars, are ev- erywhere. I've found the people who run them receptive to my wandering about with a camera—although they usually feel I'm somewhat crazy. I don't blame them. The abandoned metal they sell is junk, but I see it more aesthetically. Collections of stuff in vacant lots and buildings that are abandoned but not unsafe to enter are also sources of the incongruous and abstract. Literally, one man's junk is another man's art and can be a close-up photographer's treasure.

A visionary's plan to preserve the world's species—by counting them

THE WORLD ACCORDING TO DAN JANZEN

BY ROBERT LANGRET

Like air billowing from an open oven, the bone-dry trade winds assault Dan Janzen as he climbs a ladder to the viewing platform. Reaching the plateau, the balding, foolish ecologist helps pull his two visitors to the top, then sweeps his arm toward the unobstructed vista of pristine tropical forest in Costa Rica's Guanacaste Conservation Area.

"You can see the whole park from here," he shouts above the wind's roar. In front of Janzen, brown and yellow hills erratically descend to the shimmering Pacific a few miles away. Behind him, the thick landscape becomes greener as it rises inland toward rain-soaked territory that terminates in two

Two pages from the December 1994 issue of Popular Science *are a celebration of close-up and copy photography. Staff photographer John B. Carnett took the photographs for a story on scientist Dan Janzen in Costa Rica, and the magazine's art director, W. David Houser, assembled the insect and butterfly samples with a portrait and background landscapes. The large box of samples was 10" × 20", and John shot it and the other box with a 35mm camera and 60mm macro lens. He used a portable electronic flash with two heads attached to a single power pack, and waited for sunset to tint the subject's face.*

Close-Up Copying

My wife Kathy's 18" × 24" montage of her flower close-ups was photographed indoors by floodlight against a background of black cloth covering the ironing board where the montage was placed. She had the work plastic-laminated, so to eliminate reflections I draped my Canon Elan camera, with its Sigma 50mm macro lens, and the Bogen tripod with a piece of black velvet cloth. I used two GE 500W reflector flood bulbs in sockets on light stands. We regularly shoot her montages and my collages with both slide and print film so we can carry and show the copies easily, and have slides when we need them.

WHY MAKE COPIES?

When you own an SLR camera and macro lens, or have diopters for zooms and other lenses, there are several reasons to use your equipment for copying, including:

- To shoot duplicate slides to protect originals.
- To copy artwork that artists and designers use to submit slides to shows or for prints to show friends.
- To copy photographic prints, especially old ones with historic family value, or prints for which the negatives are lost or misplaced.
- To copy old documents.

COPYING EQUIPMENT AND TECHNIQUES

You can use a macro lens, or a zoom or single focal-length lens with a close-up diopter over it, if needed, for copying with 35mm and some medium-format cameras. For small subjects, a macro lens may be your first, or only, choice. Experiment with a close-focusing zoom and diopters before investing in a macro if you will only use it for copying.

You can use a camera mounted on a tripod to do your copying, adjusting the tripod so it points straight down to frame roughly an 8″ × 10″ area. However, this arrangement may present several problems: The subject has to be the right size to fit between the tripod legs without including parts of

the legs; and the tripod legs may throw shadows on your target, depending on its size and position. A camera on a tripod is most useful when you copy subjects fastened to a wall, or when they are propped up at a suitable angle, perhaps resting on a book or copy holder.

If you do a lot of copying on a regular basis, consider buying a copy stand. On its base a pole is mounted, and on the pole is a plate to which you attach a camera to adjust it up and down. Lights can be placed on each side of the baseboard, and some models include lights. The main advantages of a copy stand are that the camera can be mounted exactly parallel to the subject, and the subject lays flat, under glass if it tends to curl. The standard copy stand limits the size of what can be copied to about 12″ × 16″, but that may not affect your work.

You can copy materials indoors with daylight from a window. For better control and lighting, use two floodlights, one on each side of and equidistant from the work you copy. You can use reflector flood bulbs, photoflood bulbs screwed into aluminum floodlight reflectors, quartz lights or electronic flash (strobes) if you wish. (See pages 103-107 for more lighting equipment.) You can buy separate reflectors and bulbs, or assemble sockets, wire and clamps to use reflector flood bulbs for handy, portable copy lighting.

When copying reflective

One of my low-relief collages was photographed outdoors to enjoy the even lighting the sun guarantees so I didn't have to set up my indoor studio. I positioned the piece for tiny shadows to show that the components have thickness. It's best to shoot when the sun is close to a 45-degree angle in the sky, though the shape of an artwork, or the textures within it, always influence its lighting. I am not keen on the shadows thrown by the frame at the top and right side, but shadows happen.

This large painting (about 4' × 5') by Jo Blaber was photographed outdoors in front of an 8' × 10' navy blue piece of fabric. I stood the painting on a low ironing board in a position where a small shadow would reveal the two adjoining panels. When you copy works of art that are five or six feet long or high, it's often convenient to shoot outdoors where even lighting is assured. I used a 28-80mm lens on a 35mm camera with both Kodak Ektachrome Elite 100 slide film and Fuji Super G 100 print film, because she wanted both slides and prints.

materials, such as glossy prints, adjust the lights at oblique enough angles to eliminate reflections. When lighting anything covered with glass indoors, set up the work and light it. Drape a yard of black velvet material over the camera and tripod so only the lens shows. Turn off the lights in the room and drape windows, or work at night, to eliminate reflections. Do it right, and no one will know you shot through glass.

For most copying, a general exposure reading with your camera meter is fine, with or without a filter. There are exceptions, however. Give a half-stop or whole stop extra exposure to predominantly bright subjects, and a half-stop or whole stop less exposure to predominantly dark subjects. For more peace of mind, use an 18-percent gray card to determine exposure.

There are a number of tungsten slide films available for working with studio lighting, including Ektachrome 64T, 160T and 320T, or Fujichrome 64T (all for 3200K), plus Kodachrome Type A 40 (for 3400K). You can also shoot daylight slide films with floods as long as you use the appropriate correction filter. Use an 80B filter with 3400K bulbs, an 80A filter with 3200K bulbs. Color print films pose no color correction problems if you use flash. However, shooting copies with tungsten lights can cause difficulties at the lab. (For more on films and studio lighting, see pages 58-69 and 103-107.) It's better to stay with ISO 100 print films and make copies in daylight.

BASIC COPYING ARRANGEMENTS

You can usually copy flat materials without any special lighting equipment if you do it outdoors in sunlight. If the sun is uncomfortably hot, try bright shade where contrast is reduced; colors will tend to be cool and may need correction with a skylight 1A filter.

Some subjects, such as artwork and paintings, need a plain, unobtrusive background. I prefer using fabric, which can be folded for storage and is available in sections large enough for work 5′×6′ or larger. Black and dark blue materials are best for artwork because they are anonymous. Behind subjects that need brighter backgrounds I use colored fabrics or illustration boards and papers. The color of the background fabric or heavy paper you select depends on the color and type of work. I sometimes use 20″×30″ or 30″×40″ sheets of colored illustration board, which I tape to the table or ironing board. If I need to lean the work to be copied against the background, I curve it up the wall, where I hold it in place with duct tape. This eliminates any table line behind the subject.

It is easier to lay the background flat on a table and place the work you are copying on it if it's small enough to shoot down on. Otherwise, stand the work up or lean it against a wall. Angle artwork with textures, such as thick paint or laminations, so there is just enough shadow to show the surface.

Copy thin materials, such as prints, by flattening them and laying them at the front edge of a table to shoot straight down at them, hoping they will not curl before you shoot. I flattened the sepia-colored family portrait and the marriage license shown opposite at right by mounting them on black posterboard with 3M Photo

At a county fair I photographed these grapefruit, packed for shipment, solely for their pattern value. There was only weak fluorescent light, and I had no FLD correction filter or even a tripod with me. So I used the small pop-up flash unit on my 35mm camera and a 28-80mm lens. After carefully lining up the grapefruit parallel to the edges of the finder, I exposed the shot between f8 and f11 on Ektachrome Elite 100. The least expensive way to get duplicate slides is to take duplicate originals whenever possible. When you can't do this, have your slides duped. If you make dupes frequently and can afford it, spring for precision duplicating equipment. In a professional copying arrangement, the original image lies in a slide holder above translucent glass, with the camera focused on the slide. An exposure is made via electronic flash in a lightbox beneath the slide.

One of my collages, titled "Still Life," was photographed by 3200K floodlights on Ektachrome 100 slide film using an 80A correction filter. I can live with flare from the lights on the frame, since there are no reflections on the glass. The camera and tripod were wrapped in a piece of black velvet so only the lens showed. From about four feet away on each side, at about a 60-degree angle I placed a GE 500W reflector flood in a socket on a stand. I like to use my 28-80mm Canon lens for copying when the work is large enough because it's easy to zoom the work to the proper size in the finder. Be sure the lens you use to copy does not have barrel distortion, which makes straight edges bow slightly in the middle, a phenomenon that should be visible in the finder. A macro lens should be free of distortion.

Mount spray adhesive (available at art supply stores). It may also be more convenient to stand small things on a metal or plastic copy holder, the kind used by typists. Place a piece of fabric or colored paper board on the holder if you need to hide it.

Important: Manipulate the camera and the artwork so all the edges of what you copy are parallel to all the edges of the finder. This may seem obvious, but it's not always easy to do, and many copies not made carefully look slightly askew. You can leave a tiny margin all around what you copy, which may be cropped off in the printing or slide-mounting process.

DUPLICATING SLIDES

Have your best slides duplicated so the originals won't be lost or damaged. Good dupes often can't be easily distinguished from originals. You can successfully copy slides yourself with a homemade setup, though precision duplicating equipment can make a difference. You can also have slides duplicated at a photo lab. If you need dupes frequently, however, you may choose to invest in a slide duplicator similar to but simpler than the apparatus described below.

The least expensive accessory is a slide duplicating attachment, which fits onto a camera body in place of a lens. It holds a slide in front of a diffusion disk, behind which you place electronic

flash or floodlighting. Exposure with floods is determined by the camera meter. If you use a flash setup, make exposure tests by determining the distance from flash to slide, and the power output of the flash, if it's adjustable. Some duplicating attachments have a zooming feature that allows you to crop a slide to some extent. A lens is built into a duplicating device, and you should test the sharpness of such lenses for yourself. Check your local photo stores and the major photo catalogs for this attachment.

You can make your own inexpensive duplicating arrangement. My homemade setup works well, but the results are sometimes inconsistent in terms of exposure and slide placement. Here are the components:

• A small wooden rack. Mine is eight inches long and four inches high made of thick poster board. The base is four inches wide, and secured to it on each side is a piece of poster board, one edge of which is cut at a 45-degree angle to hold the opal glass. At the bottom front of the rack is a piece of wood eight inches long and ⁵⁄₁₆-inch thick, against which the bottom of the glass rests.

• A piece of opal glass; mine is about 9″ × 4½″.

• A piece of black poster-board the same size as the glass with a precise hole cut into the center the same dimensions as the opening in a slide mount. Glue a double-

My wife's mother (with the hair ribbon at age nine) and her family posed for a typical professional portrait around 1915. I mounted the print, and Kathy's grandparents' marriage license (from 1905), on black illustration board with 3M Photo Mount spray adhesive so neither would curl when I photographed them in sunlight outdoors. The photo and the couple's license were laid separately on a table, and I shot straight down with a 50mm macro lens, carefully avoiding a tripod leg shadow on either one. I was also careful to ensure all edges of the license and the photo were parallel to all the edges in the finder. Vintage photos and documents can be preserved by copying them on slide film such as Kodachrome, which will stay bright for many decades. Most color prints will begin to fade in twenty to twenty-five years. These copies were made on Kodak Elite 100 (which also has a long life span), and the exposures were 1/60 at f16.

thick piece of posterboard under the hole and another at one side to position the slide precisely in front of the hole so only the picture shows and none of the slide mount is visible.

• A piece of cardboard used as a spacer to position your electronic flash unit. Mine is eleven inches long and four inches wide and at one end is a piece of wood 1½ inches long, ½-inch wide and ⅜-inch thick. The back of my flash unit rests against the piece of wood.

• A flash unit. Any small electronic flash will do; if you cannot reduce the power of yours, move it farther from the slide and diffuse it with translucent plastic.

• 35mm camera with 50mm, 60mm or 90mm macro lens.

• Base for camera. You can use a very low tripod, such as a tabletop model. Buy your tripod first and tailor the dimensions of the holder for the glass and slide mask to suit the height of your mounted camera.

The tricky part of such a homemade rig is positioning the camera exactly to include the whole slide, with all edges parallel to the finder, without accidentally including one or two thin black edges of the mount. You must view precisely and consistently through the center of the finder to make good dupes, and that takes practice. Make exposure tests at half-stop intervals, and keep careful notes so you can re-

Although I wrote "reflections on sculpture" on the slide, I don't remember who created this work in polished brass or where I saw it. The reflections created by the light from a window falling on the metal still fascinate me, however. The undulating metal reflected one facet in another and the highlighted ridges are important to the design. The film is Kodachrome 200 and the exposure was 1/90 at f8. Get dupes of your best and/or favorite slides. If the original of this slide were lost or damaged, it could never be replaced. I could never exactly duplicate the lighting conditions that day, even if I could remember where I took it.

More Close-Up Ideas

THE JOYS OF CLOSE-UPS

Photography is more fun when you generate lots of ideas that start your mental motor running. Ideas are stimulated by photographs, paintings and other creative work you see, by classes you attend, by books and magazines you read and by discussions with friends. Excite your imagination to generate more ideas by exposing yourself to the above stimuli, and then experimenting with your camera indoors and out. Here are some projects to help you get going. They combine techniques discussed in previous chapters together with a few challenges not described before. But a few words of advice before you jump in.

Concentrate on having fun. Think about the plea-

Modern digitized timepieces don't have the classic charm of an older watch. Light coming through the window used for illumination was relatively soft and even, which helped me get even lighting despite the shiny (reflective) surface. Had it been direct sunlight, reflections and shadows would have been more harsh. I haven't had an opportunity to shoot such a watch since, and I'm glad this one is on long-lasting Kodachrome 64. Do you know of an attractive small heirloom that would be an inspirational close-up candidate? I'm thinking of old jewelry, ornate picture frames, silverware or coins with character. Results are more pleasing if you photograph these subjects by reflected daylight, floodlighting or electronic flash, and the experience can definitely improve your close-up techniques. Use small (like 8" × 10") white reflectors or a photographic umbrella, and use direct light for accents.

In most cases the objects assembled for a photographic still life are somehow related, such as a bowl of fruit and a pitcher on a tablecloth. For a change of pace, try putting together a group of things that are not related. I assembled this still life around a beautiful circuit board taken from a defunct calculator. The watch parts, rubber insulation, cork, photo of a Barbara Hepworth sculpture (snapped with flash in a museum) and other items were grouped with incongruity as the theme. I lighted the arrangement with one photoflood at the right and another reflected from the left, and used a 50mm Sigma macro lens on a Canon Elan SLR loaded with Ektachrome Elite 100 film. An 80A filter corrected the daylight film for 3200K tungsten light.

sure of seeing slides or prints that evolve from your creative ideas. You know some images will be discarded, but shoot plenty of variations of any theme you enjoy. Don't stop trying new variations as long as your flow of ideas continues. From numerous slides or prints there's a better chance of finding one or two that satisfy your sense of accomplishment. Try not to be concerned when you don't get the photos you want because valuable experience comes from making mistakes. You'll get your reward when you do it again right. And don't worry about "wasting" film. A thirty-six-exposure roll of color slide film with processing costs no more than a modest dinner out, lasts a lot longer, and can more than pay for itself with one good sale. The cost of a roll of negative color and thirty-six prints is approximately the same as shooting slides. Good luck and have fun with these projects. I did.

For a different look, investigate prism lenses that dissect a subject into two, three or more images adjoining and overlapping each other in a line, arc or circle. As you get closer to a subject, a prism effect differs in design and visual impact. Here I screwed a linear prism lens with six facets in front of my 50mm macro lens and revolved it, while looking through the SLR viewfinder until I had the pattern I wanted. A local camera shop or a mail order supplier may have prism lenses. Porter's catalog calls them "multiple image lenses."

A multiple exposure is tricky to create because you combine two or more exposures on one frame of film, and you can't be entirely sure what will happen. These multiples are worth playing with to produce images that would not otherwise exist. I enjoy intentional double exposures to challenge the gods of serendipity. Here are simple directions:

Choose two subjects, either analogous or incongruous. It helps if they are close enough to each other so you can shoot the second one within a reasonable time. Visualize where the second image should be to blend or overlap with the first one you shoot. You can do this in your imagination, or by making a rough sketch of the first shot and another sketch on tracing paper of the second one. The dark areas of one image will be replaced by part of the other image; bright areas will cause overexposure that prevents the second image from showing as anything more than a pale, washed-out shadow. When I did the horizontal picture of tomatoes at a roadside stand, I double exposed it with yellow flowers in a nearby field. This is the kind of easy combination I recommend because a pattern like flowers blends gracefully over many kinds of images, and the two shots can be harmonious.

You need an SLR capable of multiple exposures so that the shutter is cocked but the film is not advanced after each shot. Set the camera for two exposures. (See your camera's manual for specific instructions.) With slide film, you must divide the correct exposure for each image to avoid overexposure. You can do this by manually adjusting the f-stop and/or shutter speed, but it's easier to double the ISO film speed setting and expose automatically. For example, an exposure of 1/250 at f11 for an ISO 100 film becomes two exposures of 1/250 at f11 with the ISO set at 200. With color print film, for only two exposures, don't worry about exposure compensation because overexposed negatives make excellent prints. However, for more than two exposures on one frame of negative film, divide the ISO number accordingly.

My wife, Kathy, chose a vertical composition of the same tomatoes I used for my double exposure in the image shown opposite at left, which she then double exposed with trees and sky. The sky washed out some of the red at the top of the shot, but added the nice blue background. Tree foliage in the foreground adds a sense of mystery to the blend. Be prepared for unexpected, and sometimes disappointing, results because it's difficult to fully anticipate the final image of multiple exposures.

Using another blended photo technique called sandwiching, you get better control of results by combining existing slides. It is possible to create a combination image that is stronger than either shot could be separately. Start by choosing a number of slides and placing them on a lightbox where you combine pairs until you find a composite image you like. Sandwiches work the opposite of double exposures: the second image shows through the first in the light areas, but not in the dark areas. Occasional detail may be lost but that is understood. Some photographers shoot images just to sandwich; each slide is overexposed by about one-half stop to increase its transparency. Experiment with exposures until you know how much overexposure certain subjects need.

When you have a combo you like, place the two segments of film in the same mount, or copy the combined image onto duplicating film. Creating multiples at home on a lightbox can be less frustrating than blending images in the camera, and it may save film. However, you have to be particular to combine shots that read quickly enough: Details and composition should not be overly obscured or confusing. The nice thing about sandwiching slides is you can work with pictures you like until you get combinations that work. You may also do multiple-image prints using two or more negatives or slides if you have access to a darkroom and enjoy color printing.

Glass and translucent materials can be subjects for enjoyable close-up projects. Backlighting— the main light is behind the subject—produces dramatic, graphic photos. Ken Whitmore arranged cut glass decanters and a pitcher on a table behind which the sun was setting. Using a 35-105mm zoom lens on a Nikon camera, he composed the group and shot a series on Kodachrome 64 as the light faded. Warm light tinting the background accented the textures of the glass.

I struggled with this photo of cherries, a slice of lemon and a straw in a glass of carbonated water. On my first try, the lemon floated to the top, yanking the cherries with it, and I forgot the straw. The second time I anchored the lemon to the bottom with a weight, and the straw and cherry stems were taped out of sight to the top of the glass. I shot quickly while the bubbles were very active. In the background was white posterboard with a floodlight on it. The main floodlight was at the right with a reflector at left to assure even illumination. I used a 50mm macro lens on a Canon Elan camera, and Kodak Ektachrome Elite 100 film with an 80A filter. The exposure was 1/30 between f11 and f16.

AND STILL MORE IDEAS

When shooting outdoors, watch for popular subjects like butterflies, birds and flowers. This is true on any shoot in the field, on a leisurely walk around home, or on vacation. At the same time, look for water in its various forms. Drops of water on leaves and flowers can become jewel-like decorations when backlighted. Flowing water can be more pictorial by using a slow shutter speed such as one-fourth or one-half second. In

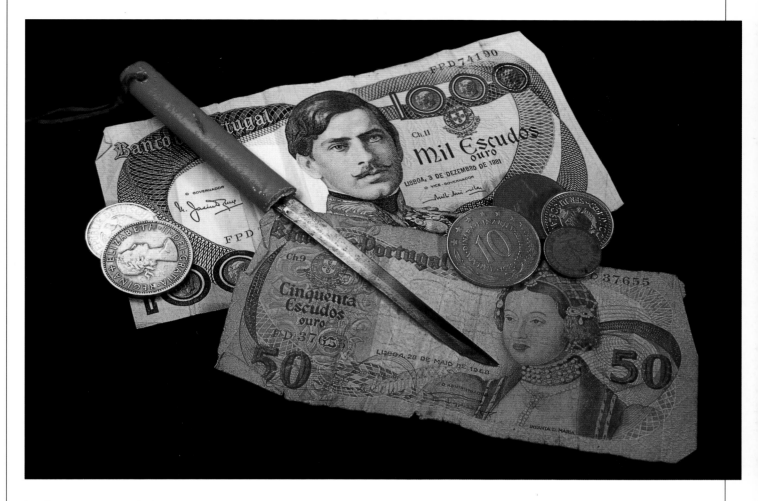

bright sun a neutral density (ND) filter, #2 or #4, darkens a subject so you can use films as fast as ISO 200 and still shoot at slow shutter speeds. Play with colored filters, such as orange or blue, to add a touch of fantasy to water and other subjects.

Here are more subjects to stimulate your close-up creativity:

- A child's hand cradled by an adult's hand
- Colored light to tint a white background behind an interesting setup
- A montage of textures, natural and/or man-made

- Reflections you devise for decorative reasons; use a small mirror or shiny metal
- Mysterious abstractions devised by combining various subjects
- The view through a rain-spattered window or windshield; experiment with close and distant focus
- A subject or scene viewed through distorting glass or plastic, similar to the kind used in shower stalls
- A spider web with dew or water droplets on it—and a spider if you're lucky

It can be fun to create your own setups for close-up work. When you want something to shoot on rainy days, shooting an indoor still life can satisfy a desire and offer a challenge. I'm fond of making still-life arrangements and lighting them several ways to explore the pictorial possibilities. Experiment with background colors, textures and materials as well as various objects. Black backgrounds add welcome contrast to many subjects. Colored backgrounds make their own accents. Here I placed paper money and coins with an old letter opener on a black background. The color is monotone for a change of pace. Lighting was with GE 3200K reflector flood bulbs, reflected from white posterboard. A 35mm SLR camera and 50mm macro lens were used to expose at 1/15 at f16 on Ektachrome Elite 100 film.

I experimented by photographing a portion of a medieval painting beneath a piece of glass I smeared with a random pattern of petroleum jelly. I exposed it normally using two GE 500W 3200K reflector flood bulbs and a Canon 35mm SLR with Canon 28-80mm lens, + 2 diopter and an 80A filter to correct daylight Ektachrome Elite 100 for tungsten lighting. Variations on copying help make close-up photography interesting.

This and other photos in the book demonstrate my fascination with electronic circuit boards as photographic close-up designs. Find your subjects by taking apart discarded radios, tape recorders or amplifiers—but not television sets because a cathode ray tube may explode if bumped sharply. Cut wires and remove transistors and diodes to suit your own sense of design, and place the circuit board in bright sun or in your indoors studio location. This was photographed using two 250W, 3200K photoflood bulbs in Smith Victor twelve-inch reflectors on light stands. One light was directed from the top right corner and the other was a fill light at the left. I shot with a 35mm SLR camera and 28-80mm zoom with 80A correction filter and + 4 diopter on Ektachrome Elite 200 film at 1/30 and f11. In my imagination it's an aerial view of a small community.

If it hadn't been snowing in the San Jacinto Mountains atop the Palm Springs, California, Aerial Tramway, I might have seen the warm light of sunset, but instead, the light was cool in keeping with the weather. I visited this area, which is about 8500 feet high, because I don't experience snow where I live near Palm Springs. In a half-hour's walk I tried to keep my SLR dry under a jacket, but it was worth wiping off the moisture to get this moody stump and rocks taken from about three feet away with a 28-105mm lens. I used ISO 200 Ekta-chrome Elite film and shot at 1/60 and f6.3. The 1B skylight filter I always keep over my lenses was not warm enough to affect the bluish tint, but I didn't switch to a warming filter such as the Tiffen 812 because I wanted this moody effect.

INDEX